THE
SHORT
STORY
OF
WOMEN
ARTISTS

LAURENCE KING

Published in 2020
by Laurence King Publishing Ltd
361–373 City Road
London EC1V 1LR
Tel +44 20 7841 6900
Fax +44 20 7841 6910
E enquiries@laurenceking.com
www.laurenceking.com

A catalogue record for this book is available from the British Library.

ISBN 978-1-78627-655-1
Designed by John Round Design
Printed in China

p.10 *Timoclea Killing the Thracian Captain,* Elisabetta Sirani
p.38 *Self-Portrait as the Allegory of Painting,* Artemisia Gentileschi
p.168 *Self-Portrait with Changuito,* Frida Kahlo
p.194 *Hanging Fire (Suspected Arson),* Cornelia Parker

THE SHORT STORY OF WOMEN ARTISTS

A Pocket Guide to Movements, Works, Breakthroughs & Themes

Susie Hodge

Laurence King Publishing

Contents

Introduction

BERTHE MORISOT: 'I WILL ONLY OBTAIN MY INDEPENDENCE THROUGH PERSEVERANCE AND BY SHOWING VERY OPENLY MY INTENTION TO EMANCIPATE MYSELF.'

Women have been creating art since antiquity, but for much of that time, they have been excluded, ignored and generally expunged from art history.

While it is likely that many prehistoric artists were women (there is evidence of female hand prints), and Pliny the Elder (23–79 CE) named six female artists of ancient Greece in his *Natural History* of 77 CE, women artists have rarely been acknowledged, and for centuries they were prevented from joining art academies and societies, taking art courses, attending life classes, entering art competitions and exhibiting their work. Until the sixteenth century, few women, apart from nuns, were educated. (Bologna in Italy, uniquely, had a university that educated women from the eleventh century, and the first school for girls was opened in Krakow, Poland, in the fifteenth century.) In the main, women's primary options were marriage or entering a convent. Additionally, women customarily change their names when they marry, and while most did not work after marriage, if they did, their work was often accredited to their better-known male counterparts.

Despite the difficulties, many women did work as artists, but they have rarely become as acclaimed as their male equivalents. Now the balance is changing. Obstructions are being erased, and more women artists are being recognized and re-evaluated.

This book introduces some art produced by women from the Renaissance to the present day. It explores their work through art movements, works, themes and breakthroughs. Its unique format means that everything can be cross-referenced and clarified as it celebrates the dedication and achievements of so many women, considering their significance and putting their work into context.

Movements

FRIDA KAHLO: 'THEY THOUGHT I WAS A SURREALIST, BUT I WASN'T. I NEVER PAINTED DREAMS. I PAINTED MY OWN REALITY.'
Art movements are the names given to certain artistic styles or approaches created during particular periods by artists who often share ideals or methods.

Most movements come about when a group of artists break with tradition, and most are named by artists or art historians in order to categorize the history of art. Some art movements evolve organically through mutual influences or external occurrences. Some emerge directly from or in reaction to a previous art movement. Some are tightly focused and others broader. Some evolve over years; others begin and end within months. They can spread across continents or be concentrated in a small area. The names of movements can be laudatory or derogatory, and the movements themselves can be accepted, rejected or even unknown by the artists involved.

Most art movements predominantly involved male artists, and although some consciously welcomed women, the majority ostracized them. As with the rest of the history of art, on the whole, the women working within certain movements are not as widely known as the men, and this section of the book explores some of these women in the context of their work and their contribution to the movements to which they were connected.

Works

GEORGIA O'KEEFFE: 'THE MEN LIKED TO PUT ME DOWN AS THE BEST WOMAN PAINTER. I THINK I'M ONE OF THE BEST PAINTERS.' This section reviews 60 notable works of art created by women artists from the sixteenth to the twenty-first centuries. Each is made with skill and originality, expanding and enriching the scope of the history of art. Among the works are paintings, sculpture, installations, performance and more, using a wide range of themes, materials and techniques.

Before the mid sixteenth century in the West, unless they became nuns, women were not taught to read or write, nor did they learn mathematics or science; they could not travel freely, and artistic tuition was forbidden. In 1528 Baldassare Castiglione published *The Courtier*, which dealt with etiquette, behaviour and morals, and became extremely popular. The book's radical claim that all aristocrats, whether male or female, should be highly trained in certain arts initiated the emergence of more female artists. But things remained limited for women. For instance, until the end of the nineteenth century, life classes were forbidden to them, and for centuries, most women had to learn alone, studying in galleries and undertaking their own experiments.

Breakthroughs

HELEN FRANKENTHALER: 'THERE ARE NO RULES. THAT IS HOW ART IS BORN, HOW BREAKTHROUGHS HAPPEN. GO AGAINST THE RULES OR IGNORE THE RULES. THAT IS WHAT INVENTION IS ABOUT.'

The Roman writer and philosopher Pliny the Elder (23–79 CE) listed several successful female artists of ancient Greece and Rome. However, after the fall of Rome women were no longer allowed to work in such prominent roles, and it was not until the sixteenth century that they began to achieve a modicum of recognition for their skills.

Largely owing to the change in attitudes towards the education of women, predominantly brought about by *The Courtier*, the first celebrated female artists came from Italy during the Renaissance. From that point on, especially determined women occasionally fought through the restrictions and produced art that broke new ground.

This section of the book explores some of those breakthroughs, including the first female members of the Royal Academy and the Académie Royale; the first abstract paintings; women artists who were the family breadwinners; and art that turned traditionally considered 'women's crafts' into fine art.

Themes

MARY CASSATT: 'I AM INDEPENDENT! I CAN LIVE AND I LOVE TO WORK.'

Different from the subject, the theme is usually an underlying presence in a work of art. Themes may be obvious or obscure, universal or unique, or complex or simple, and they are always interpreted differently by different artists.

This section of the book considers 22 themes that have been explored by women artists. It investigates why individuals chose certain themes and why they interpreted them as they did. Since women's outlooks and attitudes often contrast with those of their male counterparts, their themes frequently seem different, and it is these differences that this section particularly explores.

Artistic themes are often messages about life, society or human nature, and are usually implied rather than depicted explicitly. Certain themes are more prevalent during particular periods – for example, religion in the Renaissance.

How to use this book

The book is divided into four sections: Movements, Works, Breakthroughs and Themes. It can be read as a whole, or you can read the sections in any order. At the bottom of each page you'll find links to other parts of the book, which help to give an overview of how the art world connects and intertwines, how ideas and changes develop. Feature boxes discuss crucial developments and artists' backgrounds.

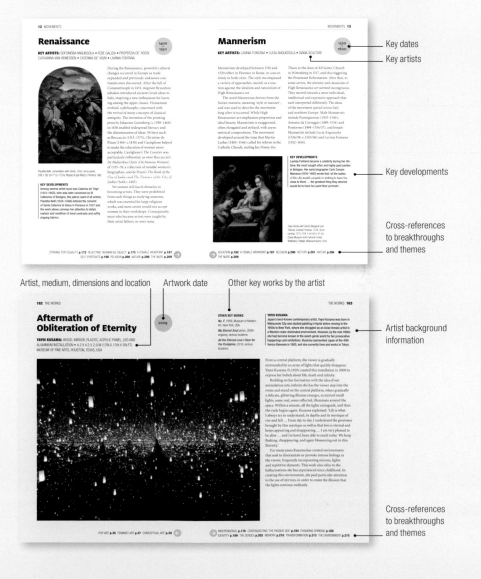

Key dates

Key artists

Key developments

Cross-references to breakthroughs and themes

Artist, medium, dimensions and location

Artwork date

Other key works by the artist

Artist background information

Cross-references to breakthroughs and themes

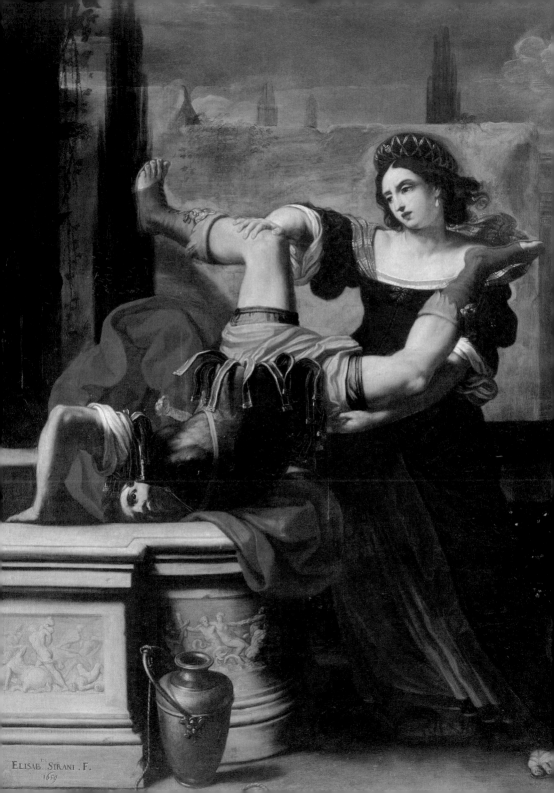

ELISAB. SIRANI . F.
1659

Movements

Renaissance

KEY ARTISTS: SOFONISBA ANGUISSOLA • FEDE GALIZIA • PROPERZIA DE' ROSSI
CATHARINA VAN HEMESSEN • CATERINA DE' VIGRI • LAVINIA FONTANA

Plautilla Nelli, *Lamentation with Saints*, 1550, oil on panel,
288 x 192 cm (113 x 75 in), Museo di San Marco, Florence, Italy

KEY DEVELOPMENTS
Among several artist nuns was Caterina de' Vigri
(1413–1463), who was later canonized as St
Catherine of Bologna, the patron saint of all artists.
Plautilla Nelli (1524–1588) entered the convent
of Santa Caterina di Siena in Florence in 1537 and
the work above conveys her attention to detail,
realism and rendition of tonal contrasts and softly
draping fabrics.

During the Renaissance, powerful cultural
changes occurred in Europe as trade
expanded and previously unknown con-
tinents were discovered. After the fall of
Constantinople in 1453, migrant Byzantine
scholars introduced ancient Greek ideas to
Italy, inspiring a new enthusiasm for learn-
ing among the upper classes. Humanism
evolved, a philosophy concerned with
the revival of many concepts of classical
antiquity. The invention of the printing
press by Johannes Gutenberg (c.1398–1468)
in 1438 enabled widespread literacy and
the dissemination of ideas. Writers such
as Boccaccio (1313–1375), Christine de
Pizan (1364–c.1430) and Castiglione helped
to make the education of women more
acceptable. Castiglione's *The Courtier* was
particularly influential, as were Boccaccio's
De Mulieribus Claris (*On Famous Women*)
of 1335–59, a collection of notable women's
biographies, and de Pizan's *The Book of the
City of Ladies* and *The Treasure of the City of
Ladies* (both c.1405).

Yet women still faced obstacles to
becoming artists. They were prohibited
from such things as studying anatomy,
which was essential for large religious
works, and most artists would not accept
women in their workshops. Consequently,
most who became artists were taught by
their artist fathers, or were nuns.

STRIVING FOR EQUALITY **p.172** REJECTING 'WOMAN AS OBJECT' **p.173** A FEMALE VIEWPOINT **p.187**
SELF-PORTRAITS **p.198** RELIGION **p.200** NATURE **p.206** THE NUDE **p.209**

Mannerism

KEY ARTISTS: LAVINIA FONTANA • LUCIA ANGUISSOLA • DIANA SCULTORI

1520
–
1600

Mannerism developed between 1510 and 1520 either in Florence or Rome, or concurrently in both cities. The style encompassed a variety of approaches, mainly as a reaction against the idealism and naturalism of High Renaissance art.

The word Mannerism derives from the Italian *maniera*, meaning 'style or manner', and was used to describe the movement long after it occurred. While High Renaissance art emphasizes proportion and ideal beauty, Mannerism is exaggerated, often elongated and stylized, with asymmetrical compositions. The movement developed around the time that Martin Luther (1483–1546) called for reform in the Catholic Church, nailing his *Ninety-five*

Theses to the door of All Saints' Church in Wittenberg in 1517, and this triggering the Protestant Reformation. After that, to some artists, the serenity and classicism of High Renaissance art seemed incongruous. They moved towards a more individual, intellectual and expressive approach that each interpreted differently. The ideas of the movement spread across Italy and northern Europe. Male Mannerists include Parmigianino (1503–1540), Antonio da Correggio (1489–1534) and Pontormo (1494–1556/57), and female Mannerists include Lucia Anguissola (1536/38–c.1565/68) and Lavinia Fontana (1552–1614).

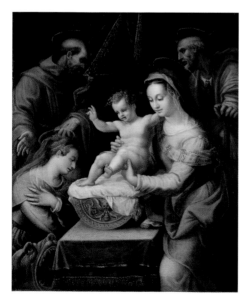

KEY DEVELOPMENTS

Lavinia Fontana became a celebrity during her lifetime: the most sought-after and highly paid painter in Bologna. Her early biographer Carlo Cesare Malvasia (1616–1693) wrote that 'all the ladies of the city would compete in wishing to have her close to them … the greatest thing they desired would be to have her paint their portraits'.

Holy Family with Saints Margaret and Francis, Lavinia Fontana, 1578, oil on canvas, 127 x 104.1 cm (50 x 41 in), Davis Museum and Cultural Center, Wellesley College, Massachusetts, USA

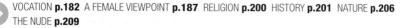

VOCATION **p.182** A FEMALE VIEWPOINT **p.187** RELIGION **p.200** HISTORY **p.201** NATURE **p.206** THE NUDE **p.209**

Dutch Golden Age

1585
–
1702

KEY ARTISTS: MARIA VAN OOSTERWIJCK • GESINA TER BORCH • RACHEL RUYSCH • CLARA PEETERS • ANNA RUYSCH • ANNA MARIA VAN SCHURMAN

Generally considered to have started in c.1585–1600, during the Eighty Years' War (1568–1648), and continuing until the end of the century, the Dutch Golden Age was a period when the Dutch Republic was the most prosperous nation in Europe.

In 1648 the Netherlands gained independence from Spanish rule, which ushered in the Golden Age, and – as well as the ensuing increase in prosperity – artists of the Dutch Republic developed extraordinarily lifelike styles of painting. Dutch Golden Age art roughly corresponded with the Baroque period, when art conveyed a sense of grandeur, drama and movement. However, Dutch Golden Age art was less extravagant and more mundane. A huge variety of painting genres was produced, including landscapes, townscapes, animals, flower paintings, still lifes, portraits, interiors and genre – or everyday scenes – all imbued with notions about the transience of life, minute details and the sparkling effects of light.

Within the widespread commercial prosperity and social progress in the Netherlands, the art market burgeoned and a number of women artists became successful. Some were still ignored or merely worked as assistants to male relatives, but others attained great success as professional artists in their own right.

KEY DEVELOPMENTS
In 1633 Judith Leyster was the first female member of the Haarlem Guild of St Luke, a privilege that allowed her to establish her own workshop and hire apprentices. Here, conveyed with lively brushstrokes, a grinning man holds up a tankard. He is Pekelharing, a stage character whose name means 'salt herring', a Dutch speciality.

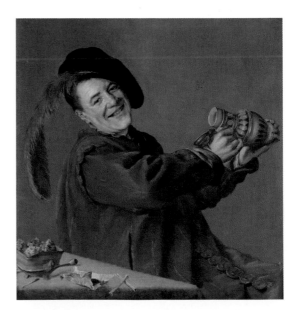

The Jolly Drinker, Judith Leyster, 1629, oil on canvas, 89 x 85 cm (35 x 33½ in), Rijksmuseum, Amsterdam, Netherlands

STRIVING FOR EQUALITY **p.172** THE ONTBIJTJE **p.174** INDEPENDENCE **p.176** VOCATION **p.182**
SELF-PORTRAITS **p.198** NATURE **p.206**

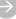

Baroque

KEY ARTISTS: ARTEMISIA GENTILESCHI • LOUISE MOILLON
JOSEFA DE ÓBIDOS • MARY BEALE • MICHAELINA WAUTIER • ELISABETTA SIRANI

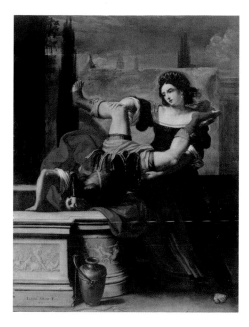

Timoclea Killing the Thracian Captain, Elisabetta Sirani, 1659, oil on canvas, 227 x 177 cm (89¼ x 69⅔ in), Museo di Capodimonte, Naples, Italy

KEY DEVELOPMENTS
Elisabetta Sirani was born into an artistic Bolognese family, first trained in her father's studio and subsequently established an academy for other women artists. According to some scholars, her artistic skills surpassed those of her father and younger sisters. She became the primary breadwinner for the family, with an extremely successful workshop.

The dynamic, dramatic Baroque movement was instigated by the Catholic Church in Rome as part of the Counter-Reformation. The term derives from the Portuguese *barocco*, meaning 'irregular pearl or stone', and it was used retrospectively to describe an art movement that blended emotion and drama with colour, contrast and realism.

The movement began after Church leaders at the Council of Trent in 1545–63 called for the Catholic Church to reassert itself, so much of the art was used as propaganda, glorifying Catholic stories and beliefs. Even when it spread to Protestant countries and had less religious content, it continued to emphasize emotion and grandeur, which appealed to both the upper and middle classes. Frequently large and ornate, Baroque art is lifelike and theatrical, and often conveys a sense of movement. As women were prohibited from joining art academies (which were similar to guilds), they were often the daughters, sisters or wives of established artists. The painters Artemisia Gentileschi and Teresa del Pò (1649–1713/16), and the sculptor Luisa Roldán (1652–1706), for example, all trained in their fathers' workshops. They flouted many of the restrictions imposed on them, as did Michaelina Wautier (1604–1689) from the southern Netherlands, who painted portraits, genre paintings and large-format historical, religious and mythological scenes.

ACCADEMIA DELLE ARTI DEL DISEGNO **p.175** VOCATION **p.182** A FEMALE VIEWPOINT **p.187**
SELF-PORTRAITS **p.198** IDENTITY **p.199** RELIGION **p.200** HISTORY **p.201** THE NUDE **p.209**

Rococo

KEY ARTISTS: ROSALBA CARRIERA • ANNA DOROTHEA THERBUSCH • MARIE-THÉRÈSE REBOUL • ADÉLAÏDE LABILLE-GUIARD • ÉLISABETH VIGÉE-LEBRUN

KEY DEVELOPMENTS
Highly sought after for her work, Rosalba Carriera produced sensitive Rococo portraits of European monarchs, including the Polish and French royal families. She also painted the portrait of one of the most highly respected French Rococo painters, Jean-Antoine Watteau. For her skill, she was admitted to the art academies of Rome, Bologna and Paris.

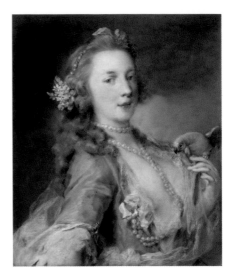

A Young Lady with a Parrot, Rosalba Carriera, c.1730, pastel on blue laid paper, mounted on laminated paper board, 60 x 50 cm (23⅔ x 19⅔ in), Art Institute of Chicago, Illinois, USA

Characterized by elegance, flowing contours and natural elements, and often expressing love, beauty and light-heartedness, Rococo began in Paris in about 1730, partly as a backlash against the excesses of the Baroque.

Although Rococo was predominantly French, the Venetian-born Rosalba Carriera became one of the movement's most successful artists, working in various European cities for prestigious patrons. Deriving from the French word *rocaille*, meaning 'pebbles or shellwork', Rococo emerged initially as an elegant interior design style, before expanding into architecture and then painting and sculpture, spreading beyond France. Most Rococo painters were men, such as François Boucher (1703–1770), Jean-Antoine Watteau (1684–1721) and

Jean-Honoré Fragonard (1732–1806), but the women who worked in the style for at least part of their careers included – as well as Carriera – Anna Dorothea Therbusch (1721–1782), Marie-Thérèse Reboul (1738–1806), Marguerite Gérard (1761–1837), Adélaïde Labille-Guiard (1749–1803), Anne Vallayer-Coster (1744–1818), Élisabeth Vigée-Lebrun (1755–1842) and Marie-Suzanne Giroust (1734–1772). Most of them earned their living painting soft Rococo-style portraits, although Gérard is best known for her intimate domestic genre scenes and Vallayer-Coster for her still lifes.

Neoclassicism

1750
–
1830/50

KEY ARTISTS: ANGELICA KAUFFMAN • ADÉLAÏDE LABILLE-GUIARD
ÉLISABETH VIGÉE-LEBRUN • MARIE-DENISE VILLERS

KEY DEVELOPMENTS
The Swiss-born child prodigy Angelica Kauffman trained with her father before gaining admission to Rome's Accademia Nazionale di San Luca. She painted the classical scene shown here while living in London. It is the moment when the shepherd Paris has been told to name the most beautiful goddess. His choice ultimately leads to the Trojan War.

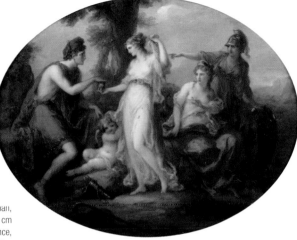

The Judgement of Paris, Angelica Kauffman, c.1781, oil on canvas, 80 x 100.9 cm (31⅓ x 39¾ in), Museo de Arte de Ponce, Puerto Rico

Evolving from a determination by many during the Age of the Enlightenment to return to the classical styles of ancient Greece and Rome, Neoclassicism developed in Europe during the late eighteenth and early nineteenth centuries.

The principles of order and reason suited the restraint of the Age of Enlightenment, and contrasted with the flamboyance and decadence of the earlier Baroque and Rococo movements. Neoclassical ideas were motivated partly by the excavations of the Roman ruins at Herculaneum and Pompeii from 1738 to 1750, and by the publication in 1755 of the book *Thoughts on the Imitation of Greek Works of Art* by the art historian and archaeologist Johann Winckelmann (1717–1768).

With smooth contours, lines and surfaces, Neoclassical art emulated aspects of the classical world and emphasized patriotic and noble feelings. Meanwhile, female artists of the period continued to be suppressed. Only a small number were admitted to France's prestigious Académie Royale de Peinture et de Sculpture, and they were still barred from life-drawing classes. Yet in Paris, where Neoclassicism particularly thrived, some attained great success. Angelica Kauffman, Adélaïde Labille-Guiard and Élisabeth Vigée-Lebrun were particularly sought after, often by noble female patrons for portraits, still lifes and figure paintings.

THE ROYAL ACADEMY **p.178** PEINTRE DES MESDAMES **p.179** THE ACADÉMIE ROYALE **p.180**
SELF-PORTRAITS **p.198** RELIGION **p.200** HISTORY **p.201** NATURE **p.206** THE NUDE **p.209**

Naturalism

KEY ARTISTS: ROSA BONHEUR • MARIE BASHKIRTSEFF
HELENE SCHJERFBECK • AMÉLIE BEAURY-SAUREL

Although naturalism with a lower-case 'n' has been used to describe certain realistic art since the seventeenth century, Naturalism as an art movement occurred only from the 1820s to the 1880s.

It started in France and spread across the world, becoming the dominant trend among several groups, including the Norwich School in England, the French Barbizon School, the American Hudson River School and the Peredvizhniki (Wanderers) in Russia. The term Naturalism was first used in 1868 by the French writer Émile Zola (1840–1902) when describing the literary and artistic trend. The artists involved worked in various ways, but all abandoned the idealization

and stylization of traditional art. Many painted 'ordinary', familiar subjects in rural locations. The advent of photography made a big impact on the art, as, rather than producing paintings that contrasted dramatically with photographs (as many modern artists did), Naturalists created lifelike images. Representations of people, objects and places are free of artifice and subjective interpretation, and show little distortion. Among the female Naturalists are the Finnish Helene Schjerfbeck (1862–1946), who also worked in France and England, and Amélie Beaury-Saurel (1849–1924), who worked in Spain, Corsica and France.

KEY DEVELOPMENTS
When she died in her mid-twenties, the Russian artist Marie Bashkirtseff (1858/59–1884) was already recognized as a painter, sculptor and intellectual. Born near Poltava (now in Ukraine), she later lived and studied in Paris. *A Meeting* is one of her best-known works. It depicts six children huddled in conversation, the paintmarks fluid, the colours natural.

A Meeting, Marie Bashkirtseff, 1884, oil on canvas, 193 x 177 cm (76 x 69¾ in), Musée d'Orsay, Paris, France

CHANGING OPINIONS **p.189** THE SENSES **p.202** NATURE **p.206** INDIVIDUALITY **p.207** THE NUDE **p.209**
THE ENVIRONMENT **p.215**

Impressionism

1865
–
1885

KEY ARTISTS: BERTHE MORISOT • MARY CASSATT • MARIE BRACQUEMOND
EVA GONZALÈS • LILLA CABOT PERRY • CECILIA BEAUX

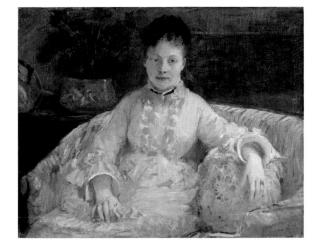

KEY DEVELOPMENTS
Berthe Morisot helped to form the group's artistic philosophy as well as to organize its exhibitions. With her soft palette and light brushstrokes, she painted *The Pink Dress* before the first Impressionist exhibition, although she was already working with their signature approach.

The Pink Dress (Albertie-Marguerite Carré, later Madame Ferdinand-Henri Himmes), Berthe Morisot, c.1870, oil on canvas, 54.6 x 67.3 cm (21½ x 26½ in), Metropolitan Museum of Art, New York, USA

In 1874 a group of artists called the Anonymous Society of Painters, Sculptors and Printmakers held their first independent exhibition in Paris, breaking away from the official annual Salon.

Focusing on ephemeral effects of light, their work was initially condemned for appearing unfinished and garish, and they were deprecatingly nicknamed the Impressionists. With sketchy brushmarks in bright colours, often created with the alla prima technique (painting in one sitting), the artists used modern technology, including photography, synthetic pigments and portable paints, and in general painted everyday scenes. Among the exponents of this style were three women artists: Berthe Morisot (1841–1895), Mary Cassatt (1844–1926) and Marie Bracquemond (1840–1916), who were

described in 1894 by an art critic as 'les trois grandes dames' of Impressionism.

Either the granddaughter or the great-niece of the Rococo painter Jean-Honoré Fragonard, Morisot was born into a bourgeois family. Having learned drawing as part of a genteel young lady's accomplishments, she defied convention and studied art seriously, for a time under Jean-Baptiste-Camille Corot (1796–1875). She and her friend (and, after 1874, brother-in-law) Édouard Manet (1832–1883) influenced each other. From 1874 to 1886 the Impressionists held eight independent exhibitions in Paris; Morisot exhibited in seven of them.

INDEPENDENCE **p.176** BREADWINNER **p.177** VOCATION **p.182** A FEMALE VIEWPOINT **p.187**
CHANGING OPINIONS **p.189** SELF-PORTRAITS **p.198** NATURE **p.206** THE ENVIRONMENT **p.215**

Post-Impressionism

1885 – 1910

KEY ARTISTS: SUZANNE VALADON • EMILY CARR • ÉMILIE CHARMY
AMRITA SHER-GIL • WILHELMINA WEBER FURLONG • SONIA LEWITZKA

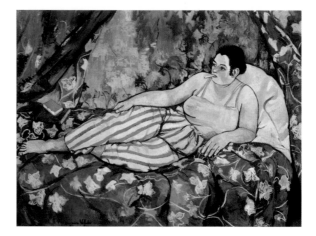

The Blue Room, Suzanne Valadon, 1923, oil on canvas, 90 x 116 cm (35⅜ x 45⅝ in), Musée National d'Art Moderne, Centre Georges Pompidou, Paris, France

The term Post-Impressionism was first used for an exhibition in London in 1910 that included Manet and nine other male artists. However, several women of various nationalities can be described as Post-Impressionist, including the French Suzanne Valadon (1865–1938) and the Canadian Emily Carr (1871–1945).

A disparate group, all the Post-Impressionists explored new, colourful approaches, often expressing feelings more than direct realism. All artists connected with the movement were individual, but generally, colour and shape were important to them all, and they still represented the visible world. Yet until the end of the nineteenth century women were excluded from free training at state-sponsored art schools, so they usually paid for (expensive) instruction with established artists or at private academies. Even when females were finally admitted to public art schools, they were initially taught separately from men and excluded from painting and life classes. Nude models remained off limits, and the training was inadequate for the creation of 'important' works of art. Women were also excluded from official competitions. Overall, the lack of freedom continued to restrict their subject matter and progress.

KEY DEVELOPMENTS

Beginning as an artists' model, Suzanne Valadon soon became an artist herself. In 1894 she was the first woman to be admitted to the Société Nationale des Beaux-Arts. Painting mainly female nudes and portraits, still lifes and landscapes, she used strong colours and patterns. The self-portrait above deliberately contrasts with male idealism of women.

REJECTING 'WOMAN AS OBJECT' **p.173** INDEPENDENCE **p.176** VOCATION **p.182** A FEMALE VIEWPOINT **p.187** CHANGING OPINIONS **p.189** ASSERTIVENESS **p.191** IDENTITY **p.199**

Art Nouveau

KEY ARTISTS: MARGARET MACDONALD MACKINTOSH • FRANCES MACDONALD MACNAIR • ALICE CARMEN GOUVY • ÉLISABETH SONREL

Towards the end of the nineteenth century, in art and design, an international style emerged that lasted for some 20 years. Now known as Art Nouveau, it was first given various names, including the Glasgow Style, Jugendstil, Modernisme and Stile Liberty.

Artists and designers working in the style created organic forms, sinuous shapes and asymmetrical compositions in soft colours. As well as reacting against the ornate, cluttered styles that were popular at the time, Art Nouveau artists and designers attempted to integrate mass production with craftsmanship and to counteract some of the prevailing concerns about the negative aspects of industrialization. Absorbing elements from earlier styles, including the Arts and Crafts movement, Celtic art, the Gothic Revival, Rococo, Aestheticism, Symbolism and Japonisme, Art Nouveau sought to be individual. (Japonisme was a craze inspired by Japanese design, and especially by *ukiyo-e* prints, 'pictures of the floating world'.)

Although some women were now more independent than in previous generations, it remained difficult for them to become professional artists. Sisters Margaret (1864–1933) and Frances Macdonald (1873–1921) were fortunate in having a father who encouraged their education, and then husbands who collaborated with them on art projects. Female Art Nouveau artists were generally naturally adept at expressing the fluidity of the style.

KEY DEVELOPMENTS

Art Nouveau embraced organic themes, featuring motifs including the female form. The Macdonald sisters and their husbands produced what came to be called the Glasgow Style, embracing elongated, stylized imagery that strongly influenced the entire Art Nouveau movement. In 1900 Margaret Macdonald Mackintosh created three panels for tea rooms in Glasgow. The drawing below is one of them.

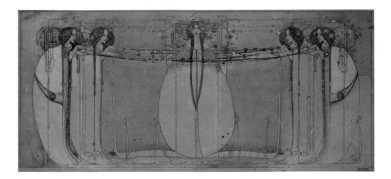

The May Queen, Margaret Macdonald Mackintosh, 1900, pencil, watercolour and bodycolour, heightened with silver, on oiled tracing paper, 33 x 69.2 cm (13 x 27 in), Private Collection

CELEBRATING THE FEMALE **p.181** VOCATION **p.182** THE SISTERHOOD **p.183** A FEMALE VIEWPOINT **p.187** HISTORY **p.201** THE SENSES **p.202** NATURE **p.206** THE NUDE **p.209** EMPATHY **p.217**

Expressionism

KEY ARTISTS: MARIANNE VON WEREFKIN • KÄTHE KOLLWITZ • PAULA MODERSOHN-BECKER • MARIA MARC • GABRIELE MÜNTER • ALMA THOMAS

Prompted by anxiety over social and political developments in the early years of the twentieth century, Expressionism began in Germany. Women were still banned from art academies, and scorned as 'mannish' or one of the 'third sex' if they worked rather than having a husband and family, but some nonetheless became artists.

Munich had become the centre of the German art world, and there Gabriele Münter (1877–1962) became involved with the avant-garde artistic circle. She helped to found the Neue Künstlervereinigung München (New Artists' Association Munich) with, among others, Marianne von Werefkin (1860–1938). In 1911 Münter, Werefkin, Wassily Kandinsky (1866–1944), Franz Marc (1880–1916) and several others formed Der Blaue Reiter (The Blue Rider), a group of Expressionist artists who definitively broke with conventional painting styles.

Other female Expressionists who used colour and line to convey their feelings and opinions included Olga Oppenheimer (1886–1941), who had a short but sparkling career, and Paula Modersohn-Becker (1876–1907), who was an important precursor of Expressionism and who joined the artists' colony in Worpswede, northern Germany. There were several more female Expressionists studying there too, among them Clara Westhoff (1878–1954), Ottilie Reylaender (1882–1965), Sophie Bötjer (1887–1966), Sophie Wencke (1874–1963) and Hermine Rohte (1869–1937).

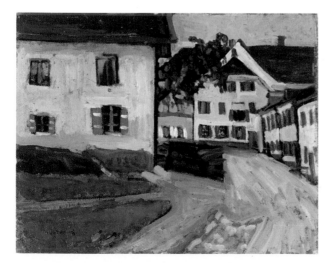

KEY DEVELOPMENTS
In 1908 Münter, Kandinsky, Werefkin and Alexej von Jawlensky (1864–1941) painted in and around the Bavarian village of Murnau, with its brightly coloured cottages. This reflects Münter's interest in both traditional Bavarian glass painting and Fauvism, as, with bold brushstrokes, she sought to capture the spirituality of nature and her own emotions.

Village Street in Murnau, Gabriele Münter, 1908, oil on board, 33 x 40.6 cm (13 x 16 in), Private Collection

INDEPENDENCE **p.176** CHANGING OPINIONS **p.189** ASSERTIVENESS **p.191** WOMEN'S WORK **p.203** INDIVIDUALITY **p.207** ANGER **p.212** TRANSFORMATION **p.213** THE ENVIRONMENT **p.215** CONFLICT **p.216**

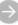

Cubism

1907
–
1914

KEY ARTISTS: MARIE LAURENCIN • MARÍA BLANCHARD • MARIE VOROBIEFF
ALEKSANDRA EKSTER • FRANCISKA CLAUSEN • NADEZHDA UDALTSOVA

Started by Pablo Picasso (1881–1973) and
Georges Braque (1882–1963) in 1907–08,
Cubism was a distinctive and influential art
movement that broke decisively with tradi-
tional representational art and influenced
many movements that followed.

Inspired by the work of Paul Cézanne
(1839–1906), Cubists abandoned the cen-
turies-old European traditions of creating
illusions of depth and distance from fixed
vantage points using linear perspective.
Instead, they drew, painted and constructed
their art from several viewpoints. Each
Cubist had his or her own style, but all their
works appear fragmented, as if made up of
angles, planes and geometric shapes, which
led to the movement's name. Among the
female Cubists were Marie Vorobieff, also
known as Marevna (1892–1984), who, after
travelling to Europe from Russia, began
mixing aspects of Cubism with Pointillism.
Another Russian artist who spent time
in Paris working with other Cubists was
Nadezhda Udaltsova (1886–1961). Marie
Laurencin was a painter and printmaker
of elegant images in soft pastel colours,
and Aleksandra Ekster (1882–1949)
combined elements of Futurism, Cubism
and Constructivism in her paintings,
and theatre set and costume designs. The
Danish-born Franciska Clausen (1899–
1986) worked in Berlin and produced
smoothly tonal Cubist paintings.

KEY DEVELOPMENTS
The Spanish artist María Blanchard (1881–1932)
incorporated Cubist ideas with aspects of Spanish
culture and the influence of her friend Juan
Gris (1887–1927), as can be seen below in her
painting *Woman with a Fan*. Fractured into brightly
coloured planes, the woman is portrayed from
different viewpoints and evokes stained glass.

Woman with a Fan, María Blanchard, 1916, oil on canvas,
161 x 97 cm (63⅓ x 38¼ in), Museo Nacional Centro de Arte
Reina Sofía, Madrid, Spain

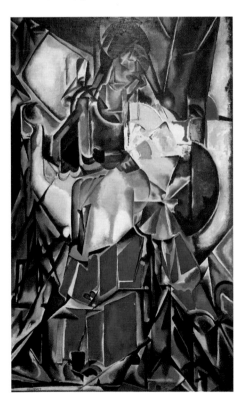

STRIVING FOR EQUALITY **p.172** INDEPENDENCE **p.176** VOCATION **p.182** A FEMALE VIEWPOINT **p.187**
CHANGING OPINIONS **p.189** NATURE **p.206** INDIVIDUALITY **p.207**

Futurism

KEY ARTISTS: NATALIA GONCHAROVA • BENEDETTA CAPPA • VALENTINE DE SAINT-POINT • ALEKSANDRA EKSTER • MARISA MORI • NINA GENKE-MELLER

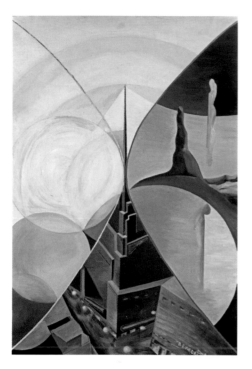

Il Grande X, Benedetta Cappa, 1930–31, oil on canvas, 129 x 90 cm (50¾ x 35½ in), Musée d'Art Moderne de la Ville de Paris, France

KEY DEVELOPMENTS
Although she did not want to be labelled, Benedetta Cappa (1897–1977) was part of the Italian Futurist movement. Her painting *Il Grande X* (*The Big X*) is considered by many to link early Futurism with its later phase. In 1930 she became the first female artist to have a work of art published in the Venice Biennale catalogue, which indicates that she was respected.

Embracing dynamism, technology and energy, Futurism started in Italy, but several women artists from elsewhere also interpreted many of the concepts in their own ways.

Futurists included painters, sculptors, musicians, writers, architects, photographers and designers, who celebrated the mechanization, power and speed of modern life at the time. In 1909 the poet Filippo Tommaso Marinetti (1876–1944) published the first Futurist manifesto in the French newspaper *Le Figaro*. He wrote: 'We declare that the magnificence of the world has been enriched by a new beauty, the beauty of speed.' The Italian painter and printmaker Marisa Mori (1900–1985) was one of the few female members of the movement, since for many male Futurists women represented softness, romance and tradition – essentially everything they sought to discard. However, they did not ban women from the movement, and those who worked and exhibited alongside them seemed different. Most were assertive, not keen on the institution of marriage, but determined to make their own way in the world. Valentine de Saint-Point (1875–1953) started her career as an artist's model, then in 1905 she met Marinetti. In 1912 and 1913 she wrote her own *Manifesto of Futurist Women* and the *Futurist Manifesto of Lust*.

INDEPENDENCE **p.176** CONTRADICTING 'THE PASSIVE SEX' **p.184** A FEMALE VIEWPOINT **p.187** CHANGING OPINIONS **p.189** ABSTRACT ART **p.190** ASSERTIVENESS **p.191** NATURE **p.206** INDIVIDUALITY **p.207**

Rayonism

1912
–
1915

KEY ARTIST: NATALIA GONCHAROVA

Influenced by the folk art of her Russian homeland, Natalia Goncharova (1881–1962) created vibrant, colourful paintings in several styles. With her partner Mikhail Larionov (1881–1964) she created the Rayonist movement, which aimed to break down barriers between artist and viewer.

Goncharova and Larionov had already been associated with the Jack of Diamonds group, where they blended elements of folk art with aspects of Cubism and Futurism. In 1912 they staged the exhibition *The Donkey's Tail*, rejecting the idea of stylistic unity. Inspired by Marinetti's ideas about Futurism, together they developed Rayonism. The name derived from scientific notions about rays of light and of the fourth dimension, and their splintered images also took ideas from Futurism and Cubism. In the literature they wrote about their art, they described Rayonism as encompassing all existing styles. They said: 'The style of Rayonist painting that we advance signifies spatial forms which are obtained from the intersection of the reflected rays of various objects and forms chosen by the artist's will. The ray is depicted provisionally on the surface by a coloured line.' They first exhibited their Rayonist paintings in 1913.

KEY DEVELOPMENTS

Although short-lived, Rayonism played a crucial part of the evolution of Russian Abstract art. Drawing on scientific discoveries and theoretical concepts, it also incorporated elements of traditional Russian folk culture. In the painting below, broken lines around the cyclist reflect the influence of Cubism and Futurism and create a sense of motion and energy as he speeds through the city streets, bumping over cobbles and passing posters.

Cyclist, Natalia Goncharova, 1913, oil on canvas, 78 x 105 cm (30¾ x 41⅓ in), State Russian Museum, St Petersburg, Russia

Constructivism

KEY ARTISTS: VARVARA STEPANOVA • LYUBOV POPOVA
ALEKSANDRA EKSTER • KATARZYNA KOBRO • SOPHIE TAEUBER-ARP

After seeing Picasso's three-dimensional work in Paris, Vladimir Tatlin (1885–1953) founded Constructivism in Russia. From about 1915 Tatlin created pieces using industrial materials, blending sculpture with architecture, and by 1921 he and like-minded artists were producing completely abstract art. Calling themselves Constructivists, in 1923 they published a manifesto in their magazine *Lef.* The ideas in it spread across Europe and America.

Constructivists believed that art should reflect Russia's social and political situation, and work towards the new society that was being built after the 1917 Revolution. The group contained several women who were trying to break down the barriers traditionally imposed on them. Among them was one of the leaders of Constructivism, Varvara Stepanova (1894–1958), whose art was often created for industrial and theatrical purposes. Sometimes working with Stepanova and her husband, Aleksandr Rodchenko (1891–1956), Lyubov Popova (1889–1924) blended influences of Cubism, Futurism and Suprematism, while after exploring Cubism in Paris, Aleksandra Ekster returned to Russia and became a key member of the Constructivist group. Her work influenced the Art Deco movement. Beyond Russia, the Polish sculptor Katarzyna Kobro (1898–1951) produced minimal, experimental Constructivist works that anticipated Modernism.

KEY DEVELOPMENTS
The Swiss-French Sophie Taeuber-Arp (1889–1943) was a significant figure in several prominent movements just before World War II, and one of the most important practitioners of Constructivism outside Russia. As well as fine art, she accepted numerous commissions for interior design projects, including a Constructivist interior for the Café de l'Aubette in Strasbourg.

Composition Horizontale-Verticale à Lignes Blanches, Sophie Taeuber-Arp, 1926–27, gouache on paper, 54 x 13.7 cm (21¼ x 5⅓ in), Musée d'Art Moderne et Contemporain, Strasbourg, France

STRIVING FOR EQUALITY **p.172** INDEPENDENCE **p.176** CHANGING OPINIONS **p.189** ASSERTIVENESS **p.191**
INDIVIDUALITY **p.207** CONFRONTATION **p.211** TRANSFORMATION **p.213**

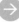

Suprematism

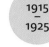

KEY ARTISTS: LYUBOV POPOVA • OLGA ROZANOVA • ALEKSANDRA EKSTER
NADEZHDA UDALTSOVA • KSENIYA BOGUSLAVSKAYA • NINA GENKE-MELLER

KEY DEVELOPMENTS
At the centre of the Suprematist debates and experiments, Olga Rozanova produced abstract collages and paintings. In the painting shown here, her solid composition consists of geometric shapes and angles in bright contrasting colours as she sought to express spiritual energy as well as the concept of a plane flying through the air.

Flight of an Aeroplane, Olga Rozanova, 1916, oil on canvas, 118 x 101 cm (46⅓ x 39¾ in), Samara Regional Art Museum, Russia

In showing his painting *Black Square* at the 0.10 (Zero Ten) exhibition in St Petersburg in 1915, Kazimir Malevich (1879–1935) instigated an artistic revolution.

Aiming to abandon lifelike representation and replace it with the 'supremacy of pure feeling or perception in the pictorial arts', he formed Supremus, a group of like-minded artists who also rejected narrative imagery and discussed the movement's philosophy and its development in other areas of intellectual life. At first, the new Communist authorities welcomed Suprematism for being progressive, but later they criticized it. Comprising only essential shapes, Suprematist paintings feature lines and colours that appear to float and overlap, displaying an apparent objectivity that freed art from traditional constraints such as politics and religion.

Although they were still not equal, from the late nineteenth century Russian women were admitted to some higher-education courses, and after the Revolution in 1917 the Bolsheviks passed legislation to emancipate women, giving them rights that were not available anywhere else in the world. That enabled some female artists to come to the fore. Those associated with Malevich's Supremus group included Aleksandra Ekster, Lyubov Popova, Olga Rozanova (1886–1918), Nadezhda Udaltsova, Nina Genke-Meller (1893–1954) and Kseniya Boguslavskaya (1892–1972).

INDEPENDENCE **p.176** BREADWINNER **p.177** THE SISTERHOOD **p.183** CHANGING OPINIONS **p.189**
INDIVIDUALITY **p.207** CONFRONTATION **p.211** TRANSFORMATION **p.213**

Dada

KEY ARTISTS: HANNAH HÖCH • ELSA VON FREYTAG-LORINGHOVEN
SUZANNE DUCHAMP • SOPHIE TAEUBER-ARP • BEATRICE WOOD

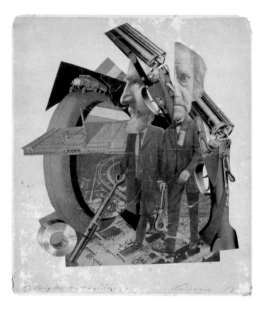

KEY DEVELOPMENTS
Höch used her innovative photo-
montages to express herself on
political and women's subjects.
In the painting shown here, two
figures have oversized heads.
One is split in two, and behind it
are two shotguns. In this work,
Höch satirizes the industrialism
and financial power in Germany
after World War I. It suggests
a world on the edge of chaos.

High Finance, Hannah Höch, 1923,
photomontage, 36 x 31 cm
(14¼ x 12¼ in), Private Collection

A reaction to the atrocities of World War I
and the bourgeois society that allowed it to
happen, Dada was one of the most anarchic
cultural movements of all time. Involving
literature, poetry, theatre and both fine and
graphic arts, it began in neutral Zurich in
1917, and branches sprang up in various
cities. The name Dada was deliberately
nonsensical, and all Dadaists conveyed
contempt and questioned authority.

Before working in publishing, Hannah
Höch studied graphic art and design. She
became part of the Berlin branch of Dada
specifically directed against the post-war
Weimar Republic. Using newspaper and
magazine imagery, she was one of the first
to create photomontages. In Paris, the sister

of Marcel Duchamp (1887–1968), Suzanne
Duchamp (1889–1963), made paintings and
drawings, juxtaposing text with imagery.
Sophie Taeuber-Arp was known for her
Dada oil paintings, watercolours, embroi-
deries, sculpture, innovations in
Performance Art and collaborations with
her artist-poet husband, Jean (Hans) Arp
(1886–1966). The American Beatrice Wood
(1893–1998) produced sculpture and
pottery, and the German-born Baroness
Elsa von Freytag-Loringhoven (1874–1927)
fused art and life. Working in New York, she
made assemblages and collages, wrote poetry,
put on performances and dressed wildly.

STRIVING FOR EQUALITY **p.172** INDEPENDENCE **p.176** CHANGING OPINIONS **p.189** ASSERTIVENESS **p.191**
INDIVIDUALITY **p.207** CONFRONTATION **p.211** TRANSFORMATION **p.213**

Harlem Renaissance

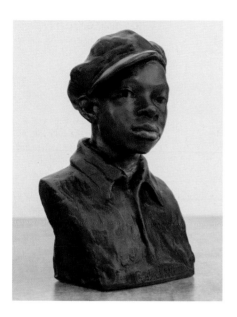

c.1918
–
1937

KEY ARTISTS: META VAUX WARRICK FULLER • AUGUSTA SAVAGE
SELMA BURKE • GWENDOLYN BENNETT • LOÏS MAILOU JONES

KEY DEVELOPMENTS
In 1934 Augusta Savage became the first African-American artist to be elected to the National Association of Women Painters and Sculptors. Her appointment boosted the civil rights movement, women's equality and the recognition of black women in society. Her sculpture *Gamin* won her a scholarship to study art in Paris.

Gamin, Augusta Savage, c.1930, painted plaster, 22.9 x 14.7 x 11.2 cm (9 x 5¾ x 4⅓ in), signed; Smithsonian American Art Museum, Washington DC, USA; courtesy of Michael Rosenfeld Gallery LLC, New York, USA

The social, artistic and intellectual movement that occurred in Harlem, New York, during the 1920s became known as the Harlem Renaissance. It began when African Americans migrated from the plantations of the South to the industrial cities of the northern United States and had to fight for their civil rights.

These artists worked in a broad range of styles, celebrating their identity as black Americans who had survived slavery, as well as their African roots. The female artists built on the success of Edmonia Lewis (1844/5–after 1911), who, although not part of the movement, was the first African-American sculptor to gain international recognition. Women in the movement included Meta

Vaux Warrick Fuller (1877–1968), Augusta Savage (1892–1962), Selma Burke (1900–1995), Gwendolyn Bennett (1902–1981) and Loïs Mailou Jones (1905–1998).

Female artists of this movement faced sexism, as well as the same racism as the men, and they struggled for the independence to pursue their artistic goals. Jones moved north from segregation in North Carolina and eventually studied art outside the United States, later becoming an influential artist and educator. Best known for her sculpture, Fuller also wrote poetry and painted, and Bennett was a poet, writer, teacher and painter.

STRIVING FOR EQUALITY **p.172** INDEPENDENCE **p.176** CHALLENGING CONTEMPT **p.194** QUESTIONING DEMOCRACIES **p.195** IDENTITY **p.199** HERITAGE **p.205** INDIVIDUALITY **p.207** RACE **p.214**

Surrealism

1924
–
1966

KEY ARTISTS: DOROTHEA TANNING • JANE GRAVEROL • MERET OPPENHEIM
• LEONORA CARRINGTON • EILEEN AGAR • LEONOR FINI

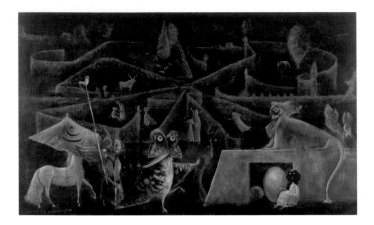

Ulu's Pants, Leonora
Carrington, 1952,
oil and tempera on
panel, 54.5 x 91.5 cm
(21½ x 36 in), Private
Collection

A twentieth-century literary, philosophical and artistic movement that explored the workings of the mind, Surrealism began in 1924 with the *Manifesto of Surrealism* by André Breton (1896–1966). Inspired by the findings of the psychoanalyst Sigmund Freud (1856–1939), Surrealists explored the unconscious, including dreams, chance occurrences and irrationality.

Several Surrealists used automatic drawing or painting to express ideas and images from their unconscious minds, while others depicted more realistic dream or fantasy worlds. Although in 1925 Freud wrote: 'Women oppose change, receive passively, and add nothing of their own,' the female Surrealists explored the ideas of the movement expansively and perceptively. Their art was often an intuitive articulation of such things as identity, emotion, trauma and female sexuality, and some, such as Leonor Fini (1907–1996) and Jane Graverol

(1905–1984), deliberately contrasted with traditional male approaches to female forms by representing their bodies as they chose. Combining everyday elements with the unexpected, Dorothea Tanning (1910–2012) aimed to depict 'unknown but knowable states' to suggest that there was more to life than it might seem. Meret Oppenheim (1913–1985) produced paintings and art objects; many of the latter were everyday objects formed or placed to suggest aspects of female sexuality.

KEY DEVELOPMENTS

An important figure in the Surrealist movement, Leonora Carrington based her dreamlike, detailed compositions of strange creatures in unnatural settings on her own personal symbolism. The characters in *Ulu's Pants* derive from the Celtic mythology she learned as a child, blended with various cultural traditions that she experienced while living in Mexico.

Art Deco

1925
–
1939

KEY ARTISTS: TAMARA DE LEMPICKA • EMMA SMITH GILLIES • ETHEL HAYS
CLAIRE COLINET • RUTH REEVES • HANNAH GLUCKSTEIN (GLUCK)

Beginning in the 1920s and ending just before World War II, Art Deco celebrated the modern, mechanized world through architecture, design and fine art. An international style that started in Paris, it was named after the International Exhibition of Modern Decorative and Industrial Arts held in that city in 1925.

Exemplifying what was seen as the streamlined, glamorous machine age, the movement's sleek, angular works symbolized wealth and sophistication. The artists and designers were influenced by Cubism, De Stijl, Futurism and the Bauhaus, as well as ancient Egyptian and Aztec art, using geometric shapes, dramatic tonal contrasts and bold colours. The Polish-born

Tamara de Lempicka (1898–1980), who became the style's leading painter, was influenced by Cubism, the Renaissance and the Neoclassical painter Jean-Auguste-Dominique Ingres (1780–1867). Another of her influences, the Cubist painter André Lhote (1885–1962), described her style as 'Soft Cubism'. Also successful were the gender-nonconforming Hannah Gluckstein, known as Gluck (1895–1978), whose refined paintings reflect the sleek elegance of the movement; the painter and textile designer Ruth Reeves (1892–1966); and the sculptor Claire Colinet (1880–1950), who was known for her animated female forms.

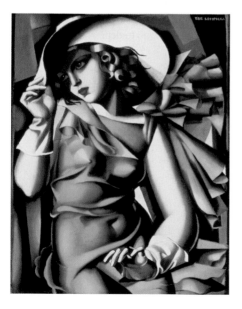

KEY DEVELOPMENTS
The smooth paint and strong tonal contrasts in many Art Deco paintings simulate the shiny materials that were so popular at the time, and simultaneously evoke a sculptural quality. This can be seen here, in de Lempicka's painting of a fashionably dressed young woman created with fractured planes of green fabric and strong lights and darks.

Young Girl in Green, Tamara de Lempicka, 1927–30, oil on plywood, 61.5 x 45.5 cm (24¼ x 18 in), Musée National d'Art Moderne, Centre Georges Pompidou, Paris, France

CONTRADICTING 'THE PASSIVE SEX' **p.184** ASSERTIVENESS **p.191** REJECTING MALE AUTHORITY **p.193**
SELF-PORTRAITS **p.198** WOMEN'S WORK **p.203** GENDER **p.204** INDIVIDUALITY **p.207**

Concrete Art

1930
–
1962

KEY ARTISTS: LOLÓ SOLDEVILLA • AURÉLIE NEMOURS
VERENA LOEWENSBERG • LYGIA PAPE • LYGIA CLARK

Introduced by Theo van Doesburg (1883–1931) in 1930, Concrete Art evolved directly from his art and architectural movement De Stijl (The Style), also known as Neoplasticism, which had begun in 1917. Van Doesburg formed the Art Concret group, which maintained that art should be completely abstract and not refer to anything in the visible world, nor feature any lyricism or sentiment. In 1930 the group published its magazine *Revue Art Concret*, featuring van Doesburg's *Manifesto of Concrete Art*.

After van Doesburg's death, the architect, designer and painter Max Bill (1908–1994) formed another Concrete Art group in Switzerland. In 1944 he organized the first international Concrete Art exhibition and helped to promote the style in Latin America. Verena Loewensberg (1912–1986) was part of Bill's Swiss group, and several other Concrete Art groups were formed in France, Italy, Argentina, Uruguay and Cuba. In Cuba, Los Dies Pintores Concretos (The Ten Concrete Painters) included Loló Soldevilla (1901–1971), while in 1959 the Neo-Concrete Manifesto was written in Rio de Janeiro, Brazil, by a group that included Lygia Clark (1920–1988) and Lygia Pape (1927–2004). The French painter Aurélie Nemours (1910–2005) produced Concrete Art using black, white and bold colours in smooth geometric shapes.

KEY DEVELOPMENTS
Part of both van Doesburg's initial Concrete Art movement and the later Brazilian Neo-Concrete movement, the sculptor, engraver and film-maker Lygia Pape produced art that encouraged interaction from viewers. Her *Book of Creation*, for instance, was created with 16 cardboard pages, each featuring an abstract image with spaces that viewers could 'fill' or 'add to' in their minds.

Book of Creation, Lygia Pape, 1959–60, gouache on board, 30.5 x 30.5 cm (12 x 12 in), Museum of Modern Art, New York, USA

VOCATION **p.182** CONTRADICTING 'THE PASSIVE SEX' **p.184** CHANGING OPINIONS **p.189** ABSTRACT ART **p.190** ASSERTIVENESS **p.191** INDIVIDUALITY **p.207** TRANSFORMATION **p.213** EMPATHY **p.217**

Abstract Expressionism

1943
–
1965

KEY ARTISTS: HELEN FRANKENTHALER • ALMA THOMAS • LEE KRASNER
ELAINE DE KOONING • CORINNE MICHELLE WEST • PERLE FINE

Largely remembered as a movement defined by Jackson Pollock (1912–1956) and Willem de Kooning (1904–1997), Abstract Expressionism developed in the 1940s as the first American art movement to have an international impact.

Originally called the 'New York School', Abstract Expressionists worked spontaneously and freely, so their approach is sometimes referred to as Action Painting. Yet despite the renown of many male Abstract Expressionists, there were several women who were equally original and innovative, but who were on the whole disparaged and denied solo exhibitions, such as Alma Thomas (1891–1978), Perle Fine (1905–1988), Lee Krasner (1908–1984), Elaine de Kooning (1918–1989), Grace

Hartigan (1922–2008), Joan Mitchell (1925–1992) and Helen Frankenthaler (1928–2011). Krasner's real name was Lena, and Corinne Michelle West (1908–1991) also made her name more masculine in an attempt to be judged equally with her male counterparts; she signed herself Michael West. Despite their marginalization, female Abstract Expressionists created sweeping, bold works in paint, printmaking, collage and sculpture, using their materials expressively and with a range of nontraditional methods. In general, they dispensed with preparatory drawings, creating gestural marks and biomorphic and geometric shapes intuitively, or 'automatically', without thinking, fuelled by their subconscious minds.

KEY DEVELOPMENTS
For more than 30 years, Lee Krasner produced huge, expressive abstract paintings. *Composition* is part of her series of *Little Image* paintings of the late 1940s that she painted flat on a table, applying pigment with sticks and palette knives and sometimes straight from the tube, creating small, roughly geometric hieroglyphic-like shapes.

Composition, Lee Krasner, 1949, oil on canvas, 96.7 x 70.6 cm (38 x 27¾ in), Philadelphia Museum of Art, Pennsylvania, USA

INDEPENDENCE **p.176** VOCATION **p.182** CONTRADICTING 'THE PASSIVE SEX' **p.184** A FEMALE VIEWPOINT **p.187** ABSTRACT ART **p.190** ASSERTIVENESS **p.191** THE SENSES **p.202** INDIVIDUALITY **p.207**

Op Art

1954

KEY ARTISTS: BRIDGET RILEY • MARINA APOLLONIO
CAROL BROWN GOLDBERG • CAROLINE KRYZECKI • TAUBA AUERBACH

Developing partly from De Stijl and Concrete Art, Op Art involves the creation of illusions and optical effects in paint. Op artists create geometric shapes using strong colours or black and white, and, because of their precise placement of lines and repetitive forms, they produce optical effects, making static images appear to move.

In 1955 some artists in this movement showed at Galerie Denise René in Paris, in the exhibition *Le Mouvement*. A decade later the exhibition *The Responsive Eye*, held at the Museum of Modern Art in New York, included many of the same artists' paintings, and from that time Op (for Optical) art – sometimes called Retinal art – became popular in the media and fashion, although it was denounced as superficial by critics. The original Op artists included Victor Vasarely (1906–1997) and Bridget Riley, while later artists who have built on the initial ideas include Marina Apollonio (b.1940), who bases her work on mathematical systems; Carol Brown Goldberg (b.1955), who uses reflective chips in acrylic paint; Tauba Auerbach (b.1981), who works with a wide range of media, including painting, photography, book design and musical performance, exploring perceptions of space; and Caroline Kryzecki (b.1979), who energizes surfaces with ballpoint pen.

KEY DEVELOPMENTS
Working with ballpoint pen in blue, black, red and green, Caroline Kryzecki produces meticulously drawn abstract works through calligraphic-style layers, lines and grids, using rulers and a detailed documentation system that only she understands. The results are complex, coded, fluid images that produce psychological reactions in viewers.

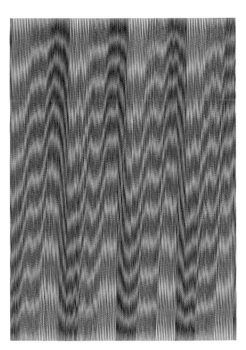

KSZ 50/35–68, Caroline Kryzecki, 2017, ballpoint pen on paper, 50 x 35 cm (19¾ x 13¾ in), Private Collection

Pop Art

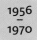
1956
–
1970

KEY ARTISTS: CORITA KENT • ELAINE STURTEVANT • ROSALYN DREXLER
MARJORIE STRIDER • MARISOL ESCOBAR • PAULINE BOTY • NICOLA L

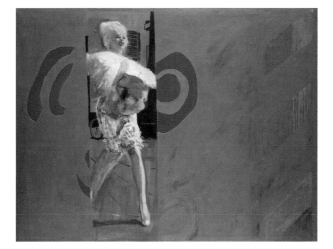

KEY DEVELOPMENTS
One of the founders of the
British Pop Art movement and
the only female British Pop art-
ist, Pauline Boty (1938–1966)
was a forerunner of 1970s
feminism. Self-assured and
rebellious, she was one of the
few women artists to present
a different view of Marilyn
Monroe at the time. This paint-
ing is deliberately ambiguous.

The Only Blonde in the World,
Pauline Boty, 1963, oil on canvas,
127 x 158 cm (50 x 62¼ in),
Private Collection

Erasing boundaries between so-called high and low culture, Pop Art was bold and irreverent, often blending commercial and fine art techniques and materials. Evolving after World War II in both London and New York, it was inspired by the growth of consumerism, while in America it was also a reaction against Abstract Expressionism.

Although the movement was male-dominated, there were several – largely unacknowledged – female Pop artists. Predominantly linked to the development of feminism, they often addressed male attitudes towards women and explored notions about female sexuality. On the whole, the Pop Art produced by women was more conceptual than male Pop artists' work. For instance, Elaine Sturtevant (1924–2014), who was known just as Sturtevant, created controversy by re-creating versions of works by artists including Andy Warhol (1928–1987) and Roy Lichtenstein (1923–1997), deliberately raising awareness of authenticity, celebrity and originality. Corita Kent (1918–1986) was an American nun who worked almost exclusively with silkscreen, creating signs, slogans and packaging as a form of political protest. Other female Pop artists also demonstrated their political or feminist beliefs, such as Nicola L (1937–2018) and Marisol Escobar (1930–2016), usually known only as Marisol, whose sculpture addressed the constraints faced by women during that period.

Nouveau Réalisme

1960
—
1970

KEY ARTISTS: NIKI DE SAINT PHALLE • LOURDES CASTRO
CHRYSSA VARDEA-MAVROMICHALI • NICOLA L

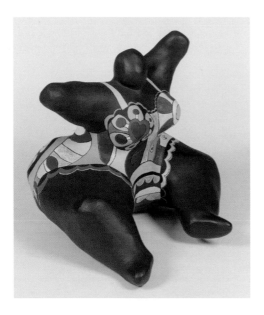

Doll Sitting; Nana Assise, Niki
de Saint Phalle, 1968, hand-painted
polyester, 73 x 81.2 x 77.5 cm
(28¾ x 32 x 30½ in), Private Collection

KEY DEVELOPMENTS
Niki de Saint Phalle's work
evolved from assemblage to
three-dimensional polyester
female forms, usually with
no heads, painted black with
brightly coloured detailing.
Of these exuberant figures,
she said, 'I thought beforehand
that to be provocative, you had
to attack religion or generals. I
realized that there was nothing
more shocking than joy.'

Founded in 1960 by the critic Pierre
Restany (1930–2003) and the painter Yves
Klein (1928–1962), Nouveau Réalisme
concentrated on bringing life and art closer
together, and its exponents believed that art
should not elevate, politicize or idealize any
subject.

In his manifesto, *The Constitutive
Declaration of New Realism*, Restany
declared that the artists involved turned to
reality, rather than the lyricism of Abstract
Art. Nouveau Réalistes therefore focused on
new materials and art forms, such as collage
and assemblage. Some incorporated real
objects into their work and some pioneered
the technique of décollage, the dismantling
of an image. There was no unified style,

since each artist's approach was individual.
Only a few women participated in the
movement, and most of their contribu-
tions were largely unacknowledged. They
included the French-American sculptor,
painter and film-maker Niki de Saint Phalle
(1930–2002), who was the only 'official'
member of the Nouveau Réaliste group, but
at the same time Lourdes Castro (b.1930),
Chryssa Vardea-Mavromichali (1933–2013)
and Nicola L (1937–2018) all produced art
that adhered to the movement's philosophy.
Although it dissolved after a decade, the
movement continued for years to exert a
strong influence on artists.

CELEBRATING THE FEMALE **p.181** CONTRADICTING 'THE PASSIVE SEX' **p.184** A FEMALE VIEWPOINT **p.187**
NATURE **p.206** INDIVIDUALITY **p.207** THE ENVIRONMENT **p.215**

Feminist Art

KEY ARTISTS: JUDY CHICAGO • BARBARA KRUGER • MIRIAM SCHAPIRO
CAROLEE SCHNEEMANN • HANNAH WILKE • JENNY HOLZER

In 1971, investigating the social and economic factors that had prevented women from achieving equal status with men, the art historian Linda Nochlin (1931–2017) published an essay, 'Why Have There Been No Great Women Artists?' It inspired a strong reaction among female artists.

The Feminist Art movement had already started, with artists blatantly rejecting traditional portrayals of female nudes as goddesses, but after Nochlin's essay, Feminist Art entered a 'second wave' as many artists continued to fight for gender equality, investigating such things as how women conform to social expectations. Although the Feminist Art movement began during the 1960s, as can be seen elsewhere in this book, there had been a long history of females seeking to generate improvements for other women artists, even if they did not describe themselves as feminist.

In their efforts to end sexism and oppression, feminist artists work with a wide range of materials and approaches, including painting, performance and crafts such as embroidery and appliqué that have conventionally been belittled as 'women's work'. The movement continues, and each new generation considers old concerns in new ways, now often including race, class and gender identity and fluidity.

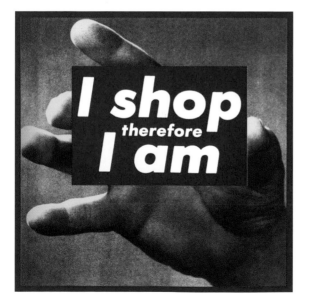

KEY DEVELOPMENTS
Barbara Kruger (b.1945) produces mainly black-and-white photographs overlaid with text. Here, to highlight feminist issues, she challenges the notion of consumption and invites viewers to reconsider consumerism, re-imagining the philosophy of René Descartes (1596–1650), 'I think therefore I am.' The work was ironically printed on to thousands of shopping bags and T-shirts.

Untitled (I Shop Therefore I Am), Barbara Kruger, 1987, photographic silkscreen on vinyl, 284.5 x 287 cm (112 x 113 in), Glenstone Museum, Potomac, Maryland, USA

STRIVING FOR EQUALITY **p.172** REJECTING 'WOMAN AS OBJECT' **p.173** INDEPENDENCE **p.176** CELEBRATING THE FEMALE **p.181** CONTRADICTING 'THE PASSIVE SEX' **p.184** SUPPORTING OTHER FEMALE ARTISTS **p.186**

Performance Art

KEY ARTISTS: MARINA ABRAMOVIĆ • ANA MENDIETA • HANNAH WILKE
JOAN JONAS • MARTHA ROSLER • ADRIAN PIPER • CAROLEE SCHNEEMANN

Alongside Feminist Art, during the 1960s several women artists began to explore Performance because it was not dominated by male artists. Performance Art had already emerged to some extent within the Futurist, Dada and Surrealist movements, but it was not until the 1960s that it developed as an independent movement.

When the movement first began, women often used their own bodies as mediums, frequently to contradict the traditional female images portrayed by men. This was alternatively called Body Art. Public performances were also a way of drawing attention to the role of women in society in general. With Performance Art, the artists usually present the work and viewers either watch or participate. Often, the artists record their performances through photographs, film or video.

From 1971, Performance Art became a significant part of the California Institute of the Arts' Feminist Art Program, founded by Judy Chicago and Miriam Schapiro (1923–2015). Performance Art flourished across the world, and although the concerns of the artists have changed since the 1960s, the genre has remained a popular medium among a wide variety of artists. It is also now generally welcomed into the museums and galleries where it was once shunned.

KEY DEVELOPMENTS

In 2010 Marina Abramović produced the performance *The Artist Is Present*. Exploring the relationship between artist and viewer, she sat silently opposite an empty chair eight hours a day for nearly three months, as people took turns to sit and look at her. Over that period she locked eyes with more than 1,000 strangers.

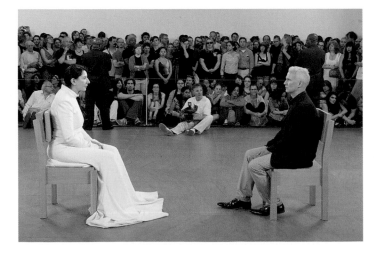

The Artist Is Present, Marina Abramović, 2010, performance, three months, Museum of Modern Art, New York, USA

INDEPENDENCE **p.176** CONTRADICTING 'THE PASSIVE SEX' **p.184** CHANGING OPINIONS **p.189**
ASSERTIVENESS **p.191** IDENTITY **p.199** THE SENSES **p.202**

Conceptual Art

KEY ARTISTS: JENNY HOLZER • BARBARA KRUGER • PIPILOTTI RIST • ADRIAN PIPER • AGNES DENES • SOPHIE CALLE • CORNELIA PARKER • TRACEY EMIN

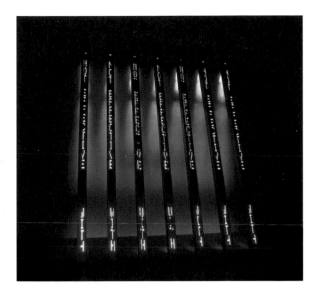

KEY DEVELOPMENTS
Jenny Holzer (b.1950) presents her conceptual art in galleries and other public places. *Blue Purple Tilt* consists of tall, narrow LED signs leaning against a wall, equidistant from one another. Illuminated text appears on them at varying speeds, deliberately confusing in order to convey the conflicting media bombardment we all experience.

Blue Purple Tilt, Jenny Holzer, 2007, six light-emitting-diode columns, each object: 419 x 13.6 x 13.6 cm (165 x 5½ x 5½ in), National Galleries of Scotland, UK

In an article in 1967, the artist Sol LeWitt (1928–2007) wrote: 'In conceptual art the idea or concept is the most important aspect of the work.' Conceptual Art developed simultaneously in Europe and America from ideas instigated by Dada. It incorporated many different approaches and forms, including performances, installations and readymades.

Disregarding almost all traditional forms of art, Conceptual artists make their ideas take precedence over beauty and technical skill. They are often involved with other movements, including Feminist, Performance, Video and Land Art and Arte Povera, and the viewer's experience and interpretation is integral to their work. Like Performance and Feminist Art, Conceptual Art has been more 'female-friendly' than many other movements, mainly because there is no strong male precedence. Female Conceptual artists explore diverse concepts, certainly not just Feminist ideas. For instance, with a PhD in philosophy, Adrian Piper (b.1948) considers such things as beliefs, behaviour and individuality through performances, drawings, installations and videos. Agnes Denes (b.1931), who was also a pioneer of Land Art, similarly uses a wide range of media, including poetry, diagrams, sculpture and installations, and often examines concepts relating to the environment.

CONTRADICTING 'THE PASSIVE SEX' **p.184** A FEMALE VIEWPOINT **p.187** WOMEN'S CRAFTS **p.188** ASSERTIVENESS **p.191** QUESTIONING DEMOCRACIES **p.195** CONFRONTATION **p.211** ANGER **p.212**

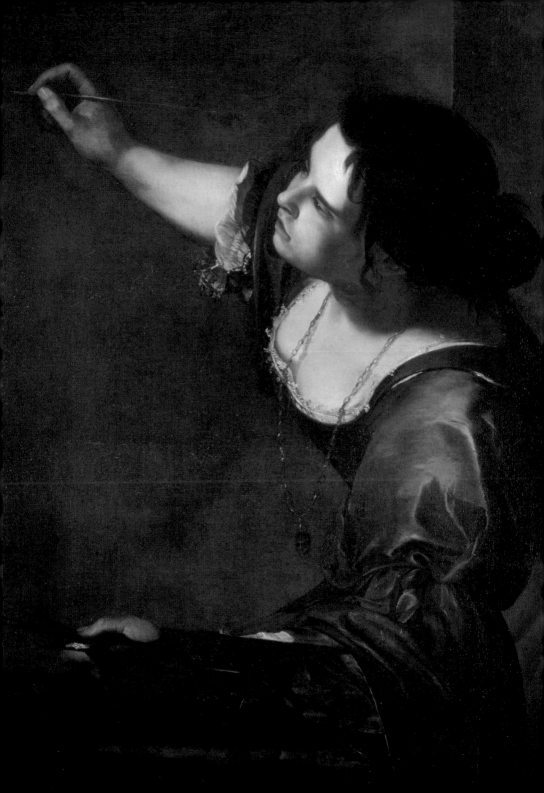

The Works

Self-Portrait at the Easel

1556

SOFONISBA ANGUISSOLA: OIL ON CANVAS • 66 X 57 CM (26 X 22½ IN)
MUZEUM ZAMEK, ŁAŃCUT, POLAND

OTHER KEY WORKS

Bernardino Campi Painting Sofonisba Anguissola, 1550, Pinacoteca Nazionale, Siena, Italy

The Chess Game, 1555, National Museum in Poznań, Warsaw, Poland

Portrait of the Artist's Family: Her Father Amilcare, Sister Minerva, and Brother Asdrubale, 1558, Nivaagaard Museum, Niva, Denmark

At a time when forthright career women were deemed unfeminine, the Italian painter Sofonisba Anguissola (c.1532–1625) asserted herself, and became one of the first female Renaissance artists to achieve an international reputation.

Unlike many other female artists of the period, Anguissola did not come from a family of artists, but her aristocratic father believed that girls should be educated, and his wealth ensured that his daughter received an extensive education, including fine art. Most of her paintings were portraits, and her skill in conveying personalities through them was pioneering.

In this unusual self-portrait, Anguissola presents herself painting the Virgin Mary. Both appear as contemporary women of virtue. Anguissola looks directly at viewers, brush in one hand, mahl stick in the other, simultaneously subject and object, painter and model. The painting is an adaptation of the legend of St Luke the Evangelist, who allegedly painted a portrait of the Virgin. Here Anguissola has taken on Luke's role. In the book *The Lives of the Most Excellent Painters, Sculptors, and Architects* (1550), the Italian painter, architect, writer and historian Giorgio Vasari (1511–1574) wrote: 'Anguissola has shown greater application and better grace than any other woman of our age in her endeavours at drawing; she has not only succeeded in drawing, colouring and painting from nature, and copying excellently from others, but by herself has created rare and beautiful paintings.'

SOFONISBA ANGUISSOLA

In 1557 Anguissola's father wrote to Michelangelo Buonarroti (1475–1564), thanking him for the 'honourable and thoughtful affection that you have shown to Sofonisba, my daughter, to whom you introduced to practise the most honourable art of painting'. She also studied with Bernardino Campi (1522–1591) and Bernardino Gatti, or Il Sojaro (c.1495–1576), and became lady-in-waiting to the Queen of Spain.

RENAISSANCE **p.12**

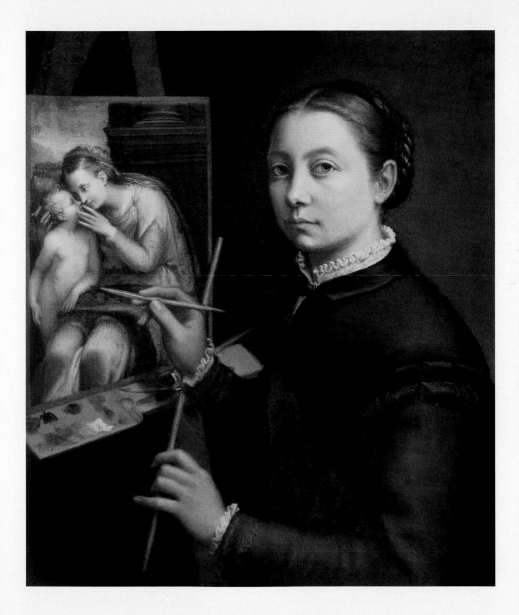

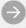

Noli Me Tangere

1581

LAVINIA FONTANA: OIL ON CANVAS • 120.3 X 93 CM (47⅜ X 36⅝ IN)
GALLERIA DEGLI UFFIZI, FLORENCE, ITALY

LAVINIA FONTANA

In Bologna, Lavinia Fontana studied with her artist father, Prospero Fontana (1512–1597), and mixed in a cultured social circle. In 1577 she married one of her father's assistants, a member of the Bologna nobility. Her marriage contract required that she and her husband remain in her father's household, and continue to work in the family workshop. Despite having 11 children, she was the main breadwinner of her family.

Founded in 1088, the University of Bologna allowed women to study and encouraged their academic and artistic talents. Lavinia Fontana (1552–1614) grew up in this progressive city and completed a degree at the university the year before she painted *Noli Me Tangere*. She was also possibly the first female artist to paint nudes.

Fontana became especially sought-after by important patrons for her portraits and her works on religious and mythological themes. In 1603 she moved to Rome and became the official painter to the papal court. During her life she received several honours, and she was the first woman to be invited into Rome's prestigious Accademia Nazionale di San Luca.

Noli Me Tangere, meaning 'touch me not', comes from the Gospel of John; it is the Latin for the words spoken by Jesus to Mary Magdalene. After the Crucifixion, Mary Magdalene is in a garden, when she suddenly realizes that a man she had thought was a gardener is actually the resurrected Christ. Stunned, she reaches out to him, but he tells her not to. Fontana has depicted Mary Magdalene as a contemporary woman at that moment, kneeling before Jesus. The ornate alabaster jar she holds symbolizes the ointment she used to anoint Christ's feet. Leaning on a spade in a tunic and large sun hat, Christ attempts to console Mary Magdalene and prevent her from yearning for his earthly self.

OTHER KEY WORKS

Self-Portrait in a Studio, 1579, Galleria degli Uffizi, Florence, Italy

Assumption of the Virgin with Saints Peter Chrysologus and Cassian, 1584, Palazzo Comunale, Imola, Italy

Minerva Dressing, 1613, Galleria Borghese, Rome, Italy

MANNERISM **p.13**

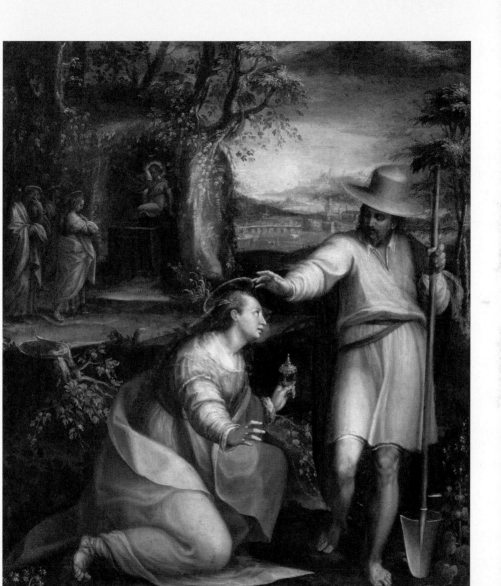

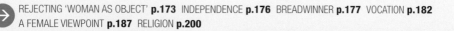

Still Life with Cheeses, Artichoke and Cherries

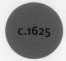

c.1625

CLARA PEETERS: OIL ON WOOD • 33.3 X 46.7 CM (13⅛ X 18⅜ IN)
LOS ANGELES COUNTY MUSEUM OF ART, CALIFORNIA, USA

OTHER KEY WORKS

Still Life with Flowers, Goblet and Dainties, 1611, Museo del Prado, Madrid, Spain

Fish Still Life with a Flower Bouquet, 1615, Rijksmuseum, Amsterdam, Netherlands

Still Life with Cheese, Bread and Drinking Vessels, 1615, Mauritshuis, The Hague, Netherlands

Breakfast Still Life, 1630s, Museum of Fine Arts, Houston, Texas, USA

Specializing in meticulously rendered still lifes, primarily of food, Clara Peeters (c.1594–1657) began painting early in her life. Her first works feature exotic foods and valuable objects such as shiny plates and goblets, coins and exotic flowers, while later she painted simpler items such as fruit, nuts, cheese and fish. Occasionally she included tiny self-portraits as reflections in metal or glass.

In the painting shown here and overleaf, she painstakingly depicts the textures and colours of the blue dish, silver plates and cutlery, the hunks of cheese, the glossy red cherries, the crumbly bread roll, the creamy butter and the artichoke half. As well as being an objective arrangement, the painting is full of symbolism. The butter and cheese allude to Dutch agriculture, which was enriching many people's lives, while the bread symbolizes life itself, and the cherry stone and stalk suggest unpredictability and impermanence. Artichokes are generally a symbol of peace, hope and prosperity, and salt represents wealth, trade and exploration.

Although she was probably born in Antwerp, Peeters spent most of her career in the Dutch Republic, where she became a pioneer of still-life paintings, especially in the

Detail: Rendered in painstaking detail, this part of the arrangement was painted with fine brushes and fluid paint. The pattern on the dish has been conveyed with the tip of the brush. Even the serrated marks on the butter are captured with astonishing realism.

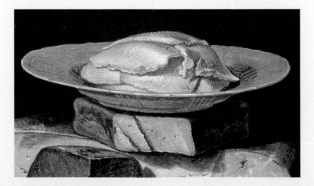

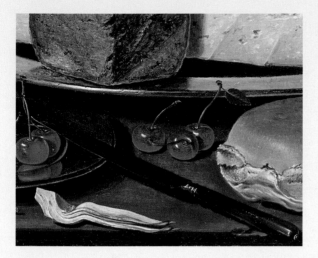

Detail, left: Both reflected in the silver plate, the flower-like artichoke and shiny red cherries have been created with fine paint layers, while the knife bears the emblem of a silversmith from Antwerp.

Overleaf and detail below: Although created with a complexity of marks, the composition of this painting is built up with geometric forms, light reflections and textures, seen in such things as the stack of cheeses topped with a plate of butter shavings and a tall silver salt cellar. The arrangement suggests that someone is present.

development of *ontbijtjes* or 'breakfast pieces', which include plain food and simple vessels, and *banketjes*, 'banquet pieces', which feature expensive cups and vessels often made of precious metals. Primarily concerned with rendering her subjects in close detail, Peeters here celebrates the beauty and wonders of the natural world while simultaneously warning of the transience of earthly existence. The painting is both a representation of objects that wilt or decay in real life but are preserved on the canvas, and a vanitas or memento mori. Set against a fashionably dark background, the palette is fairly restricted. At that time, guests took their own knives when dining in others' homes, and the knife that Peeters paints here was a popular wedding gift at the time; indeed, it may have been her own.

CLARA PEETERS
Little is known of Clara Peeters's background. It is likely that she was born in Antwerp, and she signed her first painting at the age of 14. She possibly studied with Osias Beert the Elder (c.1580–1623), and she was accomplished in the technicalities of oil painting. She married at 45, which was late for the time. By 1611 she was in Amsterdam, and in 1617 in The Hague.

→ THE ONTBIJTJE **p.174** INDEPENDENCE **p.176** VOCATION **p.182** A FEMALE VIEWPOINT **p.187** THE SENSES **p.202** NATURE **p.206**

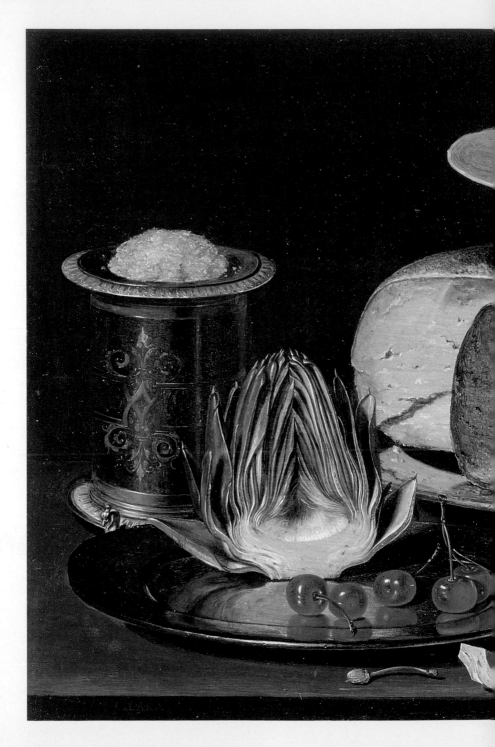

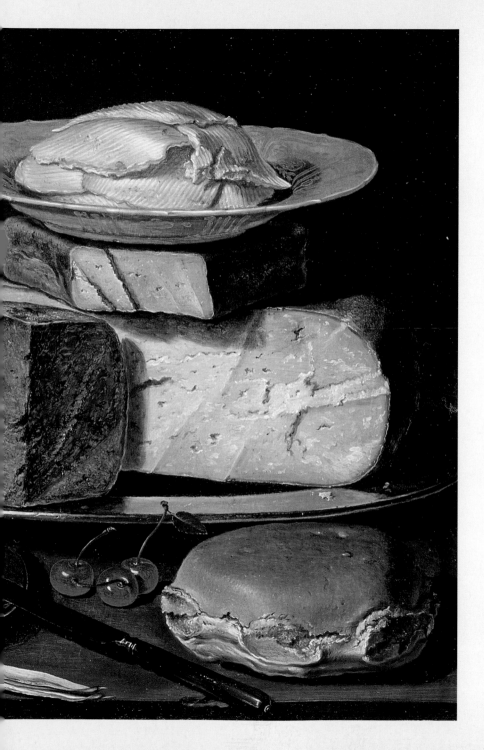

The Jolly Drinker

1629

JUDITH LEYSTER: OIL ON CANVAS • 89 X 85 CM (35 X 33 IN)
FRANS HALS MUSEUM, HAARLEM, NETHERLANDS,
ON LONG-TERM LOAN FROM THE RIJKSMUSEUM, AMSTERDAM

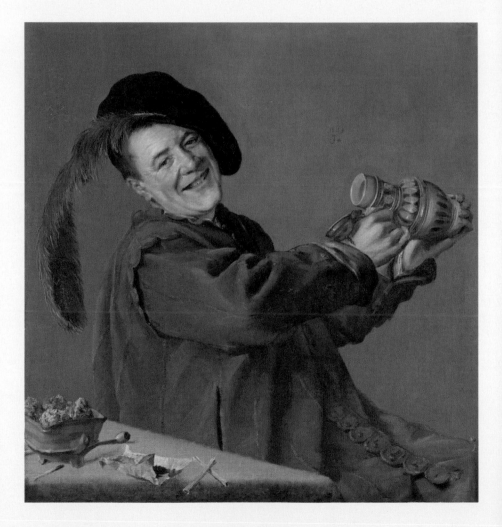

OTHER KEY WORKS

The Serenade, 1629, Rijksmuseum, Amsterdam, Netherlands

Self-Portrait, c.1630, The National Gallery of Art, Washington DC, USA

The Happy Couple, 1630, Musée du Louvre, Paris, France

From early in her artistic career, Judith Leyster (1609–1660) became acclaimed in her native Haarlem and later also in Amsterdam. By the age of 24 she was one of only two women during that century to be accepted as a master in Haarlem's Guild of St Luke.

With lively brushwork and an animated composition, this painting depicts Peeckelhaeringh or Pekelharing, a well-known figure in seventeenth-century comic plays. Leyster depicts him as a character he often portrayed: 'Kannenkijker', or 'jug-looker', who came on stage at the end of a play and looked into an empty mug to indicate that the show was over. In Leyster's portrayal of him, he is close to the picture plane, beaming and flushed, raising his beer mug to show viewers that his drink is finished. On the table in front of him is a small pipe and wrapped tobacco, and his clear enjoyment of smoking and drinking suggests both the pleasures of life and the dangers of excess. As did many Dutch paintings of the period, this one carries a moralizing message about the risk of indulgence and the transience of life.

Although Leyster was a celebrated artist during her life, after her death she was forgotten, and for years much of her work was wrongly attributed either to Frans Hals (1582–1666) or to her husband, the painter Jan Miense Molenaer (c.1610–1668).

JUDITH LEYSTER

Born in Haarlem, the eighth child of a brewer and cloth maker, Leyster may have been apprenticed to Frans Pietersz de Grebber (1573–1649) and possibly also to Frans Hals or Dirck Hals (1591–1656). Influenced by the Utrecht Caravaggisti, she became a successful independent artist and a member of the Haarlem Guild of St Luke. After marrying Molenaer in 1636, she worked with him in Amsterdam and Haarlem.

STRIVING FOR EQUALITY **p.172** INDEPENDENCE **p.176** BREADWINNER **p.177** CONTRADICTING 'THE PASSIVE SEX' **p.184** CHANGING OPINIONS **p.189** INDIVIDUALITY **p.207**

Self-Portrait as the Allegory of Painting

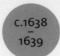

c.1638 – 1639

ARTEMISIA GENTILESCHI: OIL ON CANVAS • 98.6 X 75.2 CM (38¾ X 29½ IN)
ROYAL COLLECTION TRUST, LONDON, UK

OTHER KEY WORKS

Judith Beheading Holofernes, c.1620, Galleria degli Uffizi, Florence, Italy

Jael and Sisera, 1620, Museum of Fine Arts, Budapest, Hungary

Madonna and Child, c.1630, Pitti Palace, Florence, Italy

The foremost female painter of the Baroque period, Rome-born Artemisia Gentileschi (1593–1654 or later) followed the dramatic style of Caravaggio (1571–1610).

From 1638, at the invitation of King Charles I, she visited London, and that is probably when she painted this self-portrait. Holding a brush in one hand and a palette in the other, she depicts a personification of painting based on conventions set by the iconographer Cesare Ripa (c.1560–1622), who, in his book *Iconologia* of 1593, described allegorical figures and their equipment and accessories in great detail. Artemisia was among several artists of the period to illustrate its descriptions. Ripa described Painting as 'a beautiful woman, with full black hair, dishevelled, and twisted in various ways, with arched eyebrows that show imaginative thought, the mouth covered with a cloth tied behind her ears, with a chain of gold at her throat'. Artemisia captures the essentials of this description here. Wearing a brown apron over her green dress, she leans on a stone slab used for grinding pigments, in which the reflection of her left arm is visible. Quick brushwork conveys the movement of her arm, and fluid strokes of white delineate the edge of her sleeve.

ARTEMISIA GENTILESCHI

The renowned artist Orazio Gentileschi (1563–1639) apprenticed his daughter to his friend and fellow artist Agostino Tassi (1578–1644). However, Tassi raped Artemisia, and the subsequent trial was painful and humiliating for her. Soon afterwards she married another artist and moved from Rome to Florence. Her work was in great demand; she became the family breadwinner and, from 1616, the first female member of the illustrious Florentine Accademia delle Arti del Disegno.

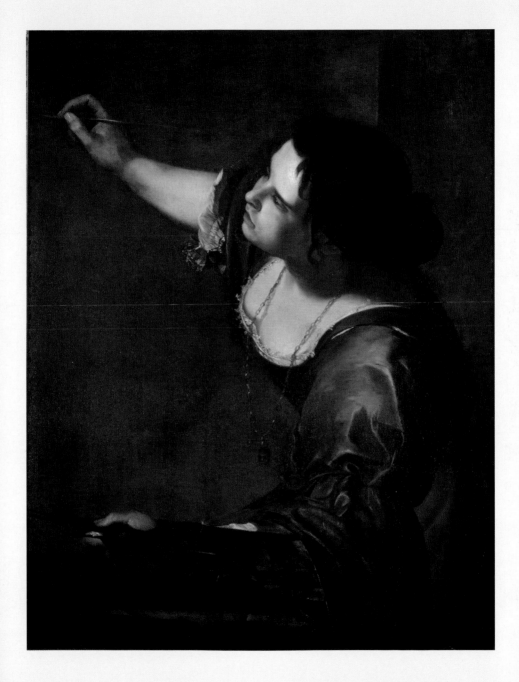

Timoclea Killing the Thracian Captain

1659

ELISABETTA SIRANI: OIL ON CANVAS • 227 X 177 CM (89⅓ X 69¾ IN)
MUSEO DI CAPODIMONTE, NAPLES, ITALY

ELISABETTA SIRANI

Born into an artistic family in Bologna, Elisabetta Sirani trained with her father, Giovanni Andrea Sirani (1610–1670). A cult grew around her as the female reincarnation of the Baroque painter Guido Reni (1575–1642), and after her father became incapacitated by gout in 1654, she supported the family. Highly successful, she never married, dying suddenly at just 27. She was given an elaborate funeral and buried in the same tomb as Reni.

During her short life, Elisabetta Sirani (1638–1665) innovatively opened a painting school for women, where she taught students from all backgrounds, as well as her sisters.

Like Lavinia Fontana, Sirani was from Bologna and created large-scale religious compositions. Early in her career the public were suspicious of her skill and speed. As a woman and the daughter of an artist, she felt she had to prove that her work was her own, and she did so by allowing observers to watch her paint. Much of her work championed women. The story of Timoclea killing her rapist was a popular tale from Plutarch's biography (c.100 CE) of Alexander the Great. During Alexander's invasion of Thebes, a captain in his army raped a woman called Timoclea. Afterwards, the captain asked where her money was hidden. Timoclea led him to the well in her garden, and as he looked over, she pushed him in, dropping heavy rocks down after him.

Most artists who painted this subject portrayed the moment when Timoclea is awaiting Alexander's judgement, but Sirani depicts the instant that Timoclea pushes the rapist to his death. Here he falls, head first, unable to save himself. In line with the Baroque style, Sirani has depicted action and drama.

OTHER KEY WORKS

Self-Portrait as Allegory of Painting, 1658, Pushkin Museum, Moscow, Russia

Virgin and Child, 1663, National Museum of Women in the Arts, Washington DC, USA

Portia Wounding Her Thigh, 1664, Collezioni d'Arte e di Storia della Fondazione Carisbo, Bologna, Italy

BAROQUE **p.15**

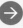

Still Life with Flowers in a Glass Vase

c.1690 – 1720

RACHEL RUYSCH: OIL ON CANVAS • 65 X 53.5 CM (25½ X 21 IN)
RIJKSMUSEUM, AMSTERDAM, NETHERLANDS

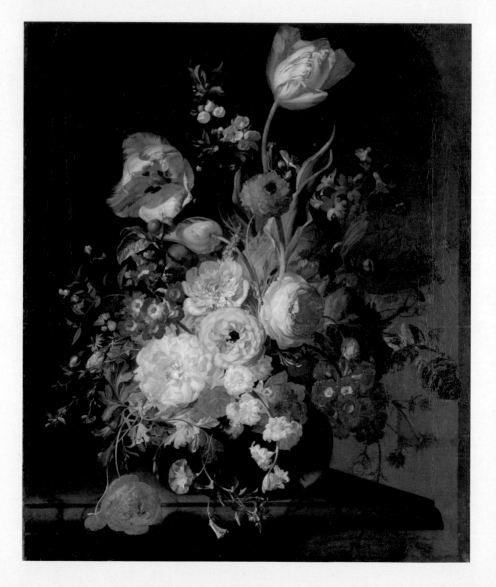

OTHER KEY WORKS

Roses, Convolvulus, Poppies, and Other Flowers in an Urn on a Stone Ledge, c.1688, National Museum of Women in the Arts, Washington DC, USA

Flowers around a Tree Trunk, with Insects and Other Animals near a Pond, 1668, Gemäldegalerie Alte Meister, Kassel, Germany

Spray of Flowers with Insects and Butterflies on a Marble Slab, 1690s, Fitzwilliam Museum, University of Cambridge, UK

The daughter of an eminent botanist and physician, Rachel Ruysch (1664–1750) became a renowned painter of floral still lifes, and her work was sought-after in important circles in The Netherlands and Germany. During her lifetime, Ruysch often earned more for her paintings than Rembrandt van Rijn (1606–1669) earned for his.

With knowledge gained from her father, Ruysch painted precise images of plants and insects, and with skills learned from her training with the still-life painter Willem van Aelst (1627–1683), she created a sense of drama. Van Aelst also taught her to arrange flowers to appear casual. This painting comprises flowers that do not bloom at the same time, but are included for symbolism. For instance, the iris, with its petals grouped into three, symbolizes the Christian Trinity, and the white poppies, associated with sleep and death, allude to the Crucifixion. The tiny insects and the fact that some of the flowers are starting to wilt symbolize the brevity of life. So-called Tulipmania occurred in the early seventeenth century in the Dutch Republic over the sale of tulip bulbs, which, having been introduced to Europe from Turkey, had become astonishingly popular. Demand exceeded supply and prices soared, but the situation was unsustainable and by 1638 the bubble had burst, leaving many people financially ruined.

RACHEL RUYSCH

At the age of 15 Rachel Ruysch moved from The Hague to Amsterdam, where she was apprenticed to Willem van Aelst. Despite marrying and having ten children, she continued working, and in 1701 she became the first female member of the artists' society Confrerie Pictura. In 1708 she was appointed court painter to Johann Wilhelm II, Elector Palatine, in Düsseldorf.

STRIVING FOR EQUALITY **p.172** INDEPENDENCE **p.176** VOCATION **p.182** THE SENSES **p.202** NATURE **p.206**

Self-Portrait Holding a Portrait of Her Sister

1715

ROSALBA CARRIERA: PASTEL ON PAPER • 71 X 57 CM (28 X 22½ IN)
GALLERIA DEGLI UFFIZI, FLORENCE, ITALY

OTHER KEY WORKS

Nymph from Apollo's Retinue,
1720–21, Musée du Louvre, Paris,
France

Antoine Watteau, 1721, Museo
Civico Luigi Bailo, Treviso, Italy

Horace Walpole, 1741, Private
Collection

The Venetian painter Rosalba Carriera (1675–1757) was 40 when she completed this commission for the Medici family in Florence. It was to hang in their Vasari Corridor, a passageway designed by Giorgio Vasari to link the Uffizi Gallery to the Pitti Palace.

With her head slightly inclined, Carriera looks directly at the viewer while holding a portrait of her sister Giovanna. The white rose in her hair symbolizes her name *alba*, being the Latin word for 'white'. The siblings were extremely close, and Giovanna kept house for Rosalba. The painting conveys the artist's love for her sister, as well as her pride in her work. Her use of pastels rather than oil paint was unusual, and with them she developed a soft, natural style. In most of her portraits, the body is turned slightly away, with the face looking at the viewer. They appealed especially to aristocratic patrons. In her home city of Venice, wealthy travellers frequently commissioned her, and she also worked in Paris, Modena, Parma, Vienna and Dresden. While staying at the court of the King of Poland in Dresden, Carriera taught the queen to paint, and the king amassed a great collection of her works; while living in Paris, she painted Jean-Antoine Watteau and the royal family. In honours rarely attained by women of the era, Carriera was admitted to the art academies of Rome, Bologna and Paris.

ROSALBA CARRIERA

Little has been verified about Rosalba Carriera's training, but she grew up in Venice and began painting miniatures for snuffbox lids before becoming a famous portrait painter. She was sought after by royalty, including her greatest patron, Augustus III of Poland, and, while she was living and working in Paris in 1720–21, the young Louis XV and his regent, Philippe d'Orléans. Carriera never married, and blindness blighted her last years.

ROCOCO **p.16**

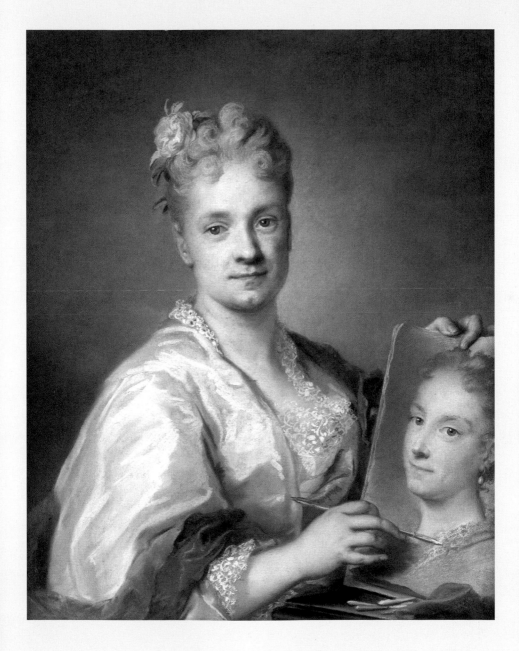

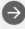

The Judgement of Paris

C.1781

ANGELICA KAUFFMAN: OIL ON CANVAS • 80 X 100.9 CM (31⅓ X 39¾ IN)
MUSEO DE ARTE DE PONCE, PUERTO RICO

OTHER KEY WORKS

Self-portrait, 1770–75, National Portrait Gallery, London, UK

The Sorrow of Telemachus, 1783, Metropolitan Museum of Art, New York, USA

Self-portrait Hesitating Between Painting and Music, 1791, Nostell Priory, West Yorkshire, UK

ANGELICA KAUFFMAN

As a child, Angelica Kauffman moved between her birthplace, Switzerland, to Austria, Britain and Italy. Recognized from an early age as a prodigy, she was elected a member of the Roman Accademia Nazionale di San Luca at the age of 23. After moving to London, she befriended Joshua Reynolds (1723–1792) and became one of two female Founder Members of the Royal Academy.

Although Angelica Kauffman (1741–1807) painted a variety of subjects, her preference was for history paintings, which were commonly considered the greatest genre of all. However, few female artists produced them, since they required knowledge of anatomy and multi-figure compositions, and women were not permitted to study from nude models.

The Swiss-born, British-based Kauffman studied with her artist father before being admitted to the Accademia Nazionale di San Luca in Rome. Despite the restrictions imposed on her as a woman, she became a successful history painter, admired by prestigious patrons and fellow artists alike. Worked in the Neoclassical style, the painting opposite is her portrayal of the Greek myth of the Judgement of Paris, an event that ultimately triggered the Trojan War. In the myth, a shepherd prince, Paris of Troy, must choose the most beautiful of three goddesses: Aphrodite, Hera and Athena (also known as Venus, Juno and Minerva). This is the moment when Paris gives Aphrodite the winner's prize of a golden apple. Aphrodite had bribed him by offering Helena, the most beautiful woman in the world, as his wife. Here, Aphrodite lifts her voile shawl as her son Cupid clings to her skirts. Behind her, Hera and Athena (in armour) are fuming not to have won.

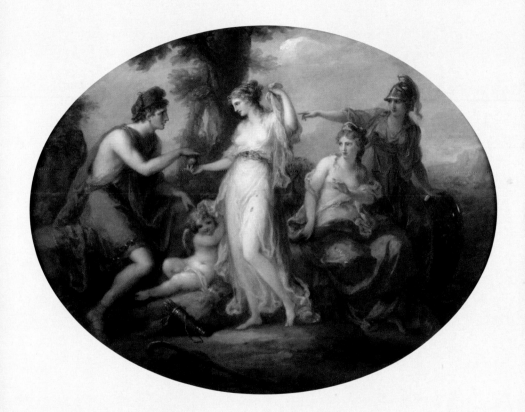

Self-Portrait with Two Pupils

1785

ADÉLAÏDE LABILLE-GUIARD: OIL ON CANVAS • 210.8 X 151.1 CM
(83 X 59½ IN) • METROPOLITAN MUSEUM OF ART, NEW YORK, USA

OTHER KEY WORKS

The Sculptor Augustin Pajou,
1783, Musée du Louvre, Paris,
France

*Portrait of Louise-Elisabeth
of France with Her Son*, 1788,
Palace of Versailles, France

*Victoire Louise Marie Thérèse of
France*, 1788, Palace of Versailles,
France

In 1783 Adélaïde Labille-Guiard (1749–1803) was admitted to the Académie Royale in Paris. At the time, the number of women artists allowed membership there was only four, and the French king had recently insisted that this number remain the same.

Probably in protest, Labille-Guiard produced this self-portrait with two of her female pupils. The life-sized, full-length painting of a fashionably dressed young woman at her easel teaching two younger women to paint was accepted for the annual Paris Salon, and helped to establish Labille-Guiard's reputation. Aware that if the painting were selected, she would reach a huge number of viewers, she presented herself as both an accomplished artist and a fashionable young woman. She had been teaching women to paint since 1780, and seen here are her favourite pupils, Marie-Gabrielle Capet (1761–1818) and Marie-Marguerite Carreaux de Rosemond (fl.1783–88). Demonstrating her expertise at rendering texture, including feathers, lace, satin, flesh, hair, taffeta, voile and gold, the painting also features statues of a Vestal Virgin and a bust of Labille-Guiard's father in the shadowy background. The artist holds a palette, several brushes and a mahl stick, and looks directly at the viewer from behind her large canvas.

ADÉLAÏDE LABILLE-GUIARD

Growing up in Paris, Adélaïde Labille-Guiard studied painting with a miniaturist before joining the Académie de Saint-Luc. She apprenticed with the pastellist Maurice-Quentin de La Tour (1704–1788), and then with François-André Vincent (1746–1816). As well as producing her own work, she taught women artists and exhibited at the Salon. With her increasing reputation, in 1787 Labille-Guiard was named official painter to Louis XVI's aunts.

ROCOCO **p.16** NEOCLASSICISM **p.17**

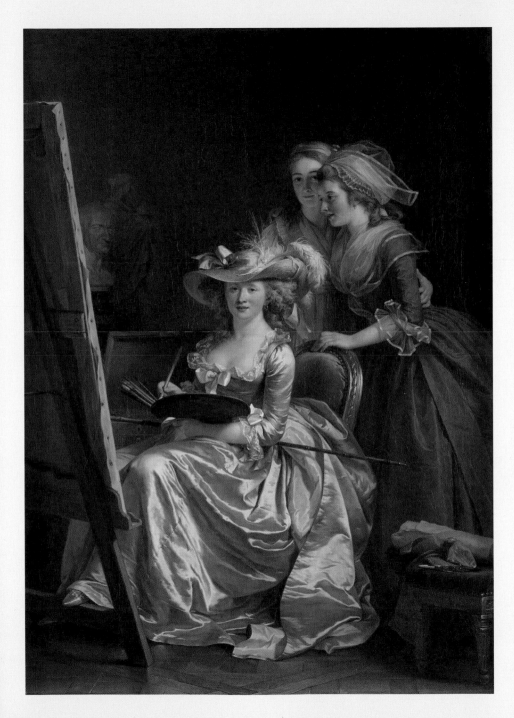

Madame Vigée-Lebrun and Her Daughter, Jeanne-Lucie-Louise

1789

ÉLISABETH VIGÉE-LEBRUN: OIL ON CANVAS • 130 X 94 CM (51 X 37 IN)
MUSÉE DU LOUVRE, PARIS, FRANCE

The painting opposite shows Élisabeth Vigée-Lebrun (1755–1842) and her daughter Jeanne-Lucie-Louise, who was known as Julie, dressed in classical-style costumes.

By the time she produced this image, Vigée-Lebrun was a highly respected portraitist, but here she depicts herself simply as a mother embracing her little girl. Set against a plain, softly illuminated background, both look directly at the viewer. Painted in Vigée-Lebrun's confident, natural style, the work shows her skill at depicting texture, including fabrics, skin and hair. Her colour palette follows the Rococo style, but her smooth contours and paint application pick up on Neoclassicism, which was emerging at the time.

As did most artists of the period, Vigée-Lebrun came from an artistic family. Her father was a portrait painter and professor at the Académie de Saint-Luc in Paris, and while she was growing up, she met prominent artists, writers and philosophers at his studio. After her father died, when she was 12, she took advice from some of the most successful artists in Paris and began her career as a portraitist soon afterwards. She married an art dealer and painter and produced more than 30 paintings of Queen Marie Antoinette and her family, but she fled France with Julie after the arrest of the royal family during the French Revolution.

ÉLISABETH VIGÉE-LEBRUN

In 1783 Élisabeth Vigée-Lebrun was received as a member of the Académie Royale de Peinture et de Sculpture, one of only 15 women to be granted full membership there between 1648 and 1793. While she was living abroad during the French Revolution, her success continued, and she was elected to art academies in ten different cities. She returned to France in 1802 and published her memoirs in three volumes (1835–37), when she was in her eighties.

OTHER KEY WORKS

Peace Bringing Back Abundance, 1780, Musée du Louvre, Paris, France
Self-Portrait in a Straw Hat, 1782, National Gallery, London, UK
Marie Antoinette and Her Children, 1785, Palace of Versailles, France

ROCOCO **p.16** NEOCLASSICISM **p.17**

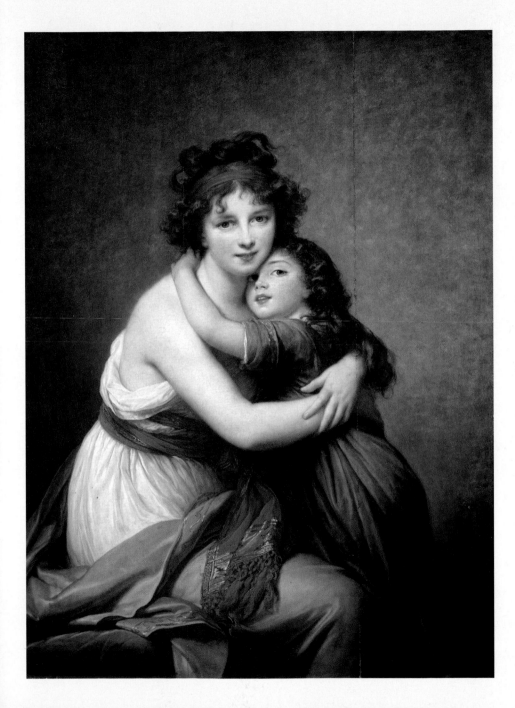

Conversation Piece

c.1851
–
1852

LILLY MARTIN SPENCER: OIL ON CANVAS • 71.9 X 57.5 CM (28⅓ X 22⅝ IN)
METROPOLITAN MUSEUM OF ART, NEW YORK, USA

LILLY MARTIN SPENCER

Born in England to French parents, and encouraged to study art – especially by her mother, who believed in greater opportunities for women – Lilly Martin Spencer was 8 when her family emigrated to America. They ultimately settled in Marietta, Ohio, and she studied art there and then in Cincinnati. At 22, she married and moved to New York. She was the breadwinner throughout her married life.

In a career that spanned more than 60 years, Lilly Martin Spencer (1822–1902) painted portraits of influential figures, still lifes and domestic scenes.

It was for her family scenes that Spencer became best known, since they were reproduced widely in engravings and lithographs. Appealing and light-hearted, they were upbeat in both subject and colour, with plenty of interest that contemporary viewers enjoyed studying. Spencer used herself, her husband and their children and pets as models in many of these works, but although her art was popular and several of her paintings were reproduced as prints, she received only a small percentage of sales. This meant that, despite being the breadwinner for her husband and seven children, for much of her life she struggled to earn a living.

The charming domestic scene opposite features a young mother and father in their middle-class parlour, admiring their baby. It is tender without being sentimental. In bright, rich colours and smooth brushmarks, Spencer portrays the wife sitting with the baby on her lap, while the husband dangles cherries to amuse the child. Around the room, various objects are precisely painted, demonstrating Spencer's ability to convey lifelike objects and texture, including crystal decanters, a silk ribbon and expensive fabric, while also alluding to her French heritage, such as in the Carcel oil lamp and the pedestal compote from Limoges.

OTHER KEY WORKS

Domestic Happiness, 1849, Detroit Institute of Arts, Michigan, USA

Reading the Legend, 1852, Smith College Museum of Art, Northampton, Massachusetts, USA

The Artist and Her Family at a Fourth of July Picnic, 1864, National Museum of Women in the Arts, Washington DC, USA

NATURALISM **p.18**

Hiawatha

1868

EDMONIA LEWIS: MARBLE • 34.9 X 19.7 X 14 CM (13¾ X 7¾ X 5½ IN)
METROPOLITAN MUSEUM OF ART, NEW YORK, USA

OTHER KEY WORKS

Forever Free, 1867–68,
Howard University Gallery of Art,
Washington DC, USA

Hagar, 1875, Smithsonian
American Art Museum,
Washington DC, USA

The Death of Cleopatra, 1876,
Smithsonian American Art Museum,
Washington DC, USA

Of African-American and Native American descent, Edmonia Lewis (1844/5–after 1911) was America's first prominent non-white sculptor.

For part of her career, Lewis lived in Rome among a community of expatriate American and British women involved in the arts. During that time, between 1866 and 1872, she completed a series of marble sculptures on the theme of the star-crossed lovers Hiawatha and Minnehaha, from the epic poem *The Song of Hiawatha* (1855) by Henry Wadsworth Longfellow (1807–1882). Although based on a true character, Longfellow's Hiawatha came from the same indigenous group as Lewis's mother, and her method of carving amalgamated knowledge gleaned from growing up with her mother's Chippewa people and the classical and Renaissance lessons she learned in Rome. The classical influence can be seen opposite, particularly in the idealized shape of Hiawatha's head and his elegant profile, as Lewis draws on the concept of the proud yet uncivilized noble savage. She also avoids the customary male artist's representation of a nude but, in order to appeal to both sexes, she creates a man in native clothing. Unusually, but partly because of her poverty, she rarely employed Italian workmen while in Rome, completing most of her sculpture without assistance.

EDMONIA LEWIS

Orphaned before she was 5, Edmonia Lewis lived with her mother's tribe. While at Oberlin College in Ohio, she was accused of poisoning two room-mates. Although she was acquitted, she was beaten by vigilantes. Subsequently accused of stealing, she moved to Boston, where she studied sculpture; she then moved to Rome. It is thought that she returned to the United States in 1872, but she was back in Rome by 1911.

The Mother and Sister of the Artist

1869/70

BERTHE MORISOT: OIL ON CANVAS • 101 X 81.8 CM (39¾ X 32¼ IN)
NATIONAL GALLERY OF ART, WASHINGTON DC, USA

OTHER KEY WORKS

The Cradle, 1872, Musée d'Orsay, Paris, France

Woman at Her Toilette, 1875/80, Art Institute of Chicago, Illinois, USA

In the Dining Room, 1886, National Gallery of Art, Washington DC, USA

'Five or six lunatics deranged by ambition – one of them a woman – have put together an exhibition of their work' is how a critic described Berthe Morisot (1841–1895) and her associates in 1876.

An original member of the Impressionist group, Morisot exhibited the painting opposite at the Salon of 1870. It is an intimate scene of her sister Edma and their mother while Edma was pregnant with her first child. Before submitting the work to the Salon, however, Morisot asked Édouard Manet for advice, and he repainted the figure of her mother. His abbreviated brushmarks can be seen there, contrasting with Morisot's elsewhere. Diagonal lines dominate the composition, such as the women's arms, their necklines, the mother's hair and the book she is holding. Soft light shimmers across the image and there are no jarring colours to draw attention away from the figures, which adds to the tranquillity of the scene. The white of Edma's loose robe is balanced and weighted by her mother's dark dress and hair, while the flowers on the table and Edma's hair bow incorporate a touch of softness. Because of the limitations society imposed on women – there were few places they could go on their own, for example – this scene of two family members was one of the few areas that Morisot could explore.

BERTHE MORISOT

Great-niece or granddaughter of the Rococo artist Jean-Honoré Fragonard, Berthe Morisot grew up in Paris, where she copied paintings in the Louvre and received instruction from Jean-Baptiste-Camille Corot. When she was 23, the Salon accepted two of her paintings, which was extremely rare for a woman. Four years later she met Manet, who introduced her to the Impressionists and to his brother Eugène (1833–1892), whom she later married.

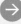

Scotland Forever!

1881

ELIZABETH THOMPSON, LADY BUTLER: OIL ON CANVAS
101.6 X 194.3 CM (40 X 76½ IN) LEEDS ART GALLERY, LEEDS, UK

OTHER KEY WORKS

The 28th Regiment at Quatre Bras, 1875, National Gallery of Victoria, Melbourne, Australia

The Return from Inkerman, 1877, Ferens Art Gallery, Kingston-upon-Hull, UK

The Defence of Rorke's Drift, 1880, Royal Collection, London, UK

Detail: A grey horse gallops directly at the viewer, its courageous rider in his scarlet uniform holding his sabre aloft as he advances, seemingly without a second thought. Tragically, at this point, the dashing cavalry charged straight through a barrage of French cannon fire, which left the Greys isolated and exhausted, to be cut down by Napoleon's 6th and 9th cuirassiers.

ELIZABETH THOMPSON, LADY BUTLER

Widely admired for her paintings of military scenes, Elizabeth Thompson studied in London at the Female School of Art, and in Florence with Giuseppe Bellucci (1844–1921) and at the Accademia di Belle Arti. After seeing the work of Ernest Meissonier (1815–1891) in Paris, she changed from producing religious scenes to war paintings.

Specializing in painting scenes from British military campaigns and battles, including the Crimean War and the Franco-Prussian War, the English artist Elizabeth Thompson, Lady Butler (1846–1933) here depicted the Scots Greys charging into the Battle of Waterloo. In her autobiography, published in 1922, Lady Butler explained: 'I never painted for the glory of war, but to portray its pathos and heroism.'

Named after a battle cry, 'Scotland Forever!', this painting depicts the charge of the Royal North British Dragoons, known as the Scots Greys, at Waterloo in 1815. The regiment's name derived from the grey uniforms the men wore in the early eighteenth century, although by the time of this battle, they wore red. When she executed the painting, Thompson was already renowned as a military painter; indeed, some of her works were so popular that

queues formed outside the Royal Academy when they were exhibited there. Her paintings created a sensation partly because she was a woman painting a 'masculine' subject, and partly because her approach was unique; she conveyed energy, human life and lifelike action. In 1877 she married Lieutenant General Sir William Butler (1838–1910), and although she never actually saw a battle, she watched and sketched his regiment during training manoeuvres. The Scots Greys did not in fact start their charge at a gallop as depicted here, but Thompson deliberately creates a spectacular moment to awe the viewer. The painting was so admired that during World War I both the British and the Germans used it for propaganda; the Germans altered the uniforms to resemble those of Prussian soldiers.

Under a threatening sky, the foreshortened cavalry charges dramatically towards the viewer. The scene is vividly painted; the directly observed horses are anatomically correct, and real soldiers modelled for Lady Butler in her studio. Rather than the panoramic views of battle scenes painted by most artists, this is intimate and immediate, imbuing both soldiers and horses with individuality.

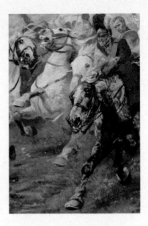

Detail: With vivid colours of red, white, blue, gold, brown and black, and fluid, seemingly rapid brushwork, Lady Butler has created a sense of movement, while still building up essential detail.

Overleaf and detail left: Cloud formations seem – like the horses, men, uniforms and even plants on the ground – to have been studied scientifically. Atmospheric mauves and blue-greys are counterbalanced by areas of golden light that highlight the horses dramatically.

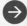

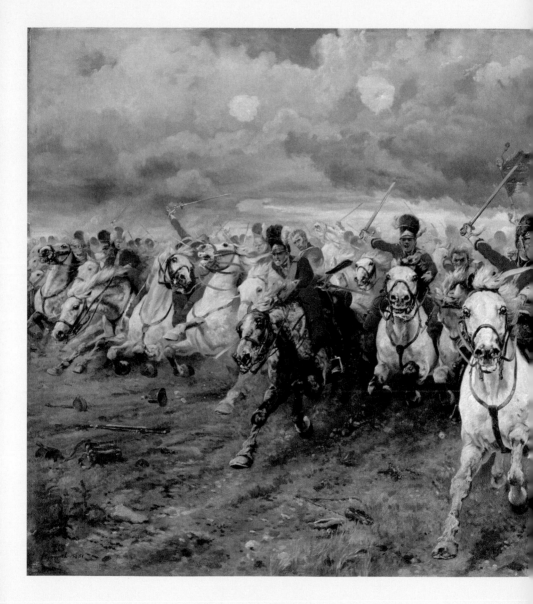

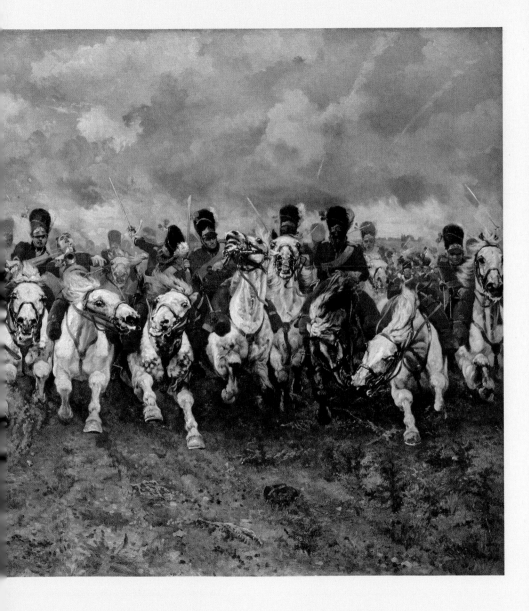

Blue Interior

1883

HARRIET BACKER: OIL ON CANVAS • 84 X 66 CM (33 X 26 IN)
NASJONALMUSEET, OSLO, NORWAY

HARRIET BACKER

Born to an affluent Norwegian family, Harriet Backer studied with several artists in Norway and Germany, and then in Paris with Léon Bonnat (1833–1922) and Jean-Léon Gérôme (1824–1904). In 1888 she moved back to Norway and established a painting school. She exhibited all over the world and won many accolades, and from 1907 until 1925 she received an annual grant from the wealthy art patron Olaf Fredrik Schou (1861–1925).

Using rich colours and strong tonal contrasts, the Norwegian painter Harriet Backer (1845–1932) became admired for her detailed interior scenes, which she painted on location.

Featuring a woman sitting in a room and sewing in front of a long window, the scene opposite is filled with softly diffused light. Deceptively simple-looking, it is actually a fairly complex arrangement. Dressed with blue curtains, the window is painted in three thin strips – blue, white, blue – and light from it appears to shine on to the woman's face, hair and blouse, and the white fabric she is sewing. Light also illuminates the wooden bureau next to her, the tall plant on the table, the seascape on the wall and one of the chairs upholstered in blue velvet. Patches of white on the wall, on the blue-and-grey rug and on parts of the chair in shadow evoke a further impression of shimmering light.

Although she did not belong to any particular art movement, Backer's work follows the traditions of realism and naturalism, and she was particularly influenced by French Impressionism. She lived in Paris from 1880 until 1888, sharing a studio with another Norwegian artist, Kitty Lange Kielland (1843–1914). Unlike the Impressionists, however, she worked slowly and painstakingly, producing only about 180 works over the course of her long career.

OTHER KEY WORKS

Avskjeden (*The Farewell*), 1878, Nasjonalgalleriet, Oslo, Norway

Solitude, c.1880, Private Collection

Chez Moi, 1887, Nasjonalgalleriet, Oslo, Norway

NATURALISM **p.18** IMPRESSIONISM **p.19**

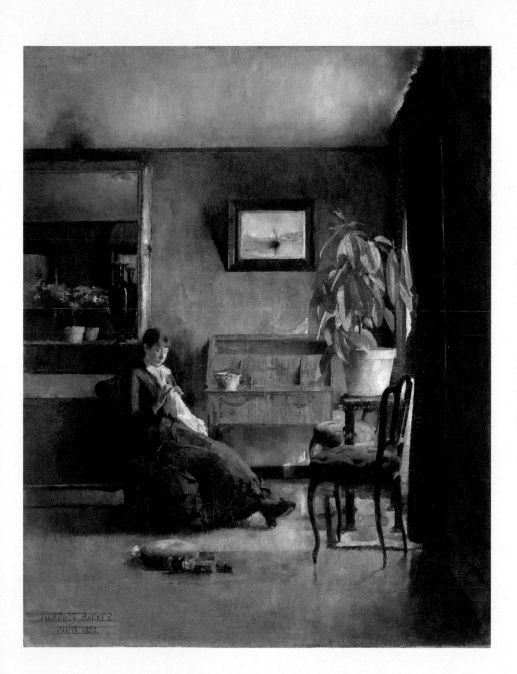

Cattle at Rest on a Hillside in the Alps

1885

ROSA BONHEUR: 54.9 X 66.4 CM (21⅝ X 26⅛ IN)
ART INSTITUTE OF CHICAGO, ILLINOIS, USA

Famous in her lifetime for her ability to depict animals realistically in their natural surroundings, Rosa Bonheur (1822–1899) became the first woman to be awarded the Grand Cross of the Légion d'Honneur.

Among other accolades, Bonheur was awarded honorary membership of the Pennsylvania Academy of Fine Arts and of the Société des Artistes Belges, the Cross of San Carlos of Mexico and membership of the Académie des Beaux-Arts in Antwerp. Achieving naturalism through a close study of animals, she kept unusual pets, including a lion and lioness, a stag, a gazelle, sheep and horses. She also spent hours drawing animal anatomy in the Bois de Boulogne park in Paris, in abattoirs, on farms, and at animal markets and horse fairs. In the painting shown here, she captures an atmospheric moment as clouds gather over distant hills and the animals settle down to wait for the storm to pass.

Bonheur ignored expectations about women's behaviour and conventional feminine subjects. Long before feminism, she believed unequivocally in women's equality. She lived independently, supporting herself financially rather than relying on a man, and she received special dispensation from the police to wear men's clothing so that she could study animals in insalubrious locations.

OTHER KEY WORKS

The Horse Fair, 1855, Metropolitan Museum of Art, New York, USA

Sheep by the Sea, 1865, National Museum of Women Artists, Washington DC, USA

Portrait of Colonel William F. Cody, 1889, Whitney Western Art Museum, Cody, Wyoming, USA

NATURALISM **p.18**

ROSA BONHEUR

Born in Bordeaux and initially taught by her father, an art teacher who believed in sexual equality, Rosa Bonheur became one of the youngest people to study painting and sculpture at the Louvre in 1836, when she was 14. She exhibited her first painting at the Paris Salon just five years later. By the age of 23 she had exhibited 18 works at the Salon and had received commissions from the French government.

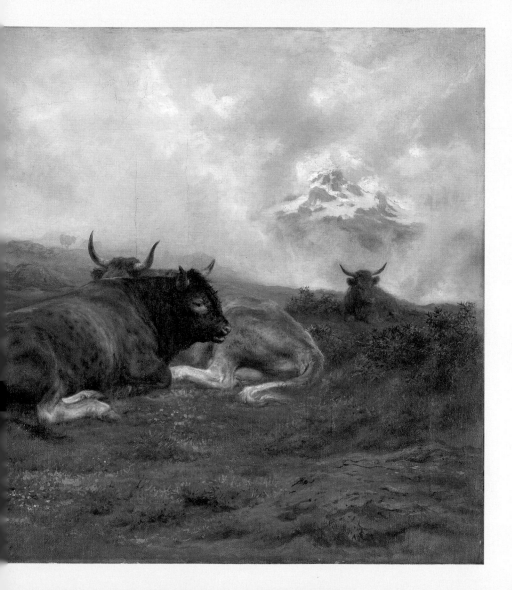

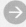

Vertumnus and Pomona

CAMILLE CLAUDEL: MARBLE • 91 X 80.6 X 41.8 CM (36 X 31¾ X 16½ IN)
MUSÉE RODIN, PARIS, FRANCE

1886
–
1905

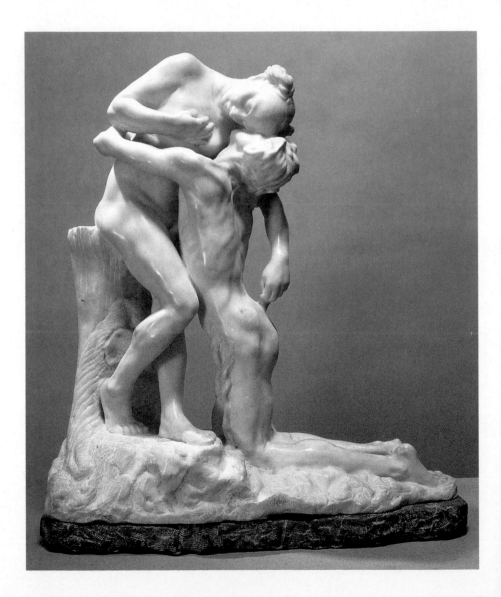

ART NOUVEAU **p.21**

OTHER KEY WORKS

The Waltz, 1889–1905, Musée Camille Claudel, Nogent-sur-Seine, France

Clotho, 1893, Musée Rodin, Paris, France

The Age of Maturity, c.1902, Musée d'Orsay, Paris, France

Inspired by an ancient Sanskrit epic, especially the most famous adaptation of it by the fifth-century writer Kālidāsa, this sculpture depicts Śakuntalā as she is reunited with her husband, Dushyanta, after a long period apart.

When Camille Claudel (1864–1943) first modelled the work in plaster in 1886, she tried to secure a state commission for a marble version, but was rejected. However, the patinated plaster version she created in 1888 won her an honourable mention at the Salon des Artistes Français. In 1905 her regular patron, Marie, Countess of Maigret (1856–1910), commissioned her and she was finally able to carve the marble version. At that point the work was named *Vertumnus and Pomona*, referring to characters from Ovid's *Metamorphoses*, since this was thought to be more appealing to a contemporary audience. In this story, the Roman god of the seasons disguises himself to gain the trust of the goddess of fruit. The work is sometimes called *The Abandon*, referring to its depiction of abandoning everything for love.

Claudel was both assistant to and lover of Auguste Rodin (1840–1917), and this work contrasts with the male viewpoint and Rodin's portrayal of ideal love as seen in pieces such as his famous sculpture *The Kiss* (1889). She was highly skilled at creating naturalistic scenes, and here she portrays raw emotion but also love as an equal attraction between male and female minds and bodies.

CAMILLE CLAUDEL

One of the first women to study art formally (at the Académie Colarossi in Paris), the French artist Camille Claudel rented a studio with three British female sculptors in 1882. Alfred Boucher (1850–1934) became her mentor, then Rodin. Despite the fact that Claudel was Rodin's muse and lover, he would not leave his girlfriend. After breaking with him, Claudel experienced bouts of rage, and her family had her committed to an asylum.

INDEPENDENCE **p.176** CELEBRATING THE FEMALE **p.181** CONTRADICTING 'THE PASSIVE SEX' **p.184**
A FEMALE VIEWPOINT **p.187** THE SENSES **p.202** THE NUDE **p.209**

The Child's Bath

1893

MARY CASSATT: OIL ON CANVAS • 100.3 X 66.1 CM (39½ X 26 IN)
ART INSTITUTE OF CHICAGO, ILLINOIS, USA

OTHER KEY WORKS

Woman with a Pearl Necklace in a Loge, 1879, Philadelphia Museum of Art, Pennsylvania, USA

Tea, 1880, Boston Museum of Fine Arts, Massachusetts, USA

The Boating Party, 1893, National Gallery of Fine Art, Washington DC, USA

MARY CASSATT

At 21, Mary Cassatt told her wealthy parents that she intended to become an artist. In 1868 she left the United States for Europe, and in 1874, after travelling around the continent, she settled permanently in Paris. Also in that year, her work was accepted at the Salon, and in 1877 she met Degas, who became a great friend. She participated in the Impressionist exhibitions of 1879, 1880, 1881 and 1886.

Described in 1894 by a critic as one of 'les trois grandes dames' of Impressionism, Pennsylvania-born Mary Cassatt (1844–1926) was the only American to work in France with the Impressionists. However, Cassatt had to fight her family's strong opposition to her wish to become a professional painter. She studied art for four years at the prestigious Pennsylvania Academy, then moved to Paris, where she trained with the painter and printmaker Charles Chaplin (1825–1891) and then with the history painter Thomas Couture (1815–1879). She worked in oils, pastels and print, and Edgar Degas (1834–1917) invited her to exhibit with the Impressionists in their independent exhibitions, beginning in 1879. Degas was a big influence on Cassatt, as were the relatively new introductions of photography and Japanese design; she was particularly taken with a large exhibition of Japanese prints she saw at the École des Beaux-Arts in Paris in 1890.

The painting shown here deals with Cassatt's most common theme: mother and child in an everyday scene. As well as showing tenderness, the painting makes the woman tending her child the main subject, which conveys a sense of the modern world, where women were becoming less sidelined. The scene is depicted from above, and the angled composition, flattening effects, strong colours and striking patterns reflect elements of Japanese design and photographic ideas. There is a strong sense of realism in the way the mother holds the child firmly to wash her feet. Outlines and thickly layered paint on the figures differentiate them from the background.

IMPRESSIONISM **p.19**

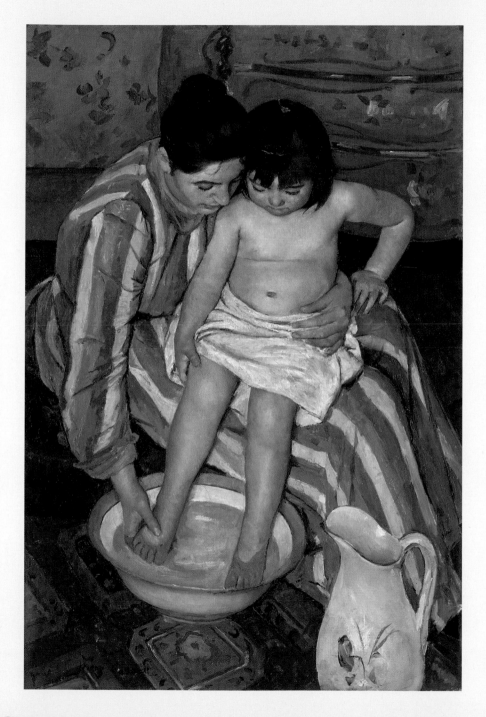

The Love Potion

1903

EVELYN DE MORGAN: OIL ON CANVAS • 104.1 X 52.1 CM (41 X 20½ IN)
DE MORGAN FOUNDATION, GUILDFORD, SURREY, UK

OTHER KEY WORKS

Phosphorus and Hesperus, 1881, De Morgan Foundation, Guildford, Surrey, UK

The Angel of Death, 1890, De Morgan Foundation, Guildford, Surrey, UK

Demeter Mourning for Persephone, 1906, De Morgan Foundation, Guildford, Surrey, UK

The English painter Evelyn De Morgan (1855–1919) evoked spiritual, mythological and allegorical ideas in her works, blending influences of – among others – the Arts and Crafts movement, Art Nouveau, Symbolism and Medievalism. Two other influences were George Frederic Watts (1817–1904), whom she had known from infancy, and his student, her tutor and uncle, John Roddam Spencer Stanhope (1829–1908). While visiting Stanhope in Florence, De Morgan studied the work of the great artists of the Renaissance, especially Sandro Botticelli (1445–1510).

This jewel-like canvas with its immaculately painted details is an example of De Morgan's exacting style. Jane Morris (1839–1940) was the model, posing in a book-lined study, mixing a potion, with a small black cat at her feet. One of a series of paintings produced by the artist, it illustrates how the soul moves towards enlightenment. The woman in the flowing golden-yellow gown is not a witch or sorceress, as has sometimes been suggested, but a powerful, skilful alchemist. De Morgan was one of several women of the period who sought to push the boundaries of society's expectations of women and to portray them in positions of authority. Among the leather-bound books behind the alchemist are works by some of the greatest scientific and philosophical minds, well known to the spiritualist movement of the time. In the background, directly above the woman's hands, a couple embrace, suggesting that they are connected with her potion.

EVELYN DE MORGAN

From 1872 Evelyn De Morgan studied at the South Kensington National Art Training School, but, disagreeing with the school's beliefs about female 'accomplishments', she left and became one of the first women to enrol at the newly established Slade School of Art. She involved herself in many of the issues of the day, including spiritualism, prison reform, pacifism and women's suffrage.

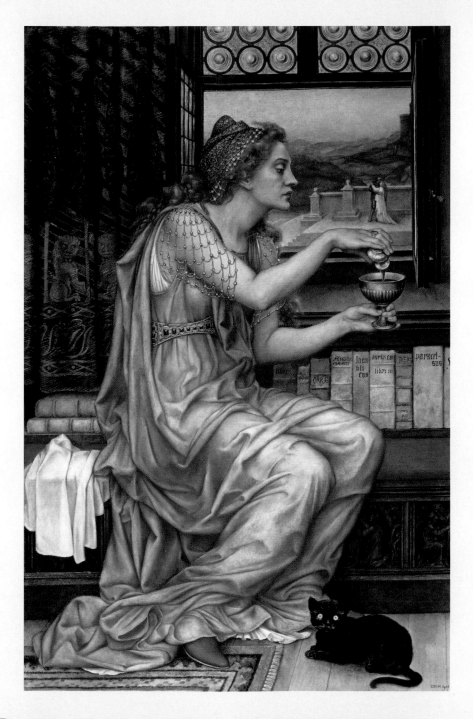

Outbreak

1903

KÄTHE KOLLWITZ: ETCHING • ENGRAVING AND AQUATINT • 49.2 X 57.5 CM
(19⅓ X 22⅔ IN) • BRITISH MUSEUM, LONDON, UK

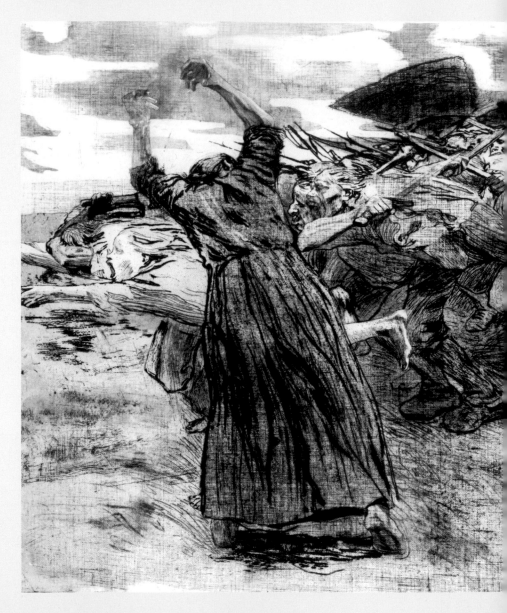

EXPRESSIONISM **p.22**

OTHER KEY WORKS

March of the Weavers, 1897, Museum of Modern Art, New York, USA

Woman with Dead Child, 1903, National Gallery of Art, Washington DC, USA

Self-Portrait with Hand on Forehead, 1910, National Gallery of Art, Washington DC, USA

The revolutionary leader known as Black Anna raises her arms to urge a mob of peasants to fight. This dynamic image, the fifth plate in a series commissioned by the German Verbindung für Historische Kunst (Society for Historical Art), illustrates the uprising of 1522–24 in Germany, known as the Peasants' Revolt (*Bauernkrieg*).

Käthe Kollwitz (1867–1945), who faced personal tragedy amid the cataclysms that overtook her country, created images that focused on the human condition. Destruction, poverty and sorrow dominate her prints and drawings as she expressed herself on social, political and personal subjects. Black Anna was a real female revolutionary, and for Kollwitz a powerful symbol of feminism. In several preparatory drawings for this work, the artist used herself as a model for Anna. Partly inspired by an illustration by Arthur Boyd Houghton (1836–1875) for *The Graphic* in 1871, the image illustrates social injustice and desperation. The peasants were ultimately brutally repressed.

Among other things, Kollwitz was inspired by the play *The Weavers* by Gerhart Hauptmann (1862–1946), writing that through it, she recognized art's power to 'transform ugly reality into something deceptively grand'. She mastered several printmaking techniques and experimented with combining them and mixing materials. She reduced all her compositions to essential elements and gestures, creating powerful emotional effects that were universally understandable.

KÄTHE KOLLWITZ

The first woman to be elected to the Prussian Academy of Arts, Käthe Kollwitz initially learned drawing with a local Prussian engraver. She studied in Berlin with Karl Stauffer-Bern (1857–1891) and was influenced by the work of his friend Max Klinger (1857–1920). After one of her sons and a grandson were killed in World Wars I and II respectively, her art expressed even greater sorrow at suffering and social injustice.

 VOCATION **p.182** A FEMALE VIEWPOINT **p.187** SELF-PORTRAITS **p.198** IDENTITY **p.199** HISTORY **p.201** MEMORY **p.210** CONFRONTATION **p.211** ANGER **p.212** CONFLICT **p.216**

The Sculptress Clara Rilke-Westhoff

1905

PAULA MODERSOHN-BECKER: OIL ON CANVAS, 52 X 36.8 CM
(20½ X 14½ IN), HAMBURGER KUNSTHALLE, HAMBURG, GERMANY

PAULA MODERSOHN-BECKER
Dresden-born Paula Becker studied drawing at St John's Wood School of Art in London. After returning to Germany, she began to train as a teacher, then studied art in Berlin, and in 1898 she joined the Worpswede colony. In 1906 she left her husband and went to Paris, but she returned to Worpswede with him the following year. The following year, soon after giving birth to her daughter, she died of an embolism.

In 1900 Paula Becker (1876–1907) met the sculptor Clara Westhoff (1878–1954) and the poet Rainer Maria Rilke (1875–1926) in the artists' colony of Worpswede in Germany. Worpswede was a village in the countryside of Lower Saxony, which from 1897 was an artistic community where women were welcomed equally with men.

In 1901 Becker married one of the colony's founders, the painter Otto Modersohn (1865–1943), and Rilke and Westhoff married each other. As close friends, the two couples nicknamed themselves 'The Family', and before their relationships foundered, Modersohn-Becker painted a portrait of her best friend, Rilke-Westhoff. Modersohn-Becker was a pioneer of Expressionism with a unique style, and also the first woman to paint a naked self-portrait. Her loose, expressive brushmarks in the portrait of her friend opposite are both flat-looking and textured, glowing and dull; the palette is muted and the overall image sculptural. Five years before painting it, she had made her first trip to Paris with Rilke-Westhoff; there she studied drawing and anatomy at the Académie Colarossi, and became fascinated by the avant-garde art she saw there. While painting this work, in November 1905, she wrote: 'Mornings I am painting Clara Rilke in a white dress. Her head and part of her hand holding a red rose. She looks very beautiful that way, and I hope that I am getting a little of her into my portrait. Her little girl, Ruth, is playing next to us.'

OTHER KEY WORKS

Old Peasant Woman, c.1905, Detroit Institute of Arts, Michigan, USA

Rainer Maria Rilke, 1906, Paula Modersohn-Becker Museum, Bremen, Germany

Self-Portrait on Sixth Wedding Anniversary, 1906, Paula Modersohn-Becker Museum, Bremen, Germany

EXPRESSIONISM **p.22**

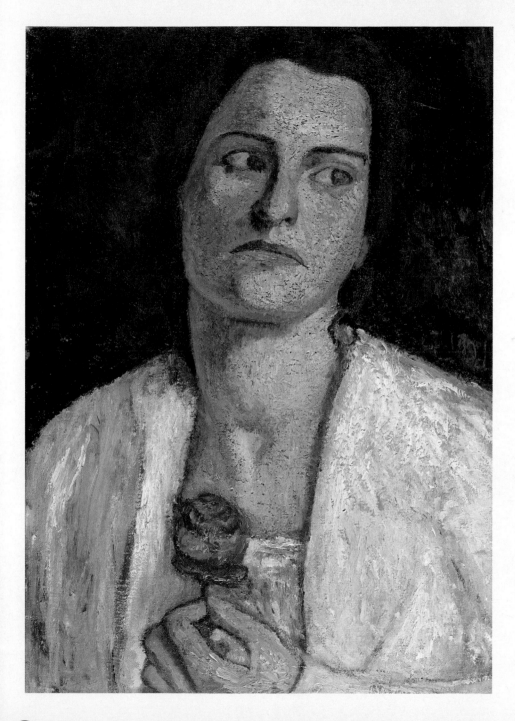

The Ten Largest, No. 2, Childhood, Group IV

1907

HILMA AF KLINT: TEMPERA ON PAPER • MOUNTED ON CANVAS • 328 X 240 CM (129 X 94½ IN) • HILMA AF KLINT FOUNDATION, STOCKHOLM, SWEDEN

HILMA AF KLINT

Inspired by theosophy and anthroposophy, Hilma af Klint was one of the first women to study painting at Stockholm's Royal Academy of Arts. In trying to understand both the visible and the invisible world, she also studied plants and animals. In 1896, with four female artist friends, she founded a group called The Five (De Fem), which held seances and experimented with unconscious writing and drawing.

In 1906, inspired by the theories of theosophy, the Swedish artist Hilma af Klint (1862–1944) began painting a series of abstract works featuring geometric shapes and symbols in bright colours. In fact, Klint was one of the first to abandon figurative art and explore relationships between colours and shapes instead, several years in advance of other artists, such as Wassily Kandinsky, Kazimir Malevich and Piet Mondrian (1872–1944). However, since she rarely exhibited her paintings and insisted that they not be shown for 20 years after her death, her work was little known until the late twentieth century.

Exploring the stages of life from a spiritual perspective, the painting shown here is the second that Klint produced in a second series of abstract works. Each of the ten paintings in the series illustrates a different phase of human life, including childhood, youth, maturity and old age, and each contains circles, spirals and organic shapes in flat, radiant colours. This huge painting expresses the notion of childhood. A large orange circle intersects with an indigo circle of the same size, and flower-like shapes hover above on a pale blue background. With only one female assistant, Klint completed this series in four months. She described her working process: 'The pictures were painted directly … without any preliminary drawings … I had no idea what the paintings were supposed to depict; nevertheless, I worked swiftly and surely, without changing a single brushstroke.'

OTHER KEY WORKS

The Ten Largest, No. 3, The Youth Age, Group IV, 1907, Moderna Museet, Stockholm, Sweden

Altarpiece Group X Number 1, 1915, Private Collection

Group IX/SUW, No. 23. The Swan, 1915, Private Collection

ABSTRACT EXPRESSIONISM **p.33**

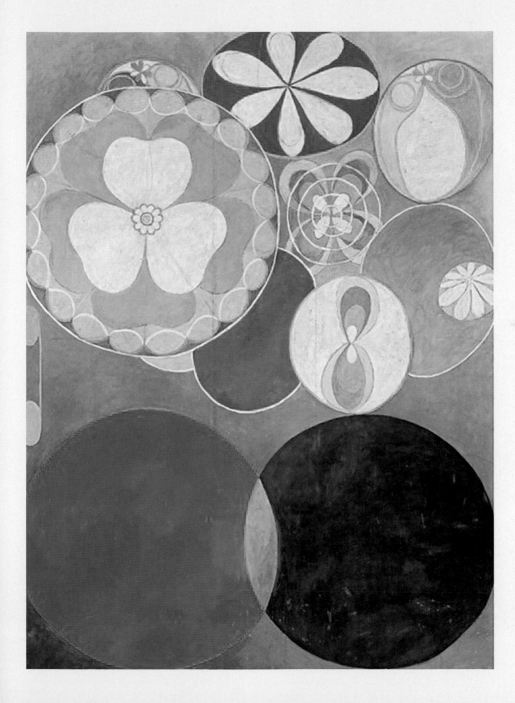

Apollinaire and His Friends

1909

MARIE LAURENCIN: OIL ON CANVAS • 130 X 194 CM (51¼ X 76⅓ IN)
MUSÉE NATIONAL D'ART MODERNE, CENTRE GEORGES POMPIDOU, PARIS, FRANCE

The French painter and printmaker Marie Laurencin
(1883–1956) painted this group portrait as a gift for the
writer and art critic Guillaume Apollinaire (1880–1918),
with whom she was having an affair.

Laurencin had previously painted a smaller version
that was bought by the American writer and art collector
Gertrude Stein (1874–1946), who is also in the scene (at the
far left). The image places Apollinaire and Laurencin in the
midst of the Parisian avant-garde. Apollinaire sits in the
centre, looking forward, his hands by his knees; a dog sits
and looks at him. Laurencin sits on the ground in a pale
blue dress, her body and leg turned towards Apollinaire,
and her face towards the viewer. She had been introduced
to Picasso in 1907, and he is there, on Apollinaire's
immediate right, while with his muse at the time, Fernande
Olivier (1881–1966) is at second left, beside an unidentified
woman in an elaborate headress. The poets Marguerite
Gillot (1883–1956, behind Picasso) and the bearded
Maurice Cremnitz (1875–1935) are also in the group.

The composition is predominantly painted with
a subdued Cubist-style palette, including earthy browns
and greys, but Laurencin's blue dress and Apollinaire's
blue tie stand out. Laurencin also creates her own
completely personal style, with curving contours and
a sense of flatness. Apollinaire defended her approach,
which was criticized at the Salon des Indépendants.
He reproduced the work in his *Cubist Painters* of 1912,
writing: 'This female art, Miss Laurencin's art, tends
towards a pure arabesque, humanized by the attentive
observation of nature.'

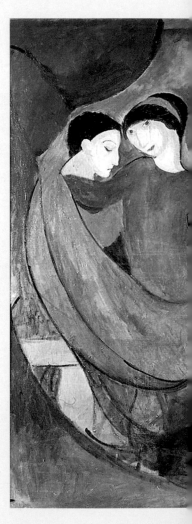

CUBISM **p.23**

OTHER KEY WORKS

Young Girls, 1911, Moderna Museet, Stockholm, Sweden

Portrait of Mademoiselle Chanel, 1923, Musée de l'Orangerie, Paris, France

The Circle, 1925, Private Collection

MARIE LAURENCIN

Specializing in paintings of stylized pale-skinned, dark-eyed figures, Marie Laurencin initially studied porcelain painting, then trained in fine art at the Académie Humbert in Paris. In 1907 she had her first solo show and met Apollinaire, with whom she lived until 1912. She often collaborated on stage sets and ballet costumes, and she was a founding member of La Société des Femmes Artistes Modernes (The Society of Female Modern Artists).

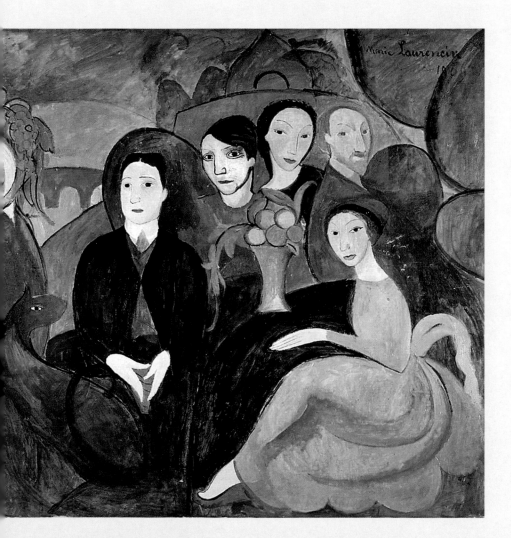

 CELEBRATING THE FEMALE **p.181** A FEMALE VIEWPOINT **p.187** SELF-PORTRAITS **p.198** INDIVIDUALITY **p.207** EMPATHY **p.217**

Cyclist

NATALIA GONCHAROVA: OIL ON CANVAS • 78 X 105 CM (30¾ X 41⅓ IN)
STATE RUSSIAN MUSEUM, ST PETERSBURG, RUSSIA

1913

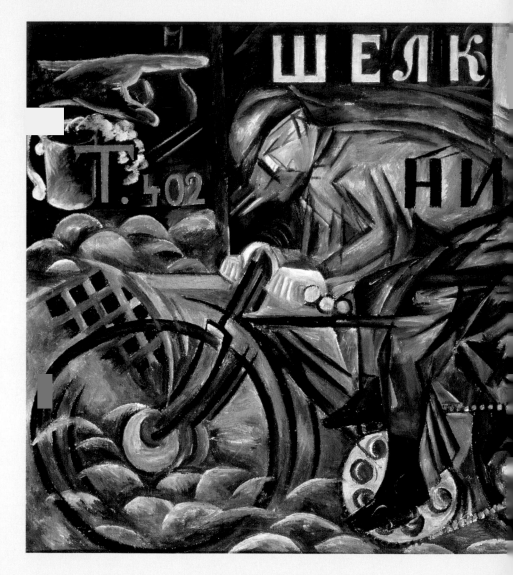

CUBISM **p.23**

OTHER KEY WORKS

Self-Portrait with Lilies, 1907, State Tretyakov Gallery, Moscow, Russia

Gardening, 1908, Tate, London, UK

Linen, 1913, Tate, London, UK

Natalia Goncharova (1881–1962) was a hugely successful painter, costume designer, writer, illustrator and set designer. The first woman and the first avant-garde artist to have a retrospective in a Moscow gallery, when she was only 32, Goncharova, who was born in the Russian town of Negaevo, was described as the 'suffragist of Russian painting'. She was also one of the first female artists to be taken seriously in the art world, and she inspired numerous other women, saying: 'Believe in yourself more, in your strengths and rights … There are no limits to the human will and mind.' Following her success, other female artists, especially in Russia after the Revolution, began to seize opportunities, working alongside men as equals for the first time in history.

Goncharova became especially recognized in Russia for her Futurist work and for inventing Rayonism, an art movement that focused on the deconstruction of rays of light. Evincing a sense of movement that was important to Futurists, *Cyclist* is made up of repetition and fractured contours to convey a cyclist speeding through a city, passing street signs and buildings, all blurring as he passes. As well as being a portrayal of an actual cyclist in motion, the painting exemplifies the technological progress of the period, and the accelerated pace of life. By the time Goncharova painted this, the political situation in Russia was unsettled and World War I was imminent.

NATALIA GONCHAROVA

While studying at the Moscow Institute of Painting, Sculpture and Architecture, Natalia Goncharova met Mikhail Larionov, who became her lifelong partner. She was a founder member of the art groups Jack of Diamonds and Donkey's Tail, co-founded the art movement Rayonism, and exhibited with the German-based painting group Der Blaue Reiter. She also became a key figure in the Parisian art and design world.

STRIVING FOR EQUALITY **p.172** CONTRADICTING 'THE PASSIVE SEX' **p.184** A FEMALE VIEWPOINT **p.187** CHALLENGING CONTEMPT **p.194** INDIVIDUALITY **p.207** TRANSFORMATION **p.213**

Composition with Figures

1913

LYUBOV POPOVA: OIL ON CANVAS • 161 X 123 CM (63⅜ X 48⅜ IN)
STATE TRETYAKOV GALLERY, MOSCOW, RUSSIA

OTHER KEY WORKS

Air+Man+Space, 1912, State Russian Museum, St Petersburg, Russia

The Pianist, 1914, National Gallery of Canada, Ottawa, Canada

Architectonic Painting, 1917, Los Angeles County Museum of Art, California, USA

LYUBOV POPOVA

One of the most original Russian avant-garde artists, Lyubov Popova was born near Moscow to an affluent family. She travelled throughout Russia and in Europe, and brought back influential modern painting ideas, in particular those relating to Cubism and Futurism. While working with Goncharova, Larionov, Vladimir Tatlin and Malevich, she moved to complete abstraction, and in 1916 she joined the Suprematist group. She also designed textiles and theatre sets.

Lyubov Popova (1889–1924) often travelled beyond her native Russia, so became aware of avant-garde art movements, including Futurism in Italy and Cubism in France. She produced paintings that amalgamated elements of both to create a unique style that portrays objects from several angles simultaneously and suggests movement.

Composition with Figures was painted soon after Popova had returned from studying in Paris under Henri Le Fauconnier (1881–1946) and Jean Metzinger (1883–1956) at the private art school the Académie de la Palette. Created with fragmented colours and lines, predominantly in shades of grey and yellow, the painting has a clear structure and a real sense of movement. Made from straight lines with curving elements at their joints, two figures are picked out in bright colours, setting them apart from the grey of the background. Specifically following some of Picasso and Braque's Cubist ideas, Popova also includes still-life objects, partly to anchor the work to the tangible world, and partly to show which way up it should be. The female figure on the left-hand side is holding a bright blue fan, which can be seen above a bowl of fruit. A guitar and a jug are visible elsewhere in the composition. Although Popova was breaking away from traditional approaches to painting, she was still working out ways of representing the physical world.

CUBISM **p.23** CONSTRUCTIVISM **p.26** SUPREMATISM **p.27**

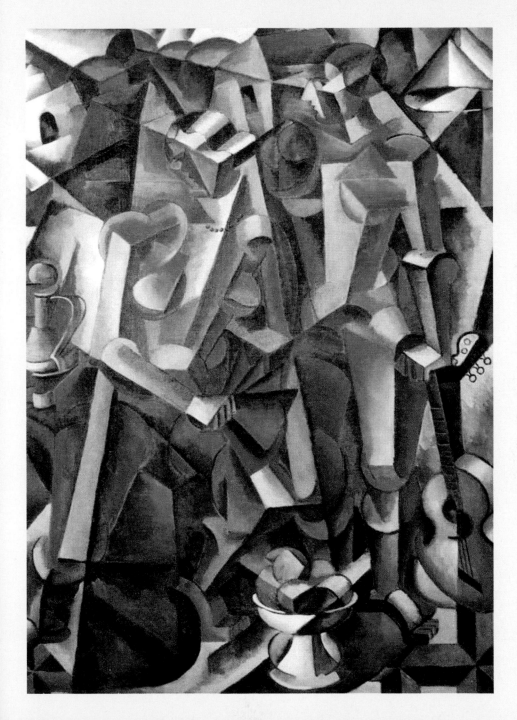

Self-Portrait with Black Background

1915

HELENE SCHJERFBECK: OIL ON CANVAS • 45.5 X 36 CM (18 X 14¼ IN)
ATENEUM ART MUSEUM, FINNISH NATIONAL GALLERY, HELSINKI, FINLAND

OTHER KEY WORKS

The Convalescent, 1888, Ateneum Art Museum, Finnish National Gallery, Helsinki, Finland

My Mother, 1909, Ateneum Art Museum, Finnish National Gallery, Helsinki, Finland

Still Life with Blackening Apples, 1944, Didrichsen Art Museum, Helsinki, Finland

HELENE SCHJERFBECK

The artistic talents of Helene Schjerfbeck were recognized when she was 11. She began studying at the Finnish Art Society's drawing school, and in 1880 she received a state travel grant and moved to Paris, where she studied with Léon Bonnat and at the Académie Colarossi. She also spent time in artists' colonies in Brittany and Cornwall. Once back in Finland, she gradually simplified and flattened her forms.

Her gaze averted, a woman's pale face emerges from a plain, dark background. This is one of many self-portraits painted by the Finnish artist Helene Schjerfbeck (1862–1946) that document her changing appearance and the evolution of her painting style from Naturalism to Expressionism.

The work was commissioned in 1914 by the Finnish Art Society, and Schjerfbeck was the only woman among the nine artists to be considered for the task. At the time, she was recognized as one of Finland's most important female painters, in a country that was more forward-thinking than many others about women; in 1906 Finland was the first European country to give women the right both to vote and to stand for election.

By the time she painted this work, Schjerfbeck had spent time in France, England, St Petersburg, Vienna and Florence, absorbing numerous influences. With a limited palette, pared-down composition, minimal details and flat areas of contrasting tones, she creates a pale-skinned, pink-cheeked woman with dark grey eyes, bright against the black background. Her defined jaw and smoothly painted face contrast with the softer brushwork and hazy contours used in her clothing and the background. The darkness that surrounds her encourages the viewer to focus on her face, while her clothes and the vermilion paint pot and brushes just behind her are painted with thin applications of rubbed paint. Overall, the image expresses a sense of tranquil contemplation.

NATURALISM **p.18** EXPRESSIONISM **p.22**

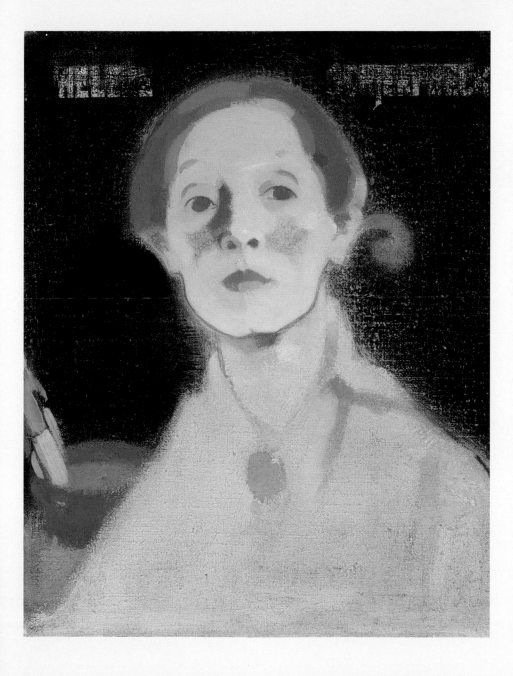

The Blue Room

1923

SUZANNE VALADON: OIL ON CANVAS • 90 X 116 CM
(35⅜ X 45⅝ IN) • MUSÉE NATIONAL D'ART MODERNE,
CENTRE GEORGES POMPIDOU, PARIS, FRANCE

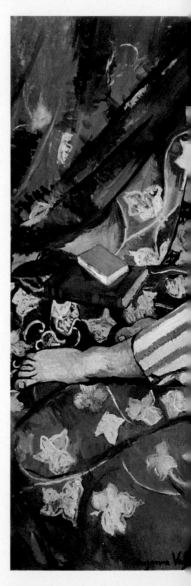

While not conforming to any particular artistic style or having any formal art training, the French painter Suzanne Valadon (1865–1938) learned various painting techniques from artists in Paris, including Pierre Puvis de Chavannes (1824–1898), Henri de Toulouse-Lautrec (1864–1901), Pierre-Auguste Renoir (1841–1919) and Edgar Degas.

Through these artists, Valadon absorbed a range of ideas and methods. In particular, Degas and Toulouse-Lautrec became her mentors, and Degas was the first to buy her work. Although many of her paintings were criticized and some of her subjects were considered bold for a woman, she was popular and financially successful.

Still prohibited from life-drawing classes, female artists of the period rarely painted nudes, but Valadon painted several, as well as still lifes and portraits. Unlike most women painted by men, this recumbent figure is not perfect. Set against patterned bedding and wall, in striped pantaloons and camisole, it is a self-portrait of a reclining Valadon at 58, a cigarette in her mouth. Male artists tended to paint even voluptuous figures as if they were delicate and weightless, but Valadon paints herself with a real sense of heaviness. Despite her contemporary, comfortable clothes, the figure echoes classical art poses, which traditionally idealize the female form; but Valadon presents her as a modern, real woman. Formed with lively brushwork, she looks boldly out of the canvas. Three-dimensional surfaces are transformed into relatively flat fields of colour.

OTHER KEY WORKS

The Abandoned Doll, 1921, National Museum of Women in the Arts, Washington DC, USA

Portrait of Lily Walton with Raminou, 1922, Private Collection

Reclining Nude, 1928, Metropolitan Museum of Art, New York, USA

SUZANNE VALADON

At 15, the illegitimate Marie Clémentine Valadon joined a circus, but after a fall she moved to Montmartre, Paris, and became an artists' model. The artists for whom she sat were among the most important of the time, and they advised her about painting. In 1896 she became a professional artist herself, and she is known as much for her vibrant paintings as for her artist son, Maurice Utrillo (1883–1955).

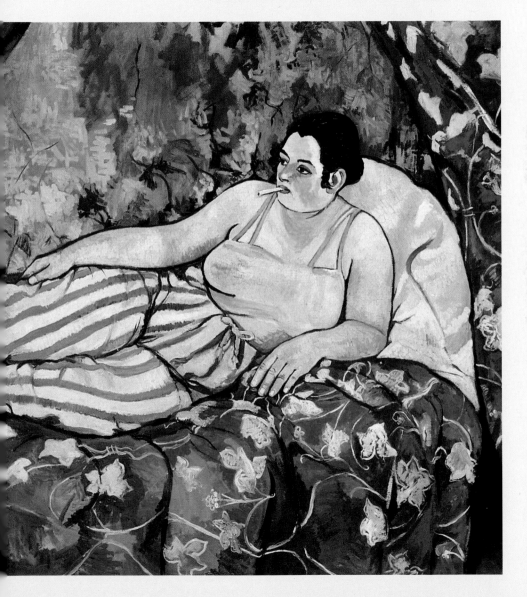

High Finance

HANNAH HÖCH: PHOTOMONTAGE • 36 X 31 CM (14¼ X 12¼ IN)
PRIVATE COLLECTION

1923

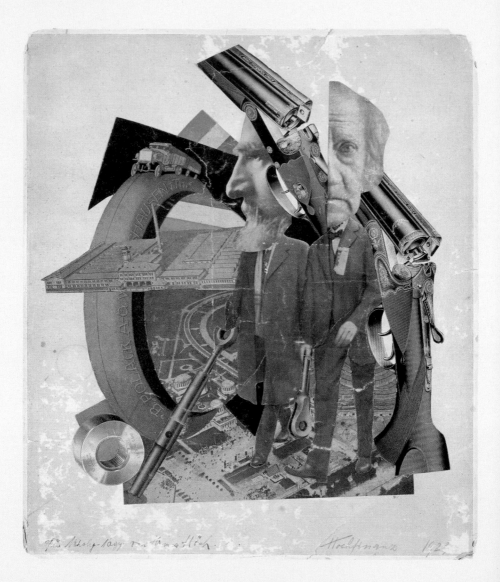

DADA **p.28**

One of a group of Dadaists living in Berlin, the German artist Hannah Höch (1889–1978) pioneered the technique of photomontage that evolved from the notion of Cubist collages and the rejection by the Dadaists of traditional artistic approaches.

Made from pasted images cut from magazines, journals and newspapers, photomontage is the placing together of seemingly unrelated images to evince various connections. Höch's photomontages both satirized politics and helped to expand the concept of fine art. *High Finance* is one of several works that she made while part of the Berlin Dada group. More than Dadaists elsewhere, the Berlin group used their art as weapons against political and social problems of the day, and the image opposite clearly shows the link between capitalism and war. It is a satirical view of industrialism and financial power in Germany following World War I.

Dressed as bankers, two figures with oversized heads carry menacing-looking mechanical tools. The hand of the man on the left has been replaced with a piston, and his face, split in half, is partially covered with a huge gun. The head of the man on the right is a photograph of the nineteenth-century British chemist and astronomer Sir John Herschel. For Höch, as for all the Dadaists, art was to be used to fight for a better world, to act as a mirror held up to society and politics, and to shame and shock viewers into changing their behaviour.

HANNAH HÖCH

In 1912 Hannah Höch entered the School of Applied Arts in Berlin to study glass design. At the outbreak of World War I she went home to work with the Red Cross, but she soon returned to the school and studied painting and graphic design. In 1917 she met the Austrian writer and artist Raoul Hausmann (1886–1971), who introduced her to the Berlin Dadaists. She also wrote and designed for magazines.

OTHER KEY WORKS

Cut with the Kitchen Knife Dada through the Last Weimar Beer-Belly Cultural Epoch in Germany, 1919, Nationalgalerie, Staatliche Museen, Berlin, Germany

The Beautiful Girl, 1920, Private Collection

Untitled (From an Ethnographic Museum), 1930, Museum für Kunst und Gewerbe, Hamburg, Germany

→ CONTRADICTING 'THE PASSIVE SEX' **p.184** CHANGING OPINIONS **p.189** QUESTIONING DEMOCRACIES **p.195**
CONFRONTATION **p.211** ANGER **p.212**

Shell No. I

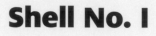

1928

GEORGIA O'KEEFFE: OIL ON CANVAS • 17.8 X 17.8 CM (7 X 7 IN)
NATIONAL GALLERY OF ART, WASHINGTON DC, USA

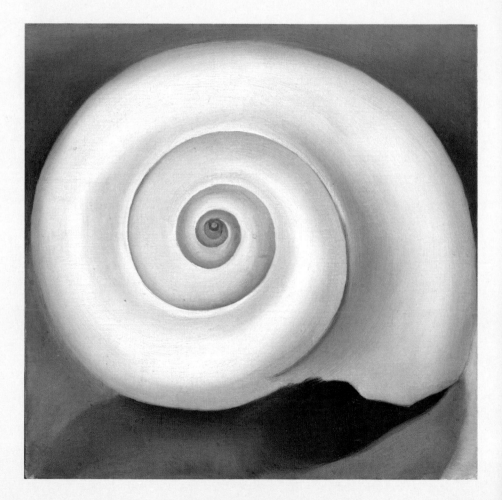

ART NOUVEAU **p.21**

Wisconsin-born Georgia O'Keeffe (1887–1986) was one of the first female painters to achieve international acclaim. Her subjects included flowers, bones, shells, deserts and skyscrapers, and her compositions were bold and often dramatically lit.

O'Keeffe's interest in shells began during her childhood, when they were displayed in her grandmother's parlour. She was told that she could hear the sea if she put one to her ear. 'I had not heard the sea at that time,' she recalled, 'but it was wonderful to me to listen to it in the shell. So when I grew up and went where there were shells, I was always looking for them.' From 1926 she painted them in both realistic and abstract ways. In the painting shown opposite she conveys the smoothness and roundness of the shell with simplified circular forms and subtly modulated layers of white and grey. The spiral dominates the composition, and soft contrasts evoke the play of light and shadow on the delicate surface.

O'Keeffe did not align herself with any specific art movement, and while some of her paintings are detailed, this one is pared down, exploiting photographic devices such as depth of field and cropping. The simple composition shows her fascination with Art Nouveau and Japanese *ukiyo-e* designs, but also, more specifically, the influence of her teacher Arthur Wesley Dow (1857–1922), who had a profound effect on her approach to composition.

GEORGIA O'KEEFFE
After spending a year at the School of the Art Institute of Chicago in 1905–6, Georgia O'Keeffe studied under William Merritt Chase (1849–1916) at the Art Students League, and then with Dow at his summer school and Columbia University's Teachers College. In 1916 the owner of avant-garde Gallery 291, the photographer Alfred Stieglitz (1864–1946), exhibited some of her drawings, and they married in 1924. She became a member of the radical National Woman's Party, and lived and worked in New York and New Mexico.

OTHER KEY WORKS

Oriental Poppies, 1927, Frederick R. Weisman Art Museum, University of Minnesota, Minneapolis, USA

Cow's Skull, Red, White and Blue, 1931, Museum of Modern Art, New York, USA

Jimson Weed/White Flower No. 1, 1932, Crystal Bridges Museum of American Art, Bentonville, Arkansas, USA

INDEPENDENCE **p.176** VOCATION **p.182** CHANGING OPINIONS **p.189** ABSTRACT ART **p.190** NATURE **p.206** INDIVIDUALITY **p.207** THE ENVIRONMENT **p.215**

Portrait of Ekaterina Serebriakova, the Daughter of the Artist

1928

ZINAIDA SEREBRIAKOVA: PASTEL ON LAID PAPER • 61.9 X 47 CM
(24⅓ X 18½ IN) • MEAD ART MUSEUM, MASSACHUSETTS, USA

OTHER KEY WORKS

Self-Portrait at the Dressing Table, 1909, State Tretyakov Gallery, Moscow, Russia

At Breakfast, 1914, State Tretyakov Gallery, Moscow, Russia

The Harvest, 1915, Odessa Art Museum, Ukraine

ZINAIDA SEREBRIAKOVA

Born in what is now Ukraine, Zinaida Serebriakova studied art in Russia, Italy and Paris from 1901. Working in oils, pastels and watercolours, she painted figuratively, and participated in exhibitions in St Petersburg and Moscow. After moving to Paris, she travelled extensively, including to North Africa. In 1947 she took French citizenship, and, after 36 years of separation, her eldest daughter, Tatiana (Tata), was finally allowed to visit her.

Part of a celebrated artistic Russian family, Zinaida Serebriakova (1884–1967) was often overlooked for her traditional painting style while so many contemporary artists were producing nonrepresentational art. Her grandfather and a brother were architects, her father and another brother artists, and her uncle a famous painter and founder of the Mir iskusstva (World of Art) art group, which she joined in 1911. After both her father and her husband died prematurely, Serebriakova was left with no income, four children and a sick mother. In 1924, therefore, she travelled to Paris, where she was commissioned to paint society portraits. She still struggled financially, however, and – even worse – once she was there, the new Soviet government would not allow her to return. Her two youngest children were eventually allowed to join her in Paris. Poverty meant that Serebriakova often used herself and her children as models for her sensitive images. In fact, the portrait opposite shows her daughter Ekaterina (1913–2014) – called Katya – at the age of 15. The artists who inspired her included Tintoretto (1518–1594), Nicolas Poussin (1594–1665), Peter Paul Rubens (1577–1640) and especially Alexey Venetsianov (1780–1847). She also absorbed elements of Realism, Impressionism, Art Nouveau and Expressionism, and in this pastel painting, she has captured Katya from direct observation. The pose adds dynamism to the composition, and the mostly unfinished background adds to the lively informality.

NATURALISM **p.18**

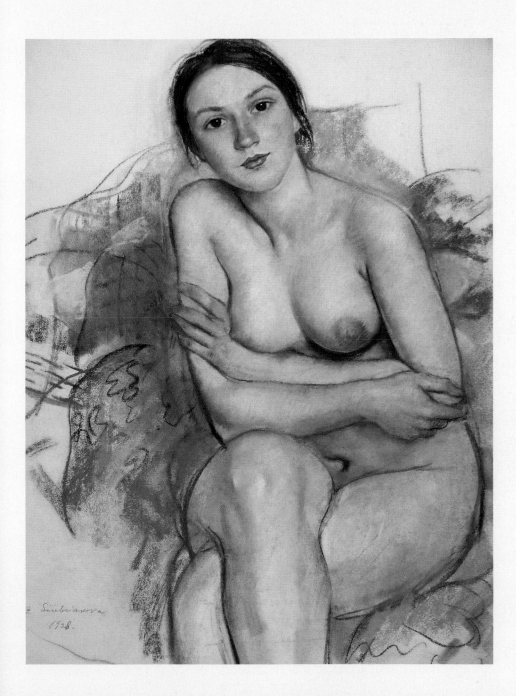

Across the Yarra

C.1931

CLARICE BECKETT: OIL ON CARDBOARD • 32.5 X 45.9 CM (12¾ X 18 IN)
NATIONAL GALLERY OF VICTORIA, MELBOURNE, AUSTRALIA

Celebrating light, atmosphere, location and modernity,
Clarice Beckett (1887–1935) defied the expectations of the
Australian art world in the early twentieth century. At the
time, women artists were accepted there if they depicted
'feminine subjects' such as flowers and domestic scenes,
but Beckett painted atmospheric, half-seen images.

Across the Yarra depicts a city veiled in mist, with some
of its lights seen vaguely through the haze. It was painted
in early evening in Melbourne, looking across the Yarra
River, and a bridge and tall Gothic spires can be seen.
Nothing is defined, and the composition conveys the
silence and stillness of a misty evening.

Long after the Impressionists and James Abbott
McNeill Whistler (1834–1903) were working in a similar
way, Beckett captures a fleeting moment. She wrote that
she aimed 'to give a sincere and truthful representation of
a portion of the beauty of nature, and to show the charm of
light and shade, which I try to give forth in correct tones so
as to give as nearly as possible an exact illusion of reality'.
Her art is part of the Australian Tonalist movement of
about 1910–50 in Melbourne, expressing the theories of
the Scottish-born artist Max Meldrum (1875–1955) and
concentrating on softly toned paintings. Meldrum's theory
was that painting should be based on optical analysis and
that all embellishments, narrative and literary references
should be ignored.

OTHER KEY WORKS

Collins Street, Evening, 1931, National Gallery of Australia,
Canberra, Australia

Passing Trams, 1931, Art Gallery of South Australia, Adelaide,
Australia

Evening, St Kilda Road, 1935, Art Gallery of New South Wales,
Sydney, Australia

CLARICE BECKETT

For three years from 1914, Clarice Beckett attended Melbourne's National Gallery School, studying with Frederick McCubbin (1855–1917) and then with Meldrum, whose controversial theories strongly affected her approach to painting. Since she was caring for her sick parents, she could go out to paint only at dawn and dusk, and she became recognized for her atmospheric, 'muffled' depictions of those softly lit times of day.

Three Girls

1935

AMRITA SHER-GIL: OIL ON CANVAS • 92.8 X 66.5 CM (36½ X 26¼ IN)
NATIONAL GALLERY OF MODERN ART, NEW DELHI, INDIA

OTHER KEY WORKS

Young Girls, 1932, National Gallery of Modern Art, New Delhi, India

Bride's Toilet, 1937, National Gallery of Modern Art, New Delhi, India

Ancient Storyteller, 1940, National Gallery of Modern Art, New Delhi, India

AMRITA SHER-GIL

As a child, Amrita Sher-Gil moved with her family from Hungary to India. She studied at the Santa Annunziata school of art in Florence, Italy, when she was 11, and from 16 she trained in Paris, at the Académie de la Grande-Chaumière and the École des Beaux-Arts. She was the youngest student at the time, and the only Asian student, to win a gold medal at the National Society of Fine Arts (Société Nationale des Beaux-Arts).

Also known as *Group of Three Girls*, this is the first painting Amrita Sher-Gil (1913–1941) made after she returned to India from Paris in 1934.

Three years later Sher-Gil's painting was awarded a Gold Medal at the annual exhibition of the Bombay Art Society, helping to establish her as one of India's most celebrated modern artists. With her European background and education, and her mixed heritage, Sher-Gil was ideally placed to synthesize Western painting methods with Indian subjects and colours. The painting also reflects the bold approach of the Parisian avant-garde artists with whom she had recently mixed, especially Paul Gauguin (1848–1903). Three young Indian women on the brink of adulthood and marriage are considering their destinies. Knowing that they are unable to change anything, they appear sad but resigned to their fate. Sher-Gil wrote: 'I realized my real artistic mission, to interpret the life of Indians and particularly the poor Indians pictorially; to paint those silent images of infinite submission and patience … to reproduce on canvas the impression those sad eyes created on me.'

The painting blends Sher-Gil's early realistic approach with her later, flatter style that emphasizes line and colour. The composition is cropped closely around the women, and what can be seen of the background is plain with strong shadows. All these aspects draw the viewer's eyes into the scene, to focus on the serene, dignified women.

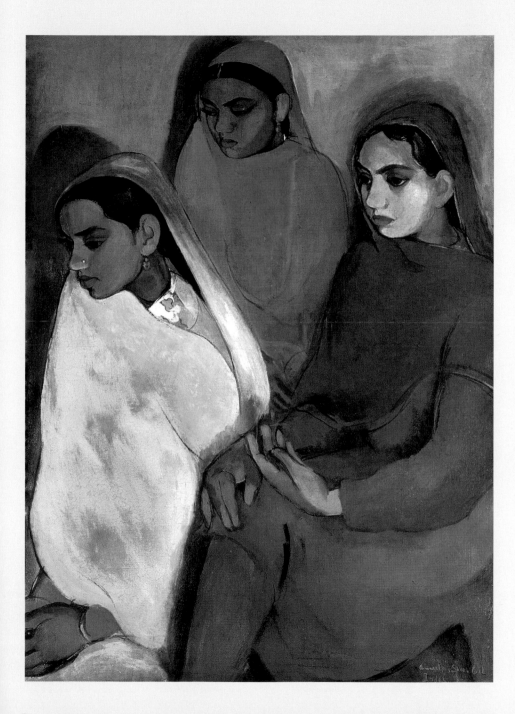

Portrait of Mildred Myers Oldden

c.1937

ALICE NEEL: OIL ON CANVAS • 93.3 X 55.2 CM (36¾ X 21¾ IN) • SAN DIEGO MUSEUM OF ART, CALIFORNIA, USA

ALICE NEEL

Born in Pennsylvania Alice Neel studied at the Philadelphia School of Design for Women. In 1930–31, after she lost one baby and her Cuban husband took another back to his homeland, she suffered a nervous breakdown and attempted suicide. Neel went on to have two illegitimate sons by different men. She continued to paint, but it was not until she was in her mid-seventies that she gained recognition for her powerfully expressive work.

Despite the fashion for abstraction at the time, New York-based Alice Neel (1900–1984) spent her career producing figurative paintings, especially portraits, and became known for her Expressionistic depictions of her friends, family and lovers.

Rather than simply producing physical likenesses, Neel used colour and line to convey energy and human psyche. She reflected: 'Even if I'm not working, I'm still analysing people. If I hadn't been an artist, I could have been a psychiatrist.' She painted the portrait opposite when she was receiving financial support from the Works Progress Administration under President Franklin Roosevelt's New Deal. She was known for making her subjects sit for hours in silence as she painted; as she once said, 'Art is not as stupid as human conversation.' However, it is likely that she was quizzing this sitter while she painted, in order to understand her personality.

Sitting in a director's chair wearing a large-brimmed hat, with a ring on her left hand and her right clasping a cigarette holder, Mildred Myers Oldden looks forthright and resolute. From La Jolla, California, she worked for Equinox Cooperative Press and is seen here as a fashionable figure in a boldly striped suit with large shoulder pads. The stripes and pointed collar emphasize her almost fierce expression and determined stance.

OTHER KEY WORKS

Pat Whalen, 1935, Whitney Museum of American Art, New York, USA

Spanish Woman, c.1950, Private Collection

Dominican Boys on 108th Street, 1955, Tate Modern, London, UK

EXPRESSIONISM **p.22**

The Broken Column

1944

FRIDA KAHLO: OIL ON MASONITE • 39 X 30.5 CM (15¾ X 12 IN)
MUSEO DOLORES OLMEDO, MEXICO CITY, MEXICO

OTHER KEY WORKS

Henry Ford Hospital, 1932, Museo Dolores Olmedo, Mexico City, Mexico

The Two Fridas, 1939, Museo de Arte Moderno, Mexico City, Mexico

Self-Portrait with Thorn Necklace and Hummingbird, 1940, Harry Ransom Center, University of Texas, Austin, USA

One of the most famous women painters, Frida Kahlo (1907–1954) is renowned as much for her tragic, pain-filled life as for her colourful, personal art. Strongly influenced by traumatic physical and psychological events and her own German-Mexican identity, she is sometimes called a Surrealist, but said she was never interested in painting dreams or the subconscious.

In the painting opposite Kahlo depicts herself alone in an arid, cracked and desolate landscape. Her torso is split down the centre with a broken, crumbling column replacing her spine. She painted this soon after surgery on her spinal column, one of many operations she underwent after suffering a near-fatal accident at the age of 18, when a tram crashed into her school bus. Sustaining multiple fractures, she never fully recovered, and after this particular spinal operation she was left bedridden; in an effort to alleviate her constant, intense pain she had to be supported by a metal corset. She has depicted her naked torso held together with metal straps. Recalling Christ's shroud, a cloth is draped over the lower part of her body, and, also echoing elements of the Crucifixion, nails penetrate her body. (The nails continue down only her right leg, which was left shorter and weaker after she contracted polio as a young child.) Despite her obvious suffering, and that her face is bathed in tears, she wears a defiant, proud expression.

FRIDA KAHLO

Born near Mexico City to a German father and a Spanish-Indian mother, Frida Kahlo contracted polio at 6 and afterwards walked with a limp. She never fully recovered from her horrific bus crash in 1925. In 1929 she married the muralist Diego Rivera (1886–1957) and began painting indigenous themes and dressing in traditional Mexican Tehuana costume. Kahlo's relationship with Rivera was volatile; she became increasingly ill, and died aged just 47.

SURREALISM **p.30**

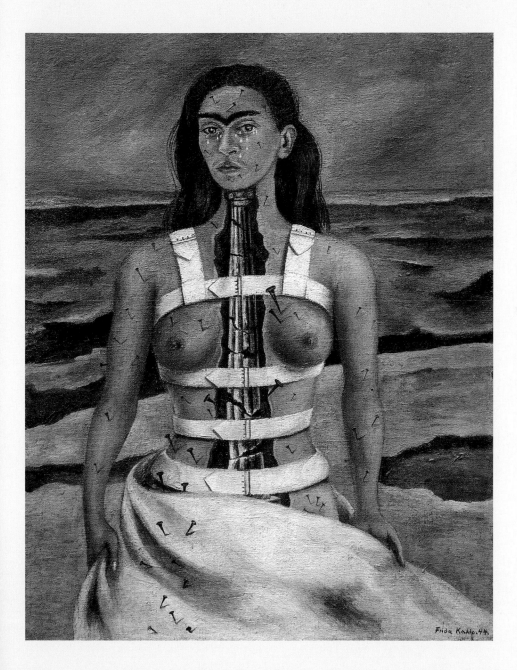

Composition

1949

LEE KRASNER: OIL ON CANVAS • 96.7 X 70.6 CM (38 X 28 IN)
PHILADELPHIA MUSEUM OF ART, PENNSYLVANIA, USA

OTHER KEY WORKS

Milkweed, 1955, Albright-Knox Art Gallery, New York, USA

Night Creatures, 1965, Metropolitan Museum of Art, New York, USA

Gaea, 1966, Museum of Modern Art, New York, USA

After Lee Krasner (1908–1984) and Jackson Pollock married in 1945, they lived in Springs on Long Island, where Krasner used a bedroom as a studio. There she created her *Little Image* series, 31 paintings that celebrate painting itself as a basic means of communication.

This is one of those works, painstakingly executed and revealing Krasner's unique ideas about communication. Working with her canvas flat on a table rather than upright on an easel, she applied thick paint repetitively and rhythmically, using sticks and palette knives, squeezing it directly from tubes or dripping it from cans. Covering the entire canvas equally is a grid of brown, green, yellow and red geometric shapes, which in turn are covered with white lines that resemble ancient hieroglyphs.

As a child, Krasner had studied Hebrew, but by the time she created this painting she could no longer read or write it. However, the symbols and marks deliberately recall similar forms of communication, even though they do not mean anything specifically. Inspired by Mondrian's grids, the painting reflects Krasner's dexterity and control, and her innovative painting method that contrasted completely with Pollock's version of Abstract Expressionism. The white lines may also connect with mysticism and the Kabbalah. In another connection with Hebrew writing, Krasner intuitively painted from right to left.

LEE KRASNER

Lena Krassner (she changed her name as a teenager) was born in Brooklyn, New York. She enrolled at Washington Irving High School, the only public school in the city to accept female art students at the time. In 1928 she joined the National Academy of Design and the Art Students League, and during the Depression she obtained work through the Works Progress Administration of the Federal Art Project. Later, she studied with Hans Hofmann (1880–1966).

Sharecropper

ELIZABETH CATLETT: LINOCUT • 56.2 X 48.3 CM (22⅛ X 19 IN)
PHILADELPHIA MUSEUM OF ART, PENNSYLVANIA, USA

1952

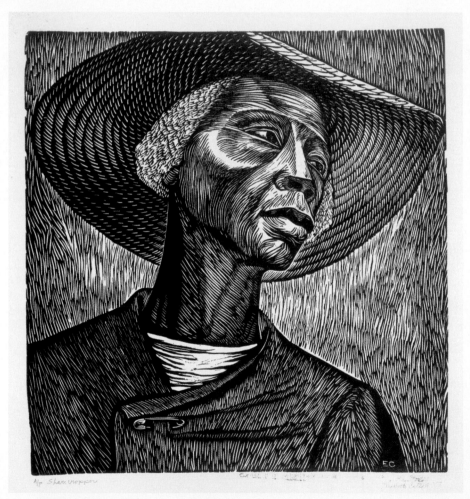

OTHER KEY WORKS

Mother and Child, 1944, Metropolitan Museum of Art, New York, USA

Untitled, 1967, DuSable Museum of African American History, Chicago, Illinois, USA

Mother and Child, 1993, The Studio Museum in Harlem, New York, USA

The sculptor and printmaker Elizabeth Catlett (1915–2012) said that the purpose of her art was to 'present black people in their beauty and dignity for ourselves and others to understand and enjoy'.

A strong supporter of the civil rights movement in the United States, Catlett used her art to stand up for the oppressed, especially for African-American women. She also insisted that black artists should create art that represented and reflected their experiences and issues that were important to them, rather than following established art movements.

After the American Civil War (1861–65), many former African-American slaves became sharecroppers. These were farmers who worked on rented land and received an agreed share of the crop as payment, but the system trapped many of them in a cycle of poverty. Catlett's painting opposite emphasizes the courage and fortitude of the woman it portrays. She is anonymous, but she represents every sharecropper, and Catlett bestows her with great dignity. The lines in her face and her greying hair suggest that she has toiled outdoors for years, yet she appears calm and determined, her head held high. Wearing a broad-brimmed hat and a jacket fastened with a safety pin, she gazes beyond the picture, exuding pride and resilience. She is positioned so that we have to look up at her, as in traditional portraits of those in power.

ELIZABETH CATLETT
Born in Washington DC, Elizabeth Catlett became an art teacher and was taught art by, among others, Loïs Mailou Jones and Grant Wood (1891–1942). She studied sculpture at the University of Iowa and was a guest artist at the Taller de Gráfica Popular (Workshop for Popular Graphic Art) in Mexico, a group of printmakers who promoted social change through their art. In 1962 she became a Mexican citizen.

Ulu's Pants

1952

LEONORA CARRINGTON: OIL AND TEMPERA ON PANEL • 54.5 X 91.5 CM
(21½ X 36 IN) • PRIVATE COLLECTION

OTHER KEY WORKS

Self-Portrait, c.1937–38,
Metropolitan Museum of Art,
New York, USA

The Meal of Lord Candlestick,
1938, Private Collection

The Giantess (The Guardian of the Egg), 1947, Private Collection

Drawing on Celtic myths that she had learned as a child,
cultural traditions that she absorbed while living in Mexico
as an adult, and various other legends, Leonora Carrington
(1917–2011) explores her identity in this eerie scene.

Her fascination with dream imagery, alchemy,
witchcraft and spiritualism is evident in the distorted
perspective, unusual colours and strange creatures that fill
this canvas. The work is also known as *Garden of the Genie*,
and all who enter are seeking awareness and evolving
spiritually and intellectually. The unnerving figures in the
foreground include exporia, or ghost moths, and bird- and
fish-like creatures, while in the distance shadowy figures
search for pathways through a maze. A green, sphinx-
like figure sits watch over a cave, and a figure with a red
head guards its entrance. Inside the cave is the cosmic
or primeval egg that represents fertility, rebirth and the
future. This egg was made by Khnum, one of the earliest

Detail: Carrington and Ernst's love affair
was passionate and volatile. Ernst called
her his 'bride of the wind', a name he
gave to several of his paintings featuring
two flying horses. Here, showing that
she is free of Ernst, Carrington depicts
a lone horse. She often incorporated
a white horse into her compositions
as a symbol of herself.

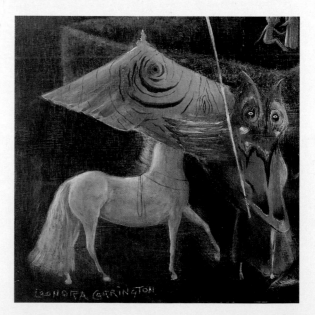

SURREALISM **p.30**

Detail, left: Using meticulous brush-strokes and fluid paint in rich colours, Carrington's output was limited, and her style remained the same throughout her career.

Egyptian gods, who was believed to create human babies on his potter's wheel and place them inside their mothers' wombs. It was said that anyone who managed to enter the cave would return to a time before Khnum, when humans were protected from being born.

The painting investigates Carrington's attempts to make sense of her own life experiences, including her wealthy upbringing, her escape from the Nazis in World War II, her traumatic love affair with Max Ernst (1891–1976) and her subsequent breakdown, her marriages to the Mexican poet, journalist and ambassador Renato Leduc (1897–1986) and the photographer Emérico Weisz (1911–2007), and her move to Mexico in the 1940s.

Detail, above and overleaf: Combining both cryptic messages and absurd juxtapositions, this rather sinister world is bathed in half-light. Carrington wrote: 'Dawn is the time when nothing breathes, the hour of silence. Everything is transfixed, only the light moves.'

LEONORA CARRINGTON

A rebellious child, British-born Leonora Carrington was sent to art school in Florence, Italy, and then Chelsea School of Art and Ozenfant Academy, both in London. From 1937 she lived with the artist Max Ernst, but in 1940 she moved to Spain, suffered a breakdown and was institutionalized. From 1942 she lived mainly in Mexico, painting, sculpting, writing and becoming a founding member of the Women's Liberation Movement there.

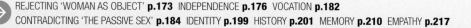

REJECTING 'WOMAN AS OBJECT' **p.173** INDEPENDENCE **p.176** VOCATION **p.182**
CONTRADICTING 'THE PASSIVE SEX' **p.184** IDENTITY **p.199** HISTORY **p.201** MEMORY **p.210** EMPATHY **p.217**

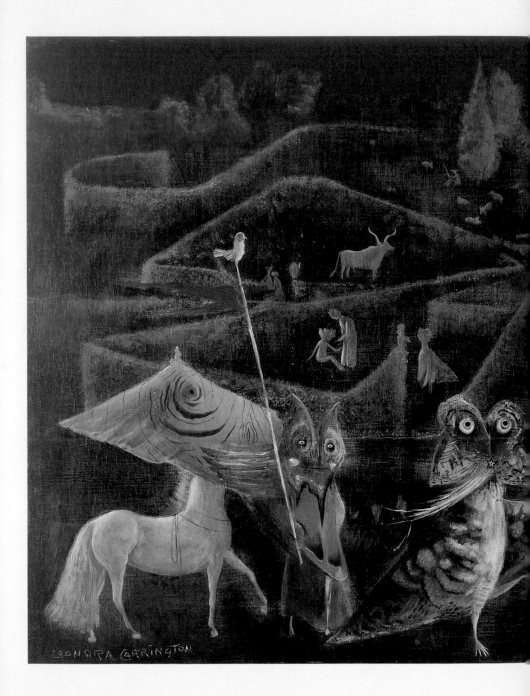

Homage to Greece

AGNES MARTIN: OIL, CANVAS, COLLAGE AND NAILS LAID DOWN ON PANEL
30.4 X 30.4 CM (12 X 12 IN) • PRIVATE COLLECTION

OTHER KEY WORKS

Little Sister, 1962, Solomon R. Guggenheim Museum, New York, USA

Leaf, 1965, Modern Art Museum of Fort Worth, Texas, USA

Happy Holiday, 1999, Tate Modern, London, UK

By contrast with many other artists of the time, Agnes Martin (1912–2004) sought to create beauty through her art. She said: 'When I think of art I think of beauty. Beauty is the mystery of life. It is not just in the eye. It is in the mind. It is our positive response to life.'

Canadian-born Martin moved to the United States in 1931. Her work became abstract after 1947, and while the spareness of her work has meant that she is often described as a Minimalist, she maintained that she was an Abstract Expressionist. She is recognized for her pared-down mixed-media works, often featuring precise grids and stripes. *Homage to Greece* is one of the first of her grid works. From the 1940s onwards doctrines of Taoism and Zen Buddhism influenced her strongly, and she was also interested in the philosophy and culture of ancient Greece.

Aiming to capture a sense of infinite space, the tranquil work opposite is informed directly by classical Greece, focusing on harmony and beauty. She created the grid by carefully overlapping painted canvas squares and sticking them on to board. Then she hammered in a roughly horizontal line of nails across the top half of the work. Martin's rejection of recognizable forms and her acute reduction of compositional elements in this work demonstrate how she was aiming to capture infinite space.

AGNES MARTIN

After emigrating to the United States from Canada in 1931, Agnes Martin studied education in Washington DC before moving to New York and beginning to paint. There she befriended other emerging artists, including Sol LeWitt (1928–2007). In the 1940s she began investigating Taoism and Buddhism. In 1958 she had her first solo show, at the Betty Parsons Gallery in New York, and from 1968 she lived alone in New Mexico.

STRIVING FOR EQUALITY **p.172** INDEPENDENCE **p.176** A FEMALE VIEWPOINT **p.187** ABSTRACT ART **p.190** INDIVIDUALITY **p.207** EMPATHY **p.217**

Untitled

1962

MIRA SCHENDEL: OIL ON CANVAS • 74.9 X 74.7 CM (29½ X 29⅜ IN)
MUSEUM OF FINE ARTS, HOUSTON, TEXAS, USA

OTHER KEY WORKS

Untitled, from Droguinhas (Little Nothings), c.1964–66, Museum of Modern Art, New York, USA

Little Train, 1965, Museum of Modern Art, New York, USA

Untitled, from Graphic Objects, 1967, Museum of Modern Art, New York, USA

MIRA SCHENDEL

Baptized and raised a Catholic, Swiss-born Mira Schendel was stripped of her Italian citizenship in 1938 and forbidden to continue her philosophy studies because of her Jewish heritage. Forced to leave Italy, she travelled through Switzerland and Austria, then settled in Sarajevo, Yugoslavia. In 1949 she emigrated to Brazil, where she met many other émigré intellectuals, studied life drawing and sculpture, and created paintings and ceramics.

One of Latin America's most prolific post-war artists, Mira Schendel (1919–1988) associated with philosophers and poets, and explored their theories through her art.

Schendel's long letters to acquaintances and intellectuals reveal her intense interest in theology, metaphysics, philosophy and Zen Buddhism. Using language, voice, words and gestures, she created drawings, monotypes, oil paintings, watercolours and three-dimensional objects, exploring how we understand one another and the world around us through various means of communication.

Schendel created the painting opposite during a period of intense activity in the early 1960s. Comprising four triangles, three painted ochre and one painted black, the apparently simple composition has some subtle additions. For instance, in the light brown areas, she stippled the paint to create the effect of a slightly rough texture that contrasts with the smooth, flat black triangle. One area of painting that interested her was the organic aspects of the materials she used. The geometric and fluid elements and the rigid shapes and textured paint convey similarities and differences, echoing contrasts and affinities in life and, more specifically, between the artist and the viewer. The work seeks to suggest various ideas, from the ways in which we communicate, to contrasts between our perceptions, to religious experiences and painting processes.

CONCEPTUAL ART **p.39**

The Bay

HELEN FRANKENTHALER: ACRYLIC ON CANVAS • 205.1 X 207.6 CM
(80¾ X 81¾ IN) • DETROIT INSTITUTE OF ARTS, MICHIGAN, USA

1963

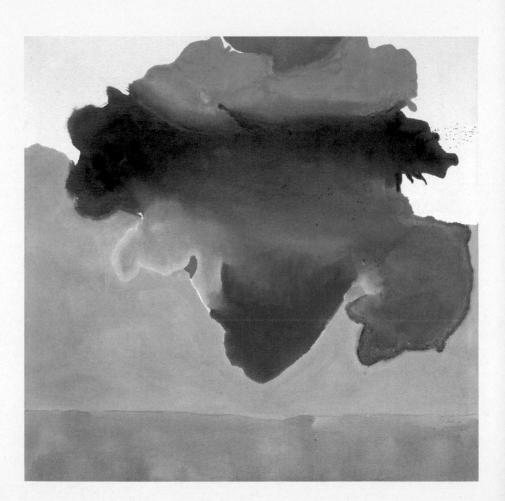

In October 1952 Helen Frankenthaler (1928–2011) poured diluted oil paint from cans directly on to a canvas she had tacked to her studio floor. The resulting painting became the first of her influential 'soak-stain' works.

Frankenthaler later used diluted acrylic paint rather than oils, as in the painting opposite, where the spontaneous, translucent, veil-like composition vaguely references the real world. Although she relied on the element of chance, she nonetheless had in mind an overall appearance that avoided emotional or personal content. The vivid colours soaked into the canvas and merged, blue to violet, indigo to navy and several greens, seeping, pooling and creating shapes that emphasize the flatness of the canvas and the properties of the paint itself; the work is not an illusion. However, because the chance shapes and colours suggest realistic elements, Frankenthaler named the work after something that it vaguely resembles.

Frankenthaler's friend the art critic Clement Greenberg (1909–1994) believed that more art should be abstract so as to express some of the difficult emotions and attitudes that had developed after the trauma of World War II. Frankenthaler also believed that viewers could respond more broadly and individually to abstract art than to figurative art. She later explained: 'These are colours and the question is what are they doing with themselves and with each other? Sentiment and nuance are being squeezed out.'

OTHER KEY WORKS

Mountains and Sea, 1952, National Gallery of Art, Washington DC, USA

Tutti Frutti, 1966, Albright-Knox Art Gallery, New York, USA

Western Dream, 1967, Metropolitan Museum of Art, New York, USA

HELEN FRANKENTHALER
From the age of 15, New York-born Helen Frankenthaler studied with artists including Rufino Tamayo (1899–1991), Paul Feeley (1910–1966) and Hans Hofmann. After visiting Nova Scotia in 1952, she pioneered her soak-stain technique, working on the floor and using window wipers and sponges to manipulate her paint. She also experimented with printmaking and with clay and steel sculpture, and designed sets and costumes for the English Royal Ballet.

INDEPENDENCE **p.176** A FEMALE VIEWPOINT **p.187** CHANGING OPINIONS **p.189** ABSTRACT ART **p.190** NATURE **p.206** INDIVIDUALITY **p.207** THE ENVIRONMENT **p.215**

Untitled, *or* Not Yet

1966

EVA HESSE: NETS, POLYETHYLENE, PAPER, LEAD WEIGHTS AND CORD
180.3 X 39.4 X 21 CM (71 X 15½ X 8¼ IN) • SAN FRANCISCO MUSEUM
OF MODERN ART, CALIFORNIA, USA

Fascinated by the psychological explorations of Surrealism and determined to create art that could not be translated literally or aligned with political ideas, the German-born American artist Eva Hesse (1936–1970) made reliefs and sculptural works with both industrial and everyday materials, such as rope, string, wire and paper.

Creating tension through the inclusion of opposites, Hesse said she wanted to achieve a kind of 'non-art' in her work: 'It has to do with contradictions and oppositions. In the forms I use in my work, the contradictions are certainly there. I was always aware that I should take order versus chaos, stringy versus mass, huge versus small, and I would try to find the most absurd opposites or extreme opposites … I was always aware of their absurdity and also their formal contradictions and it was always more interesting than making something average.'

As a young Jewish child when Nazism was prevailing, Hesse escaped from Germany when very young, ultimately to America. She studied painting and commercial design and painted at first in an Abstract Expressionist style. The work opposite, comprising lead weights inside net bags hanging on a wall, is one of several that she called 'Nothings'. She intended it to initiate questions about what constitutes a work of sculpture, and to inspire thoughts about art in general, including the artist's hand, positivity and negativity, and purpose and expectations.

EVA HESSE

At the age of 2 Eva Hesse escaped persecution in Nazi Germany via the Kindertransport. Her family settled in America, but her mother committed suicide, an event that traumatized Hesse. Later she studied at the Pratt Institute of Design, the Art Students League, the Cooper Union Art School and the Yale School of Art and Architecture. Although she spent most of her life in America, during her marriage, from 1964 to 1965, she lived in Germany.

OTHER KEY WORKS

Repetition Nineteen III, 1968, Museum of Modern Art, New York, USA

Sans II, 1968, San Francisco Museum of Modern Art, California, USA

Accession II, 1969, Detroit Institute of Arts, Michigan, USA

ABSTRACT EXPRESSIONISM **p.33** CONCEPTUAL ART **p.39**

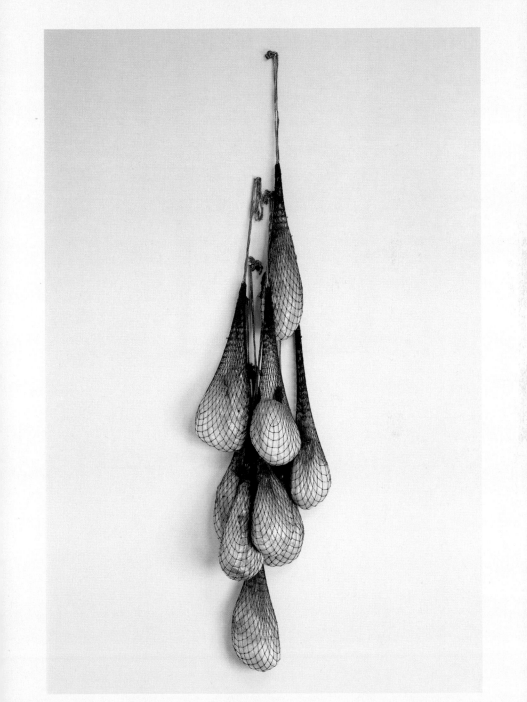

Three figures from Family of Man

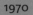
1970

BARBARA HEPWORTH: BRONZE • VARIOUS HEIGHTS, TALLEST 276.9 CM (109 IN) SNAPE MALTINGS, SUFFOLK, UK

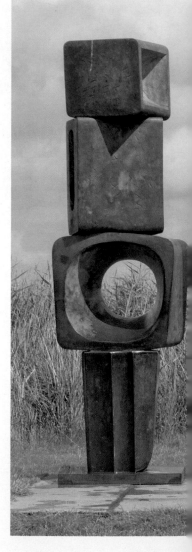

Also known as *Nine Figures on a Hill*, this is part of one of the last major works created by the British sculptor Barbara Hepworth (1903–1975).

Shown here are three of the nine bronze sculptures that represent stages of human life and beyond: Ancestor 2, Ancestor 1 and Parent 2. While each sculpture resembles the others to a certain extent, as in a human family, they are all abstract forms, also inspired by the land. Beginning with Youth and Young Girl, the compositions become more sophisticated as they mature. The forms resemble totems, and influence their surrounding environment, while holes and cavities invite space into and through them. Hepworth said she wanted them to appear as if they had 'risen out of the ground' like geological formations, and to convey a universal expression of human life.

Hepworth was always interested in connections within families. After moving to Cornwall in 1939, she began producing sculpture that expressed her fascination with what she called 'the Pagan landscape' around Land's End, where standing stones had both strong sculptural qualities and a spiritual presence. She stated that she rarely recreated what she saw, but expressed what she felt, an approach that evolved out of her interest in Christian Science and its belief in the spiritual over the material. This work also draws on Hepworth's own experiences as a mother, a sculptor and a wife.

OTHER KEY WORKS

Large and Small Form, 1934, Tate Britain, London, UK

Pelagos, 1946, Tate Britain, London, UK

Curved Forms (Pavan), 1956, Barbara Hepworth Museum and Sculpture Garden, St Ives, Cornwall, UK

BARBARA HEPWORTH

Throughout a career lasting five decades, Barbara Hepworth focused on nature. She grew up in Yorkshire, England, attended Leeds School of Art and the Royal College of Art, then spent two years in Italy, where she began using the then little-used practice of direct carving. Later she lived and worked in Cornwall, and after she met Ben Nicholson (1894–1982) in 1931 (they would marry in 1938), the two artists developed their work towards the abstract.

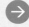

Springtime in Washington

1971

ALMA THOMAS: ACRYLIC ON CANVAS • 121.9 X 121.9 CM (48 X 48 IN)
PRIVATE COLLECTION

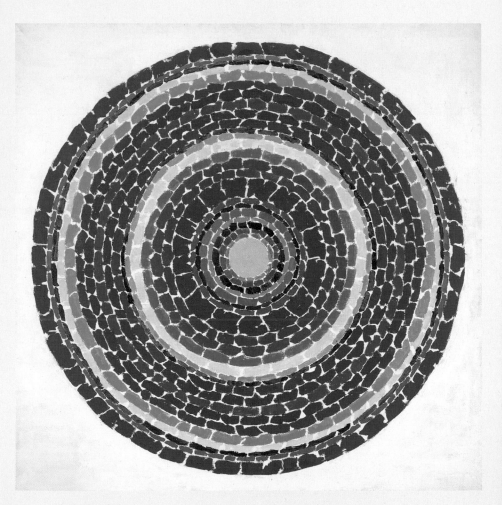

ABSTRACT EXPRESSIONISM **p.33**

Inspired by the formal gardens of Washington DC, this vividly coloured work by Alma Thomas (1891–1978) corresponds with Colour Field paintings in conveying and invoking emotion through colour and shape. However, Thomas deviated from other Colour Field art in that she often hints at elements of the real world.

Spending most of her career painting in and near Washington DC, Thomas frequently focused on the flowers and plants in the city's parks and gardens. This is one of several of those paintings, where she concentrated on the bright plants that were grown in the city's many traffic circles. Creating an imaginary panorama viewed from above, these colourful rings allude to reality without trying to depict it. Most other Colour Field painters minimized their personal involvement by pouring paint or painting rigid geometric forms, but Thomas applied energetic, irregular brushstrokes, creating uneven shapes as she made this radiating composition.

As a black woman artist, Thomas encountered many obstacles in her career. Nonetheless, believing that the creative spirit is independent of race or gender, she did not turn to racial or feminist subjects in her work. Reflecting on the fact that most other black artists working during the civil rights era produced art that represented aspects of African-American struggles, she said: 'Through colour, I have sought to concentrate on beauty and happiness, rather than on man's inhumanity to man.'

OTHER KEY WORKS

Iris, Tulips, Jonquils and Crocuses, 1969, National Museum of Women in the Arts, Washington DC, USA

Starry Night and the Astronauts, 1972, Art Institute of Chicago, Illinois, USA

Elysian Fields, 1973, Smithsonian American Art Museum, Washington DC, USA

ALMA THOMAS

In 1924 the American artist Alma Thomas became the first graduate of Howard University's newly formed art department. Later, she obtained an MA in education from Columbia University. In Washington DC, where she lived, taught and painted from 1921, she became identified with Colour Field painters. In 1972 she became the first African-American woman to have a solo exhibition at the Whitney Museum in New York.

→ VOCATION **p.182** CHANGING OPINIONS **p.189** THE SENSES **p.202** NATURE **p.206** MEMORY **p.210**

The Dinner Party

1974
–
1979

JUDY CHICAGO: CERAMIC, PORCELAIN, TEXTILE • 14.6 X 14.6 M
(48 X 48 FT) • BROOKLYN MUSEUM, NEW YORK, USA

Aiming to improve female artists' experiences, Feminist Art was pioneered in the 1970s by several women artists, and predominantly by Judy Chicago (b.1939), who invented the term.

Incorporating stereotypical female skills such as needlework alongside typical male pursuits such as welding and pyrotechnics, Chicago creates art that focuses specifically on female-orientated themes, most famously in *The Dinner Party*, which celebrates the achievements of women throughout history. She worked with artisans – more than 400 people over six years – to make the installation, creating such things as ceramic decorations and embroidery. However, soon after it was made, it was rejected as offensive by critics, and by many women, who said that Chicago's overriding representation of female achievement was the vagina. The work was consequently stored away for nearly 30 years.

This was a blow, as Chicago's aim had been to celebrate the richness of women's heritage, after history had marginalized them. The 39 main women included in the work are arranged in three groups of thirteen, the number of people who were present at the Last Supper, where there were only men. The first side of the triangular table (far right) features goddesses from prehistory until the time of the Roman Empire; the second (near right) covers the rise of Christianity and ends with the Reformation; and the third (top) represents the Age of Revolution and ends with Georgia O'Keeffe.

JUDY CHICAGO

Born in Chicago, Judith Cohen later changed her name to detach herself from patriarchal convention. After studying painting and sculpture at the University of California in Los Angeles, in 1971 she ran a women-only art course with the artist Miriam Schapiro in California. From this emerged Womanhouse, where women could teach, perform, exhibit and discuss. In 1973 Chicago established the Feminist Studio Workshop in Los Angeles.

OTHER KEY WORKS

Earth Birth, 1983, Brooklyn Museum, New York, USA

Power Headache, 1984, Brooklyn Museum, New York, USA

Rainbow Shabbat, 1992, Brooklyn Museum, New York, USA

The Advantages of Being a Woman Artist

1988

GUERRILLA GIRLS: SCREENPRINT ON PAPER • 43 X 56 CM (17 X 22 IN)
TATE MODERN, LONDON, UK

OTHER KEY WORKS

Dearest Art Collector, 1986, Tate Modern, London, UK, and Walker Art Center, Minneapolis, Minnesota, USA

Do Women Have to Be Naked to Get into the Met. Museum?, 1989, Tate Modern, London, UK, and Walker Art Center, Minneapolis, Minnesota, USA

When Racism & Sexism Are No Longer Fashionable, What Will Your Art Collection Be Worth?, 1989, Tate Modern, London, UK, and Walker Art Center, Minneapolis, Minnesota, USA

GUERRILLA GIRLS

Formed in 1984 as a protest group, the Guerrilla Girls are anonymous activists who use humour and shock tactics to highlight the unconcealed discrimination in the international art world. They have targeted museums, dealers, curators and art critics, exposing gender-based and racial discrimination and using their anonymity to focus attention on their messages.

One of 30 posters published in a portfolio entitled *Guerrilla Girls Talk Back* by the group of anonymous American female artists who call themselves the Guerrilla Girls, this poster is deliberately ironic. It lists 13 points, including 'working without pressure of success', 'having the opportunity to choose between career and motherhood' and 'being included in revised versions of art history', all to raise consciousness about sexual and racial inequality in the art world.

The Guerrilla Girls formed after the 1984 International Survey of Painting and Sculpture at the Museum of Modern Art, New York, included the work of nearly 200 artists, of whom fewer than 10 per cent were women. Members of the group protect their identities by wearing gorilla masks in public and by assuming pseudonyms. In 1985 they produced posters and pasted them around the streets of SoHo in the middle of the night. The posters listed New York galleries that showed few works by women artists, and successful male artists who allowed their work to be displayed in galleries that included little or no work by women. The Guerrilla Girls soon began organizing forums, putting flyers inside all book covers in the Guggenheim Museum's bookshop and holding demonstrations. They also make presentations and run workshops, all while wearing their gorilla masks, and all aiming to highlight the intrinsic patriarchal and discriminatory traditions in the art world.

FEMINIST ART **p.37**

THE ADVANTAGES OF BEING A WOMAN ARTIST:

Working without the pressure of success
Not having to be in shows with men
Having an escape from the art world in your 4 free-lance jobs
Knowing your career might pick up after you're eighty
Being reassured that whatever kind of art you make it will be labeled feminine
Not being stuck in a tenured teaching position
Seeing your ideas live on in the work of others
Having the opportunity to choose between career and motherhood
Not having to choke on those big cigars or paint in Italian suits
Having more time to work when your mate dumps you for someone younger
Being included in revised versions of art history
Not having to undergo the embarrassment of being called a genius
Getting your picture in the art magazines wearing a gorilla suit

A PUBLIC SERVICE MESSAGE FROM **GUERRILLA GIRLS** CONSCIENCE OF THE ART WORLD

REJECTING 'WOMAN AS OBJECT' **p.173** CELEBRATING THE FEMALE **p.181**
CONTRADICTING 'THE PASSIVE SEX' **p.184** SUPPORTING OTHER FEMALE ARTISTS **p.186**

Certain Day

1989

BRIDGET RILEY: OIL ON LINEN • 165 X 227.5 CM (65 X 89⅜ IN)
PRIVATE COLLECTION

Before the 1980s, the British artist Bridget Riley (b.1931)
painted many abstract works in monochrome to generate
optical effects in the viewer's eyes, building on the idea that
new colours and dynamism can seem to appear through
lines and shapes where they are not physically present.

After one of her paintings was used for the catalogue
cover of the exhibition *The Responsive Eye* (1965), Riley's
evocations of colour and motion became among the
best-known works of Op Art. Her completely abstract
paintings have since that time consistently explored
the fundamentals of painting, including space, shape,
line and optical connections. In the 1980s, after a trip
abroad, she adopted her colourful 'Egyptian Palette', and
simultaneously reduced elements of her compositions.

With *Certain Day*, as with other paintings of the period,
Riley worked everything out meticulously with gouache
on paper, exploring colour interactions before creating
the final work in oils. Although completely abstract, the
painting evokes a hot, bright day in dazzling sunlight.
Divided vertically and diagonally, the composition appears
simple at first glance, but on closer inspection it can be
seen that the position of each colour has been considered
carefully for its similarity to or contrast with adjacent
shapes. This dynamic painting is a visual sensation with
an emphasis on rhythm and counter-rhythm, creating
effects that Riley described as 'stabilities and instabilities,
certainties and uncertainties'.

OP ART **p.34**

BRIDGET RILEY

After studying at London's Goldsmiths College and Royal College of Art, Riley produced monochrome abstract paintings. She taught art part-time and worked as a commercial illustrator at an advertising agency, and in 1962 her first solo exhibition attracted worldwide acclaim. She began using colour in 1966, was awarded the International Prize for Painting at the 1968 Venice Biennale, and adopted a brighter palette in the 1980s.

OTHER KEY WORKS

Movement in Squares, 1961, Arts Council Collection, London, UK

Arrest 2, 1965, Nelson-Atkins Museum of Art, Kansas City, Missouri, USA

Conversation, 1992, Abbot Hall Art Gallery and Museum, Kendal, UK

Ghost

1990

RACHEL WHITEREAD: PLASTER AND STEEL FRAME • 269 X 355.5 X 317.5 CM
(106 X 140 X 125 IN) • NATIONAL GALLERY OF ART, WASHINGTON DC, USA

CONCEPTUAL ART **p.39**

OTHER KEY WORKS

House, 1993 (destroyed), formerly Tate Britain, London, UK

Water Tower, 1998, Museum of Modern Art, New York, USA

Cabin, 2016, Discovery Hill, Governors Island, New York, USA

Often described as the breakthrough work of Rachel Whiteread (b.1963), *Ghost* is a plaster cast of the interior of a Victorian living room in north London.

Whiteread explained that this work makes the 'viewer become the wall', and that she intended to 'mummify the air in the room'. It was the first of several casts she produced of domestic spaces and objects, including other rooms, staircases, furniture such as tables and bookcases, and, in 1993, an entire house. All these works deal with space, opposites, comparisons, interior and exterior forms, and the existence of everyday things.

While still a student of fine art at Brighton Polytechnic in 1982–85, Whiteread learned the casting technique from the sculptor Richard Wilson (b.1953). She created *Ghost* over three months in an abandoned house, covering the interior walls of the living room with thick plaster moulds. When the plaster dried, she peeled the moulds from the walls and reassembled them on a steel frame. The cast picks up details of the walls, windows, fireplace, skirting boards, door and other aspects of the room, which, seen in this unexpected way, seem at once imposing, disconcerting, familiar and unfamiliar, tomb-like and sculptural. The massive installation presents the viewer with notions about connections and contrasts between interior and exterior spaces, proportion, and the similarities and differences between sculpture and architecture.

RACHEL WHITEREAD

After studying fine art, Rachel Whiteread trained in sculpture at the Slade School of Fine Art in London. In 1988 she had her first solo exhibition, and five years later she was the first woman to be awarded the prestigious Turner Prize. In 1995 her work was shown at the Venice Biennale, as a result of which she was commissioned to produce a memorial to the Holocaust in Vienna.

INDEPENDENCE **p.176** CHANGING OPINIONS **p.189** HISTORY **p.201** HERITAGE **p.205** MEMORY **p.210** TRANSFORMATION **p.213**

The Wounded Shooting Star (L'Estel Ferit)

1992

REBECCA HORN: STEEL, IRON, GLASS AND CONCRETE • HEIGHT 10 M (32¾ FT) • PASSEIG MARÍTIM DE LA BARCELONETA, BARCELONA, SPAIN

OTHER KEY WORKS

Einhorn (Unicorn), 1970–72, Tate Modern, London, UK

Concert for Anarchy, 1990, Tate Modern, London, UK

Tower of the Nameless, 1994, Naschmarkt, Vienna, Austria

Nicknamed 'The Cubes' by local residents, this massive installation was created by Rebecca Horn (b.1944) in Spain during the period leading up to the 1992 Olympic Games.

Four steel-and-glass cubes are stacked and twisted seemingly at random, rising from a concrete base set in the sand. It is one of several sculptures that were installed along the waterfront in Barcelona during the Olympics build-up. Some believe it references the run-down *chiringuitos* (beach bars) and seafood stalls that stood in La Barceloneta, Barcelona's fishing district, before the area was refurbished for the Games, while others maintain that it echoes the tiny apartments that were built in the area during the early years of the twentieth century. Representing a wounded star that has fallen from the sky, the sculpture with its large windows also resembles an abandoned, unstable tenement block set against the sea.

Having moved to Barcelona from her native Germany, Horn fell seriously ill with lung poisoning in 1964 after working with fibreglass without a mask in an unventilated workshop. She spent a year in hospital, during which time both her parents died. The illness and isolation she suffered had a profound influence on her artistic development, and it has been suggested that the title of this work refers to her own feelings in Barcelona during that time.

REBECCA HORN

Born during World War II in Michelstadt, Germany, Rebecca Horn first studied economics and philosophy, before transferring to the Hamburg Academy of Fine Arts in 1964. She began making large sculptures using mainly polyester and fibreglass. In 1972 she was the youngest artist to show at *Documenta 5*, and soon afterwards she moved to New York, where she remained for nine years, producing films and her first mechanical sculptures.

FEMINIST ART **p.37** PERFORMANCE ART **p.38**

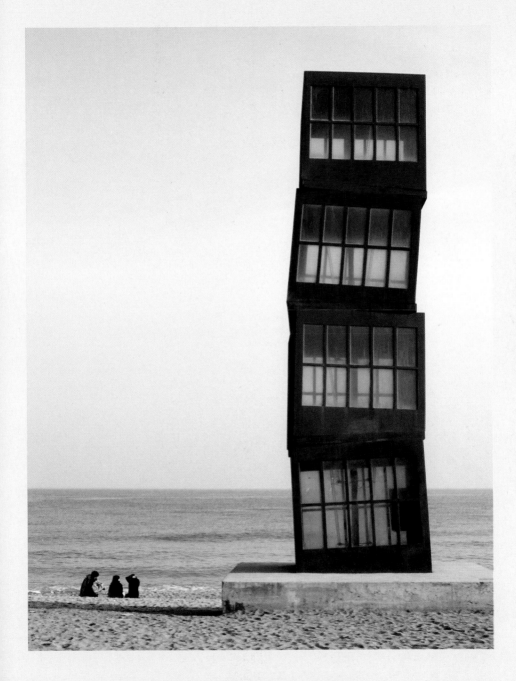

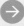

Plan

1993

JENNY SAVILLE: OIL ON CANVAS • 274 X 213.5 CM (108 X 84 IN)
PRIVATE COLLECTION

JENNY SAVILLE
Known best for large paintings of women's bodies, Jenny Saville was born in Cambridge, England, and obtained an art degree from Glasgow School of Art. While there, she was awarded a six-month scholarship by the University of Cincinnati. The businessman and art dealer Charles Saatchi (b.1943) subsequently offered her a contract to paint more. She was included in the Young British Artists' exhibitions, and catapulted to international fame in the 1990s.

This foreshortened nude is a self-portrait by Jenny Saville (b.1970) with exaggerated elements. She later reflected: 'When I made *Plan* [showing the lines drawn on a woman's body to designate where liposuction would be performed] I was forever explaining what liposuction was. It seemed so violent then. These days, I doubt there's anyone in the western world who doesn't know what liposuction is.'

In the year she began the work, Saville had observed a New York plastic surgeon in the operating theatre, and she subsequently began painting women with surgical markings on the contours of their bodies so that they resembled topographical maps. She painted this work while she was still a student at the Glasgow School of Art, and it won the highest award that could be given to a Glasgow student: the Newbery Medal. Massive and fleshy, the figure contrasts markedly with the traditional male representation of the female form. Thick impasto and fluid paint with subtle changes of colours create the appearance of mottled flesh. Saville said: 'The lines on her body... look like targets. I like this idea of mapping the body, not necessarily areas to be cut away, but like geographical contours on a map.'

OTHER KEY WORKS
Branded, 1992, Private Collection
Propped, 1992, Private Collection
Torso, 2004, Saatchi Gallery, London, UK

CONCEPTUAL ART **p.39**

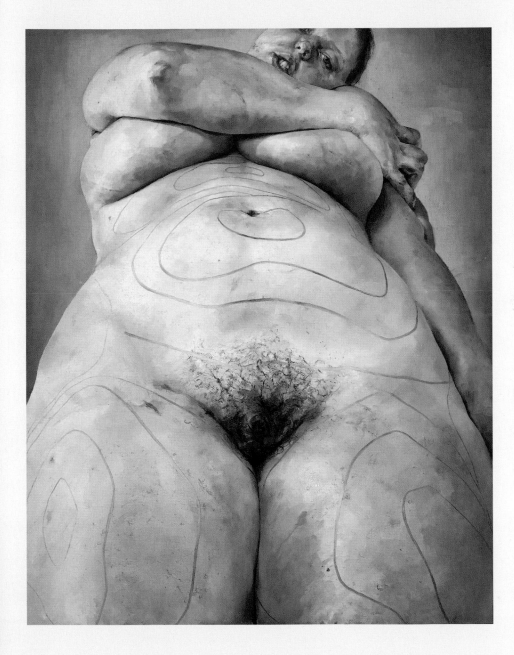

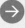

Dancing Ostriches from Disney's 'Fantasia'

1995

PAULA REGO: PASTEL ON PAPER MOUNTED ON ALUMINIUM • 150 X 150 CM
(59 X 59 IN) • PRIVATE COLLECTION

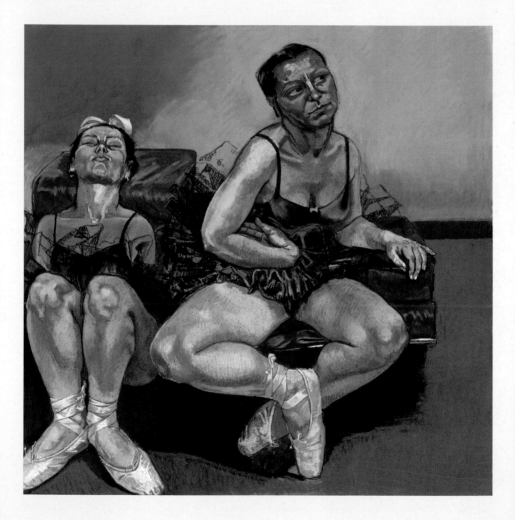

FEMINIST ART **p.37**

OTHER KEY WORKS

The Policeman's Daughter, 1987, Saatchi Gallery, London, UK

The Dance, 1988, Tate Modern, London, UK

War, 2003, Tate Modern, London, UK

Opposite is the left panel of a triptych by Paula Rego (b.1935) that was commissioned for the exhibition *Spellbound* at the Hayward Gallery in London in 1996.

The triptych was inspired by Walt Disney Studio's *Fantasia* (1940), and was Rego's response to the centenary of cinema in Britain. One of several artists commissioned for the occasion, she had at that point been captivated by the immediacy of pastels for about a year, and fascinated by Disney films since childhood. Drawing from her memory along with direct observation, Rego replaced the animals in the Disney film with robust, clumsy-looking women who challenge the traditional idealizations of women's bodies that are seen in art, cinema in general and specifically Disney cartoons.

Lila Nunes, one of the models, has worked with Rego since she was first employed to nurse Rego's husband, Victor Willing (1928–1988), in 1985. Since then she has modelled for several of Rego's paintings, and for this series she sat in various poses, from which Rego drew her finished pictures. Using Nunes for all eight of her ostrich women enabled Rego to convey a variety of positions and emotions, while retaining similarities and connections between the figures; they could be the same person, or they might be different. As in most of her works, Rego presents these figures in varying proportions, and each seems awkward, ungainly and self-conscious.

PAULA REGO

After growing up in Portugal, Paula Rego attended the Slade School of Fine Art in London and exhibited with the London Group. In 1988 she was the subject of a retrospective exhibition at the Calouste Gulbenkian Foundation, Lisbon, and the Serpentine Gallery in London. In 1989 she was shortlisted for the Turner Prize, and in 1990 she was invited to be the first artist in residence at London's National Gallery.

VOCATION **p.182** CONTRADICTING 'THE PASSIVE SEX' **p.184** A FEMALE VIEWPOINT **p.187** ASSERTIVENESS **p.191** IDENTITY **p.199** INDIVIDUALITY **p.207** BODY IMAGE **p.208**

Retopistics: A Renegade Excavation

JULIE MEHRETU: INK AND ACRYLIC ON CANVAS • 260 X 530 CM (101½ X 208½ IN)
CRYSTAL BRIDGES MUSEUM OF AMERICAN ART, BENTONVILLE, ARKANSAS, USA

OTHER KEY WORKS

Stadia II, 2004, Carnegie Museum, Pittsburgh, Pennsylvania, USA

Middle Grey, 2007–09, Solomon R. Guggenheim Museum, New York, USA

Haka (and Riot), 2019, Private collection

Layered colourful lines, shapes and other graphic marks in ink and acrylic paint were worked across the vast painting shown here and overleaf to evoke the sense of a busy public space.

For this work, Julie Mehretu (b.1970) was inspired by dynamic places such as airports and railway stations, where emotional, personal partings and meetings often occur in the midst of intense public activity. In her practise, she observes, then collects and uses the information to convey some of the diverse interactions she has seen while considering the social, physical and technological environments. She has said that her compositions are intended 'to be felt as much as read'. Despite their apparent spontaneity, all her marks are carefully considered and placed in specific ways to create a complex, multifaceted landscape of differences, affiliations and disconnections. Each mark has its own unique pattern and purpose. Sweeping or short layered lines, curves and squiggles evoke the multitude of individual stories that occur wherever many people are gathered, and this conveys the impression that everything

Detail: Despite their apparent freedom, Mehretu's marks are carefully considered; some imply action, while others are free, calm or explosive.

Detail: Each mark has its own unique pattern and purpose, its own place in the landscape. The colourful lines, streaks and arcs are layered over architectural drawings that are based on blueprints and plans of buildings and structures around the world.

Detail: Mehretu wanted this image to appear dynamic and busy from a distance, featuring various layers and suggesting locations we are all familiar with, but on closer study to break up into smaller, more individual areas featuring different levels of action and interaction.

is evolving, moving and interacting with everything else. Different thicknesses of line, layers of colour and types of mark all portray aspects of the environments that Mehretu sees and subsequently represents in abstract form to convey feelings, activities, emotions and diversifications rather than actual figures and objects. Marks, smudges, flicks and arcs are sometimes heavy, sometimes fragile. As in any public space, there is a rhythm because everything is in a state of flux, continuously moving, like a huge, multilayered pattern. With no single focal point, the composition draws the viewer's eyes in, around, across, through and back again. Mehretu said: 'I wanted *Retopistics* to be made of the conglomerate of all airport plans,' and stated that her aim 'is to have a picture that appears one way from a distance, almost like a cosmology, city or universe from afar – but then when you approach the work, the overall image shatters into numerous other pictures, stories and events'.

JULIE MEHRETU
Born in Addis Ababa, Ethiopia, Julie Mehretu lives and works in New York City and Berlin. She studied at the Rhode Island School of Design and has won many awards for her art, including the MacArthur Award (2005) and the US Department of State Medal of Arts Award (2015). She shows her work extensively and is represented in public and private collections around the world.

→ VOCATION **p.182** CONTRADICTING 'THE PASSIVE SEX' **p.184** ABSTRACT ART **p.190**
THE ENVIRONMENT **p.215** EMPATHY **p.217**

Giant Crouching Spider

2003

LOUISE BOURGEOIS: BRONZE AND STAINLESS STEEL • 2.7 X 8.4 X 6.3 M
(8.9⅞ X 27⅖ X 20⅗ FT) • CHÂTEAU LA COSTE ART CENTRE, PROVENCE, FRANCE

With a bulbous, egg-shaped body and long, attenuated legs, this is one of several spider sculptures made by Louise Bourgeois (1911–2010), who explained that the spider was a reference to her industrious, protective mother.

Bourgeois said: 'The spider is an ode to my mother. She was my best friend. Like a spider, my mother was a weaver. My family was in the business of tapestry restoration, and my mother was in charge of the workshop. Like spiders, my mother was very clever … spiders are helpful and protective, just like my mother.' While emphasizing the positive traits of spiders, Bourgeois also acknowledged their more usual menacing associations in the dark, towering structure and sharply pointed feet.

From a young age, Bourgeois helped her parents in their workshop, acquiring a technical dexterity with dyes and fabrics that helped her later as an artist. Her first image of a spider was a small charcoal-and-ink drawing that she made in 1947, and decades later, when she was in her eighties, she began creating spider sculptures, associating the arachnid's strengths with her mother, who had died in 1932, when Bourgeois was 21. The grief she felt over her mother's death, as well as her father's adulterous affair with her English tutor, affected her intensely. From then on all her art explored such things as loneliness, betrayal, danger, passion and vulnerability.

LOUISE BOURGEOIS

With a career that spanned most of the twentieth century, Bourgeois influenced Feminist and Installation Art in the 1960s. She was born in Paris and first studied mathematics, but after her mother's death she studied art at several schools, including the École des Beaux-Arts, the Académie Ranson, the Académie Julian and the Académie de la Grande-Chaumière. She joined the Surrealist movement briefly before emigrating to the United States in 1938.

SURREALISM **p.30** FEMINIST ART **p.37** CONCEPTUAL ART **p.39**

OTHER KEY WORKS

Dagger Child, 1947–49, Solomon R. Guggenheim Museum, New York, USA

Quarantania, 1947–53, Museum of Fine Arts, Houston, Texas, USA

The Nest, 1994, San Francisco Museum of Modern Art, California, USA

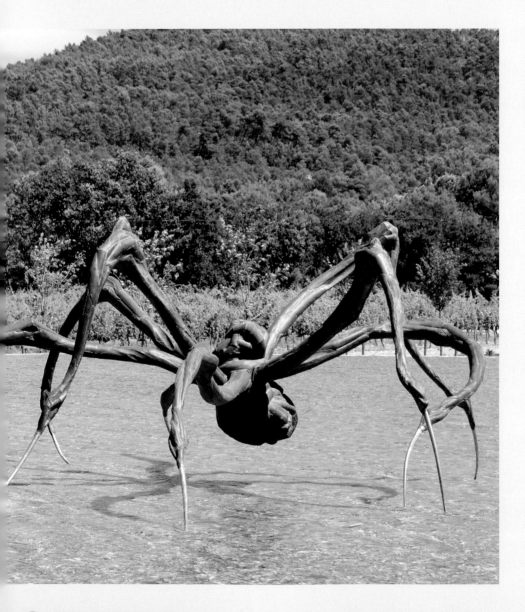

Picturesque (Panel III: Of Your)

2006

KARA WALKER: CUT PAPER ON WOOD PANEL • 5 PANELS, 121.9 X 153 CM (48 X 60¼ IN) EACH • PRIVATE COLLECTION

OTHER KEY WORKS

Gone: An Historical Romance of a Civil War as It Occurred b'tween the Dusky Thighs of One Young Negress and Her Heart, 1994, Museum of Modern Art, New York, USA

The End of Uncle Tom and the Grand Allegorical Tableau of Eva in Heaven, 1995, Modern Art Museum of Fort Worth, Texas, USA

A Subtlety, or the Marvellous Sugar Baby, 2014, Domino Sugar Plant, Williamsburg, Virginia, USA

KARA WALKER

A Californian painter's daughter, Kara Walker makes silhouettes and works as a painter, printmaker, sculptor, installation artist and film-maker. She attended Atlanta College of Art and Rhode Island School of Design, and became one of the youngest recipients of the MacArthur Foundation grant. She has taught at Columbia University and Rutgers University. In 2018 she was elected to the American Philosophical Society.

Famous for her use of the Victorian medium of cut-paper silhouettes to address subjects including race, gender, sexuality, slavery, violence and black history, Kara Walker (b.1969) creates disconcerting images that have provoked various reactions, from critical acclaim to shock.

Walker's use of these huge, intricate silhouettes began in 1994, while she was still a student, and aimed to convey uncomfortable truths, primarily about racism, in a blatant way. Referring to black memorabilia, historical novels, films, cartoons and old advertisements, her provocative images confront racial myths and stereotyping. The fluidly contoured images seen here make up the third panel of a five-panel work that explores a fantasy slave plantation invented by Walker. Intentionally encouraging viewers to add to the story, she created a deliberately incoherent narrative. For instance, here, a young (black) woman is seemingly sinking into the ground under the weight of either an entire (white male) figure or just a pair of (male) legs. Out of scale – or far in the distance – two tiny children appear to be labouring. Like most of Walker's silhouettes, the artwork alludes to the horror of racial inequality.

CONCEPTUAL ART **p.39**

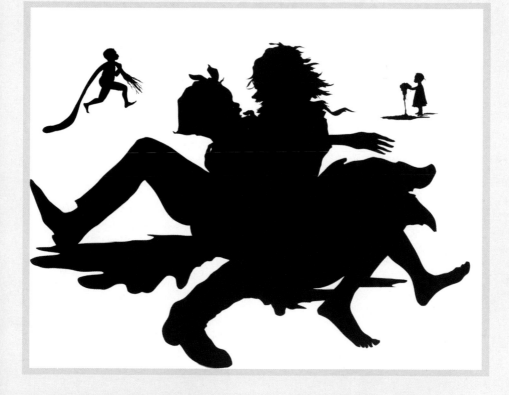

Nature morte aux grenades

MONA HATOUM: CRYSTAL, MILD STEEL AND RUBBER • 95 X 208 X 70 CM (37⅜ X 81⅝ X 27⅝ IN) • DALLAS MUSEUM OF ART, TEXAS, USA

OTHER KEY WORKS

Roadworks, 1985

Light Sentence, 1992

Remains to Be Seen, 2019

FEMINIST ART **p.37** PERFORMANCE ART **p.38**

MONA HATOUM

After studying at Beirut University College, Mona Hatoum travelled to London in 1975. When the Lebanese civil war broke out, she remained in London, enrolling at the Byam Shaw School of Art and the Slade School of Fine Art (University College London). She has held several artist's residencies internationally, and has taught part-time in London, Cardiff, Maastricht and Paris.

Often exploring themes of war, exile and violence, Mona Hatoum (b.1952) has produced videos, performances, photography, sculpture and installations.

This work takes its title from a 1947 still-life painting by Henri Matisse (1869–1954) that features pomegranates and other fruit on a table. However, Hatoum plays with the French word *grenade*, which means both pomegranate and grenade. Here the brilliantly coloured glass objects allude to both the innocent subject of fruit in traditional still lifes and the glamorization of lethal weapons in popular culture. The transformation of shiny, colourful ornaments or still-life fruits into deadly weapons evokes various ideas about both art and life.

While Beirut-born Hatoum was on a visit to England in 1975, civil war broke out in her home country, forcing her to remain in London. The notion of weapons and their fatal consequences is therefore personal to her. Meanwhile, the stainless-steel table recalls a surgical trolley or an embalming table on which surgical instruments are placed. Hatoum's 'grenades' were made in collaboration with skilled Italian glassmakers, a fact that draws attention to the reduction in demand for indigenous crafts across the world and the difficulties that many craftspeople face. This multifaceted work alludes to many things, including displacement caused by war, financial and political struggle, similarities and differences, and life and death.

VOCATION **p.182** CONTRADICTING 'THE PASSIVE SEX' **p.184** CHANGING OPINIONS **p.189**
ASSERTIVENESS **p.191** INDIVIDUALITY **p.207** CONFRONTATION **p.211** CONFLICT **p.216** EMPATHY **p.217**

Invasion *from the series* House Beautiful: Bringing the War Home, New Series

2008

MARTHA ROSLER: PHOTOMONTAGE • MITCHELL-INNES & NASH, NEW YORK, USA; GALERIE NAGEL DRAXLER, COLOGNE AND BERLIN, GERMANY

During the 1960s the American artist Martha Rosler (b.1943) began making political photomontages that protested about the Vietnam War.

The photomontage series *House Beautiful: Bringing the War Home* (c.1967–72), which places scenes of war amid luxurious American domestic interiors, became among Rosler's best-known works. In addressing a range of political and social concerns, such as war and feminist issues, using a variety of media including video, photography, installation, performance and text, Rosler's art and activism are interwoven. Her astute, sardonic approach has been highly influential. In 2004, during the US presidential election, and in response to the Iraq War, she created a new series of *Bringing the War Home* images, which she continued in 2008. The work shown here, *Invasion*, is part of that series. Set against an orange and yellow explosion, army tanks advance. Walking in the same direction is an army of immaculate male models, all tall and slim, dressed in dark suits, white shirts, shiny shoes and narrow ties, their hair slicked back, their faces inscrutable.

Unlike Rosler's earlier series, this one comprises large, vibrantly coloured, digitally printed images. She reflected that although she was revisiting something she had created 30 years earlier, she wanted to make the point that for all the differences, the Iraq War followed the same scenario as the Vietnam War. 'We haven't advanced at all in the way we go to war,' she said.

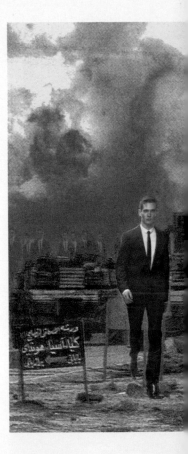

CONCEPTUAL ART **p.39**

MARTHA ROSLER

In New York, where she grew up, and California, where she attended graduate school, Martha Rosler participated in civil rights and anti-war protests. She graduated from the University of California, San Diego, in 1974. From the start of her career she has aimed to raise consciousness of a variety of social issues. She has lectured and taught extensively, her writing has been widely published and her work has been recognized with numerous prizes.

OTHER KEY WORKS

Body Beautiful, or *Beauty Knows No Pain*, c.1966–72

The Bowery in Two Inaccurate Descriptive Systems, 1974/75

Prototype (God Bless America), 2006, MACBA, Barcelona, Spain

Aftermath of Obliteration of Eternity

2009

YAYOI KUSAMA: WOOD, MIRROR, PLASTIC, ACRYLIC PANEL, LED AND ALUMINIUM INSTALLATION • 4.2 X 4.2 X 2.9 M (13⅗ X 13⅗ X 9⅗ FT)
MUSEUM OF FINE ARTS, HOUSTON, TEXAS, USA

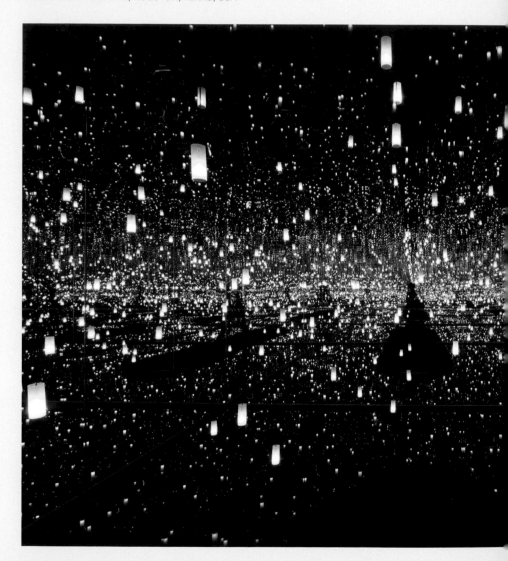

POP ART **p.35** FEMINIST ART **p.37** CONCEPTUAL ART **p.39**

OTHER KEY WORKS

No. F, 1959, Museum of Modern Art, New York, USA

My Eternal Soul series, 2009–ongoing, various locations

All the Eternal Love I Have for the Pumpkins, 2016, various locations

YAYOI KUSAMA

Japan's best-known contemporary artist, Yayoi Kusama was born in Matsumoto City and studied painting in Kyoto before moving in the 1950s to New York, where she struggled as an Asian female artist in a Western male-dominated environment. However, by the mid-1960s she had become known in the avant-garde world for her provocative happenings and exhibitions. Kusama represented Japan at the 45th Venice Biennale in 1993, and she currently lives and works in Tokyo.

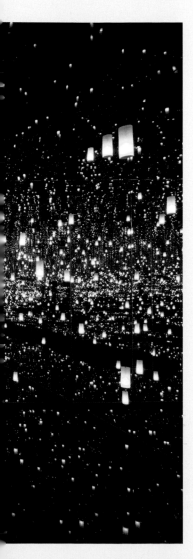

From a central platform, the viewer is gradually surrounded by an array of lights that quickly disappear. Yayoi Kusama (b.1929) created this installation in 2009 to express her beliefs about life, death and infinity.

Building on her fascination with the idea of our assimilation into infinity she has the viewer step into the room and stand on the central platform, where gradually a delicate, glittering illusion emerges, as myriad small lights, some real, some reflected, illuminate around the space. Within a minute, all the lights extinguish, and then the cycle begins again. Kusama explained: 'Life is what I always try to understand; its depths and its mystique of rise and fall … From day to day, I understand the greatness brought by this mystique as well as that love is eternal and keeps appearing and disappearing … I am very pleased to be alive … and [to have] been able to reach today. We keep flashing, disappearing, and again blossoming out in this Eternity.'

For many years Kusama has created environments that seek to disorientate or provoke intense feelings in the viewer, frequently incorporating mirrors, lights and repetitive elements. This work also refers to the hallucinations she has experienced since childhood. In creating this environment, she paid particular attention to the use of mirrors, in order to create the illusion that the lights continue endlessly.

INDEPENDENCE **p.176** CONTRADICTING 'THE PASSIVE SEX' **p.184** CHANGING OPINIONS **p.189** IDENTITY **p.199** THE SENSES **p.202** MEMORY **p.210** TRANSFORMATION **p.213** THE ENVIRONMENT **p.215**

The Artist Is Present

2010

MARINA ABRAMOVIĆ: PERFORMANCE • 3 MONTHS • MUSEUM OF MODERN ART, NEW YORK, USA

Since the early 1970s Marina Abramović (b.1946) has been exploring the complex relationship between artist and audience through performances that challenge both herself and, in many instances, the participants, emotionally, intellectually and physically.

In 2010, for eight hours a day for almost three months, she engaged in an extended performance called *The Artist Is Present*. During that period she sat opposite an empty chair, and viewers came one at a time to sit on it and lock eyes with her. Throughout the whole three months, the

OTHER KEY WORKS

Rhythm 10, 1973, Edinburgh, UK

Rest Energy, 1980, Amsterdam, Netherlands

The House with the Ocean View, 2002, Sean Kelly Gallery, New York, USA

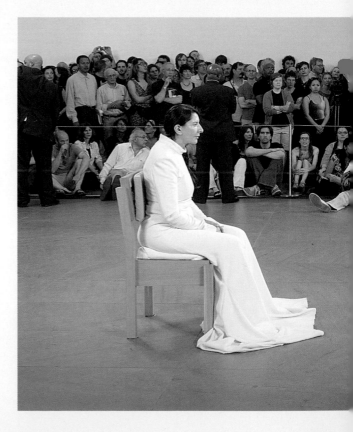

FEMINIST ART **p.37** PERFORMANCE ART **p.38** ←

chair was never empty, and there was always a queue of
viewers waiting to take their turn on it. Over the course
of the performance, she met the gaze of approximately
1,000 strangers, many of whom were moved to tears as
they focused on the rhythms of their bodies, such as their
breathing and heartbeat, and on the connection they
had for that time with another human being. Frequently
including the viewer in her work, Abramović often
explores such things as the limitations of the human body,
the possibilities of the mind, perception, her own personal
struggles, intolerance of those around her and connections
between people. She once said: 'The most important
[thing] is the concept and this was the beginning of my
performance art. And the first time I put my body in front
of [an] audience, I understood: this is my media.'

MARINA ABRAMOVIĆ
As a child, Marina Abramović
lived in Belgrade (then
in Yugoslavia) with her
grandmother. She studied
at the academies of fine
arts in Belgrade and Zagreb,
Croatia. In 1975 she met the
German artist Ulay (Frank Uwe
Laysiepen, b.1943), and the two
created art together, wrote a
manifesto and travelled through
Europe, Australia, India and
China. Since 1990 Abramović
has worked as a visiting pro-
fessor in Paris, Berlin, Hamburg
and Brunswick.

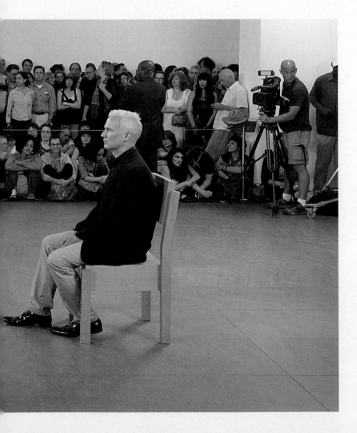

Dress-Stage

2012

ROSEMARIE TROCKEL: WOOL, CANVAS AND PLEXIGLAS
100.5 X 130.5 CM (39⅝ X 51⅜ IN) • SPRÜTH MAGERS, BERLIN, GERMANY

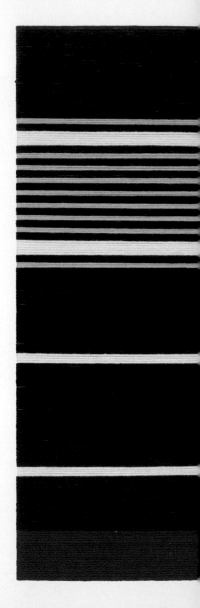

Challenging traditional notions of femininity and artistic production, Rosemarie Trockel (b.1952) uses a wide range of materials, including video, ceramics, drawing, found objects and wool, to create her varied artworks.

From early in her career, Trockel merged aspects of Pop and Conceptual Art, and Minimalism and Surrealism. *Dress-Stage* alludes to connections between all these, using the materials for which she came to prominence in the mid-1980s. The art is created using industrial knitting machines and computerized designs produced by a technician. Trockel stretches lengths of her machine-knitted woollen materials or simply lengths of wool on to frames or across wood, or, as here, canvas and Plexiglas in plain or patterned abstractions. The work deliberately raises questions about the value of women's work, and the imaginary line between fine art and craft.

Trockel began making these large woollen works in 1985 as a way of addressing feminist subjects, including attitudes towards sexuality and artistic production. The wool references knitting, which is generally perceived as a 'women's craft'. Trockel reflected: 'I wanted to know what causes a given kind of work to be regarded by women as embarrassing, both in the past and in the present: whether this has to do with the way the material is handled or whether it really lies in the material itself.'

ROSEMARIE TROCKEL
Born in Schwerte, Germany, Rosemarie Trockel studied from 1974 to 1978 at the Werkkunstschule in Cologne, where she became influenced by the conceptual work of Joseph Beuys (1921–1986). In the early 1980s she met and was inspired by the Cologne-based group of painters known as the Mülheimer Freiheit (Mülheim Freedom), and she exhibited at the Cologne gallery of Monika Sprüth. She continues to create emphatically feminist works of art.

SURREALISM **p.30** POP ART **p.35** CONCEPTUAL ART **p.39**

OTHER KEY WORKS

A Ship So Big, a Bridge Cringes, 2004, STAMPA, Spalenberg, Switzerland

German Spring, 2011, Sprüth Magers, Berlin, Germany

Music Box, 2013, Sprüth Magers, Berlin, Germany

We Are Free to Choose, but We Are Not Free from the Consequences of Our Choices: Arrival & Departure

2017

LIN JINGJING: LED DISPLAY PANELS, ACRYLIC, ALUMINIUM-PLASTIC PANEL 203 X 203 X 25.5 CM (80 X 80 X 10 IN), PRIVATE COLLECTION

LIN JINGJING

Shanghai-born Lin Jingjing graduated in 1992 from the fine art department of Fujian University, and in 1994 from the Central Academy of Fine Arts in Beijing. Through installations, performances, video and mixed media, she explores social and personal identity in contemporary society, especially the way individuals define themselves within the world. She has become especially known for her process of layering thread over paintings and installations to create surreal effects.

Since 2006 Lin Jingjing (b.1970) has worked as a multimedia artist, and she currently divides her time between Beijing and New York.

Lin created the artwork opposite while living in New York as part of her 'airport' project, *Take Off*. Building on a theory proposed by the French anthropologist Marc Augé (b.1935), it explores airports as 'non-places', where individual identities are erased and merge into one. She is particularly interested in how people perceive, project and define themselves, and also how the world affects individual identity.

The project focuses on an absurd future airport invented by Lin, and includes fabricated signs and advertising that portray concerning elements of contemporary culture, such as the act of giving away private information online. Focusing on the notions of contradiction and uncertainty, underlying anxiety and the loss of individuality in contemporary society, Lin transformed a gallery space into an international airport in the imaginary nation of the People's Republic of Dreamland. Her replication of airport departure and arrivals boards conveys feelings of uncertainty and anxiety. Instead of constantly updating planes and destinations, this arrivals board displays emotions and ideas, including frustration, resentment, apathy and insight, enabling Lin to comment on war, cultural crises and other problems that individuals regularly face in contemporary society.

OTHER KEY WORKS

This Is the Beginning of My Destination, 2017, De Sarthe Gallery, Hong Kong

A New Dawn for America – 2020 AI Presidential Campaign Speech, 2019, De Sarthe Gallery, Hong Kong

Remain Magical Despite Cruelty, 2019, De Sarthe Gallery, Hong Kong

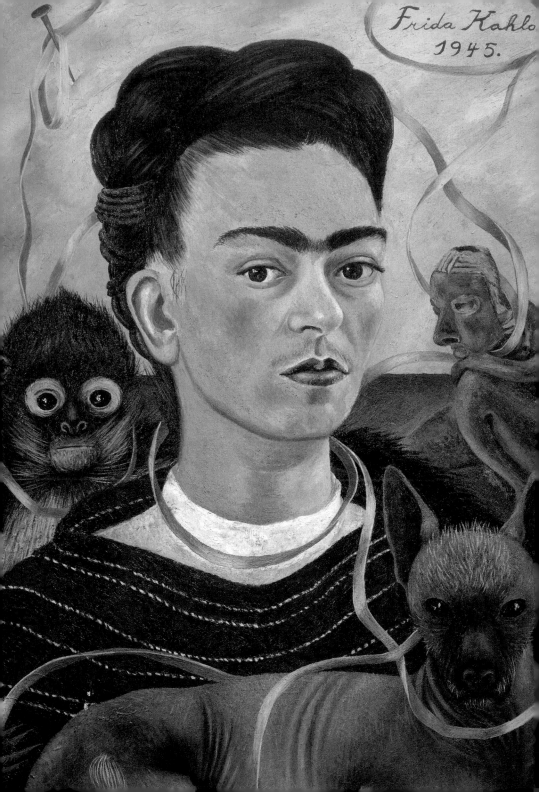

Breakthroughs

Striving for Equality

KEY ARTISTS: LAVINIA FONTANA • JUDITH LEYSTER • SOFONISBA ANGUISSOLA
RACHEL RUYSCH • NATALIA GONCHAROVA • AUGUSTA SAVAGE • SUZANNE VALADON

KEY DEVELOPMENTS
One of about 40 women artists working in Renaissance Italy, Properzia de' Rossi (c.1490–1530) was also one of the first female sculptors at a time when sculpting was considered a masculine pursuit. Additionally, she was among just four women to be written about in Giorgio Vasari's *Lives of the Artists*. The carving to the left is the only verified work by her in marble: a relief for the cathedral of San Petronio, Bologna.

Joseph and Potiphar's Wife, Properzia de' Rossi, c.1520, marble, 54.5 x 59 cm (21½ x 23¼ in), Museo de San Petronio, Bologna, Italy

Ancient Greek mythology attributes the invention of painting to a young woman who sketched the outline of her lover's shadow on the wall before he went to war. In the centuries following, some women artists gained respect, but few were judged equally with men.

Sofonisba Anguissola was one of the first female artists to achieve an international reputation – even though she did not come from a family of artists, which was the usual way for women to become involved in the art world. Several women artists from Bologna, including Lavinia Fontana, also gained respect and an almost equal standing with men, but the vast majority had to work under assumed male names.

Others were given no credit at all, but simply required to work in the background, and others were deleted from history after they had died, their signatures replaced with those of male substitutes. Plautilla Nelli (1524–1588), Judith Leyster, Rachel Ruysch, Natalia Goncharova and Georgia O'Keeffe were among the few women artists who were judged almost equally with their male counterparts. In the later twentieth century and the twenty-first, many began using unusual materials and creating diverse types of art so that their work would be viewed independently from men's art.

Rejecting 'Woman as Object'

KEY ARTISTS: ARTEMISIA GENTILESCHI • SOFONISBA ANGUISSOLA • ELISABETTA SIRANI
EMILY CARR • LEONORA CARRINGTON • JUDY CHICAGO • MARINA ABRAMOVIĆ • JENNY SAVILLE

Audacious, anonymous and determined to expose discrimination against women in the art world, the Guerrilla Girls first appeared in 1985. They were championing not only artists, but also all women involved with art, including those who ran museums and bought art, such as Lillie P. Bliss (1864–1931), Mary Quinn Sullivan (1877–1939) and Abby Aldrich Rockefeller (1874–1948), who in 1929 co-founded New York's Museum of Modern Art.

The Guerrilla Girls made an impact with their satirical poster *Do Women Have to Be Naked to Get Into the Met Museum?* of 1989. However, they were preceded by many women artists who throughout history have sought to reject the male-dominated traditions of objectifying women. Artemisia Gentileschi, for instance, painted the popular Baroque subject *Susanna and the Elders* in 1610, interpreting it in a way that contrasted dramatically with many male artists' versions. Gentileschi's Susanna is not idealized, and is uncomfortable at being watched by two men while she bathes. Numerous other female artists, including Elisabetta Sirani, Emily Carr, Leonora Carrington, Barbara Kruger and Jenny Saville, have made strong visual assertions that reject the male objectification of women and help to change long-established notions.

KEY DEVELOPMENTS
For centuries art was judged by male standards. From the Renaissance until the end of the nineteenth century, if a work of art created by a woman was described as 'masculine' or 'manly', that was a compliment. Yet at a time when ambitious career women were perceived as unwomanly (an insult), Sofonisba Anguissola became celebrated, and her work aimed to reject the portrayal of women as objects.

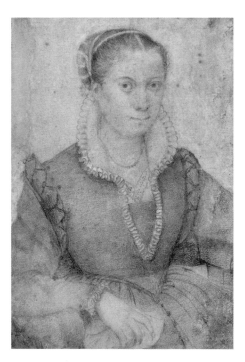

Portrait of a Lady, Sitting to the Right, Sofonisba Anguissola, c.1540–1626, paper and chalk, 18.4 x 12.4 cm (7¼ x 5 in), Rijksmuseum, The Netherlands

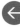

BAROQUE **p.15** NEOCLASSICISM **p.17** POST-IMPRESSIONISM **p.20** SURREALISM **p.30**
TIMOCLEA KILLING THE THRACIAN CAPTAIN **p.54** THE SCULPTRESS CLARA RILKE-WESTHOFF **p.88**

The Ontbijtje

KEY ARTIST: CLARA PEETERS

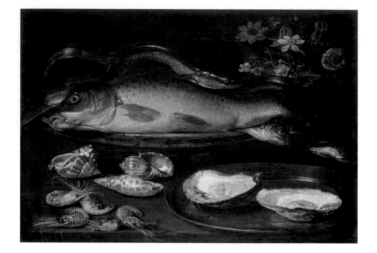

Still Life with Fish, Oysters and Shrimps, Clara Peeters, 1607–50, oil on panel, 25 x 34.8 cm (9¾ x 13¾ in), Rijksmuseum, Amsterdam, Netherlands

The first still-life paintings were made in the Dutch Republic during the sixteenth century, probably in celebration of the people's newly acquired wealth after their independence from Spain.

The term 'still life' derives from the Dutch word *stilleven*, and describes paintings featuring arrangements of objects, such as flowers, food, shells, vessels and utensils. Many early still-life paintings represented expensive or rare goods, while others met the ideals of Protestantism, once again reflecting the Dutch Republic's independence from Catholic Spain. These paintings conveyed a Christian message about the transience of life, and became known as vanitas or memento mori.

While Clara Peeters trained in the exacting technical tradition of Flemish Baroque painting, which was influenced by the Italian Baroque and developed before the period subsequently called the Dutch Golden Age, she seems to have spent much of her career in the Dutch Republic, and is recognized as the first acclaimed female painter of the Dutch Golden Age. Still-life painting did not require knowledge of anatomy, so it was a practical choice for women. After 1620 Peeters painted plain food, such as cheese and bread, and simple vessels such as wooden platters. These constitute the first *ontbijtjes*, or 'breakfast pieces', which became especially popular.

KEY DEVELOPMENTS

Peeters's influence on Dutch and Flemish artists can be seen in her subject matter, her fairly restricted palette, her low viewpoints, her compositions comprising just a few objects, and her *ontbijtjes*, which consist of mundane objects or the ingredients of a simple meal, as in her *Still Life with Fish, Oysters and Shrimps* (above) with its humble depiction of mostly local products.

DUTCH GOLDEN AGE **p.14** BAROQUE **p.15** STILL LIFE WITH CHEESES, ARTICHOKE AND CHERRIES **p.46**

Accademia delle Arti del Disegno

KEY ARTISTS: ARTEMISIA GENTILESCHI • ANGELICA KAUFFMAN

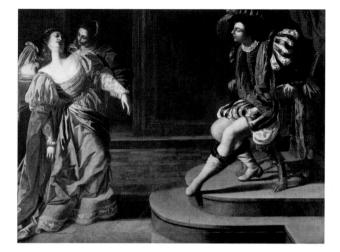

Esther Before Ahasuerus,
Artemisia Gentileschi,
1628–30, oil on
canvas, 208 x 274 cm
(82 x 107¾ in),
Metropolitan Museum
of Art, New York, USA

Evolving from an idea by Giorgio Vasari, the Accademia e Compagnia delle Arti del Disegno (Academy and Company of the Arts of Drawing) was founded in January 1563 by Cosimo I de' Medici (1519–1574), Duke of Florence.

The Accademia was set up as a guild to protect its members and raise standards, status and working conditions for artists in Florence and its environs. Later called the Accademia delle Arti del Disegno (Academy of the Arts of Drawing), the institution was supported for years by the powerful Medici family. However, it accepted only male artists until 1616, when Artemisia Gentileschi became the first female member. Later in the seventeenth century three more women were accepted, although little is known about them, not even their dates. They are: Rosa Maria Setterni, Caterina Angiola Corsi Pierozzi

and Colomba Agrani. In general, however, for centuries it remained almost impossible for women to be admitted. In 1762, while living in Milan, the Swiss-born British artist Angelica Kauffman was accepted as a member. By then the curriculum of the school, which had been restricted to drawing, had expanded to include painting.

KEY DEVELOPMENTS

Five years after becoming the first woman member of the Accademia at just 23 (which says more about her reputation as an artist than about the open-mindedness of the institution), Artemisia Gentileschi moved to Rome. However, her acceptance at the Accademia did not make it easier for women to join. Gentileschi was perceived as a quirk, an unnatural woman with the skill of a man.

RENAISSANCE **p.12** MANNERISM **p.13** BAROQUE **p.15** NEOCLASSICISM **p.17**
SELF-PORTRAIT AS THE ALLEGORY OF PAINTING **p.52** THE JUDGEMENT OF PARIS **p.60**

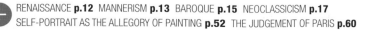

Independence

KEY ARTISTS: PROPERZIA DE' ROSSI • GEORGIA O'KEEFFE • LEONORA CARRINGTON
AGNES MARTIN • MIRA SCHENDEL

KEY DEVELOPMENTS
One of the consequences of the Dutch Republic's independence was the way in which women were treated and perceived. This made it slightly easier for female artists to achieve independence there than in many other parts of Europe. In 1633 Judith Leyster joined the Haarlem Guild of St Luke, which gave her independence and allowed her to establish her own workshop with students.

For centuries, because men traditionally financed households, fathers and husbands generally dictated how much independence their daughters or wives could have, and before the twentieth century few females managed to attain any kind of autonomy.

One woman artist who did achieve her own liberty was Properzia de' Rossi, who was described by her contemporaries as 'brilliant, fickle and untamable'. She was one of the first female Renaissance sculptors at a time when sculpting was considered a masculine occupation because of the strength and stamina it required. Her reputation was established through her early, tiny sculptures on peach and cherry stones, and her work inspired envy among her male peers.

Despite being a wife and the mother of 11 children, from the age of 25 Lavinia Fontana was acknowledged as one of the most important portraitists in Bologna. In 1603 she was invited by Pope Clement VIII to Rome, where she worked independently, her reputation rising as she painted more portraits and altarpieces. In the twentieth century several women artists, such as Georgia O'Keeffe and Leonora Carrington, established their own independence, and from the 1960s, as equal rights and feminist movements became more prevalent, female artists' independence became accepted.

Judith Leyster, *The Serenade*, 1629, oil on panel, 45.5 x 35 cm (18 x 13¾ in), Rijksmuseum, Amsterdam, Netherlands

CUBISM **p.23** SURREALISM **p.30** ABSTRACT EXPRESSIONISM **p.33**
SELF-PORTRAIT HOLDING A PORTRAIT OF HER SISTER, **p.58** ULU'S PANTS **p.120**

Breadwinner

KEY ARTISTS: MARIETTA ROBUSTI •ELISABETTA SIRANI • BARBARA LONGHI • RACHEL RUYSCH
LAVINIA FONTANA • MARY BEALE • ARTEMISIA GENTILESCHI • LILLY MARTIN SPENCER

KEY DEVELOPMENTS

Elisabetta Sirani had a remarkable, although short, career. She supported her father when he could no longer paint, making a great success of the family workshop, and established an art school for girls. As the primary breadwinner for her family, she became internationally famous and her paintings were acquired by noble and royal patrons, including the Grand Duke Cosimo III de' Medici.

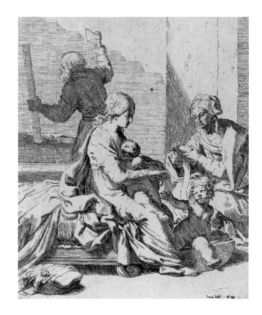

The Holy Family with St Elizabeth and St John the Baptist, Elisabetta Sirani, c.1650–60, etching, 29.4 x 21.9 cm (11½ x 8⅝ in), National Gallery of Art, Washington DC, USA

Before the late twentieth century most females were not allowed to earn their own money, yet, surprisingly, some women artists did contribute to or completely run the family finances.

For instance, Marietta Robusti (1554–1590) worked alongside her father, Tintoretto, in Venice. After she died in childbirth, Tintoretto's work and earnings declined considerably. In Ravenna, Barbara Longhi (1552–1638) worked with her father, Luca (1507–1580), and her brother Francesco (1544–1618). While she became recognized during her lifetime for her portraits and paintings of Madonnas, and thus subsidized the family economy, after her death she was forgotten. Artemisia Gentileschi, Rachel Ruysch and Lavinia Fontana had children (Ruysch had 10, Fontana 11), yet they also earned more than their husbands and supported their families financially.

As the wife of a courtier of Charles I, the portraitist Joan Carlile (c.1606–1679) became the family breadwinner after her husband lost his position following the English Civil War (1642–51). A few years later, also at the English court, Mary Beale (1633–1699) flourished through her art, commanding grand sums of money for her paintings and becoming the financial provider for her family.

RENAISSANCE **p.12** BAROQUE **p.15** NEOCLASSICISM **p.17** NOLI ME TANGERE **p.44** STILL LIFE WITH FLOWERS IN A GLASS VASE **p.56** CONVERSATION PIECE **p.66** VERTUMNUS AND POMONA **p.80**

The Royal Academy

KEY ARTISTS: MARY MOSER • ANGELICA KAUFFMAN • LAURA HERFORD
LAURA KNIGHT • ANNIE SWYNNERTON • EILEEN COOPER • FIONA RAE • TRACEY EMIN

In 1768 in London, King George III authorized the establishment of the Royal Academy of Arts (RA) to encourage public appreciation of the arts, to raise the professional status of artists by regulating art training, and to regularly exhibit excellent contemporary art.

Among the 36 founding members of the RA were two women: Mary Moser (1744–1819) and Angelica Kauffman. They took an active role in the Academy, although they were treated differently from their male colleagues. For instance, because two male life models were present for the official portrait of the Academicians, the two women could appear only as portraits on the wall, rather than being present in person. Neither were they allowed to participate in the running of the institution.

In 1860 Laura Herford (1831–1870) sent a drawing to the RA school signed only with her initials. Before anyone realized that she was a woman, it was accepted, but even while training, she was prohibited from attending life classes. Elizabeth Thompson exhibited her painting *The Roll Call* at the RA in 1874 to widespread acclaim, but she was not elected.

KEY DEVELOPMENTS

In 1922 Annie Swynnerton (1844–1933) became the first female Associate of the RA. Laura Knight (1877–1970) was elected as an Academician in 1936, and nearly 30 years later she became the first female artist to have a solo retrospective there. In 2010 Eileen Cooper (b.1953) became the first female Keeper of the Royal Academy Schools, and the Academy's first female professors, Fiona Rae (b.1963) and Tracey Emin (b.1963), were appointed.

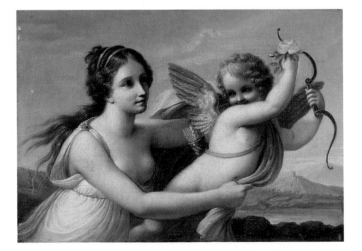

The Victory of Eros, Angelica Kauffman, 1750–75, oil on canvas, 48 x 60 cm (18 x 23 in), Metropolitan Museum of Art, New York, USA

NEOCLASSICISM **p.17** IMPRESSIONISM **p.19** THE JUDGEMENT OF PARIS **p.60**
SCOTLAND FOREVER! **p.72**

Peintre des Mesdames

KEY ARTISTS: ADÉLAÏDE LABILLE-GUIARD

Although not born into an artistic family, through determination, diligence and self-discipline Adélaïde Labille-Guiard became a successful miniaturist and portrait painter. Her work was accepted to the Paris Salon, and in 1783 she was elected a member of the Académie Royale in Paris and the Académie de Saint-Luc, a Parisian painters' guild that dissolved in 1776.

For five years Labille-Guiard received tuition from Maurice-Quentin de La Tour and the history painter and portraitist François-André Vincent. She was an advocate for the idea that women should receive the same opportunities as men to become great painters, and she was the first female artist to receive permission to set up a studio for herself and her students at the Louvre. Her work was discovered and especially admired by the aunts of Louis XVI (Princess Marie-Adélaïde, her sister Victoria Louise, and the king's sister Elizabeth); they made her their own royal painter, with a pension of 1,000 livres, and she became known as the 'Peintre des Mesdames'. She was later commissioned by the king's brother, the Count of Provence (later Louis XVIII of France), and in 1795 she obtained artist's lodging at the Louvre and a new pension of 2,000 livres.

KEY DEVELOPMENTS

Adélaïde Labille-Guiard became celebrated for her mastery in pastels and oils, as well as her detailed miniatures. After she had been admitted to the Académie Royale de Peinture et de Sculpture, she was talked about, which led to the aunts of the King of France discovering her work, commissioning her and bestowing her with her highly prestigious title.

Portrait of Madame de Genlis, Adélaïde Labille-Guiard, 1780, oil on canvas, laid down on board, 74 x 60 cm (29 x 23½ in), Los Angeles County Museum of Art, California, USA

NEOCLASSICISM **p.17** SELF-PORTRAIT WITH TWO PUPILS **p.62**

The Académie Royale

KEY ARTISTS: ROSALBA CARRIERA • MARIE-THÉRÈSE REBOUL • ANNA DOROTHEA THERBUSCH • ADÉLAÏDE LABILLE-GUIARD • ÉLISABETH VIGÉE-LEBRUN

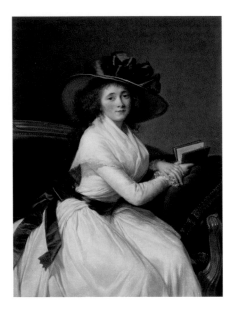

KEY DEVELOPMENTS

Although Élisabeth Vigée-Lebrun was one of the most fashionable artists in Europe, it took the intervention of Marie Antoinette for her to be admitted to the Académie Royale. She became a member in 1783, on the same day as Adélaïde Labille-Guiard and two other female artists. Many praised the women's achievements, but others criticized them for brazenness, and they were often derided in pamphlets.

Comtesse de la Châtre, Élisabeth Vigée-Lebrun, 1789, oil on canvas, 114.3 x 87.6 cm (45 x 34½ in), Metropolitan Museum of Art, New York, USA

The Académie Royale de Peinture et de Sculpture (Royal Academy of Painting and Sculpture) in Paris was founded in 1648 under Louis XIV. In 1795 it merged with the Académie de Musique (founded in 1669) and the Académie d'Architecture (founded in 1671) to form the Académie des Beaux-Arts (the Academy of Fine Arts). Rejecting avant-garde styles, training artists (at its school, the École des Beaux-Arts) and choosing who could exhibit in the annual Salon, the Académie set the standards for art across France.

The first female member was elected in 1663, and only another 15 women were elected over the next 80 years. In 1706 women were banned completely, but in 1720, while staying in Paris, Rosalba Carriera painted a pastel portrait of the young Louis XV and, on the strength of it, was asked to join the Académie. Thirty-seven years later another woman, Marie-Thérèse Reboul, known as Madame Vien, became a member. In 1767 Anna Dorothea Therbusch was admitted, as was Anne Vallayer-Coster in 1770. For years only four women at a time were admitted, to keep the number in check. Members were allowed to teach and to exhibit their work at the Salon.

NEOCLASSICISM **p.17** SELF-PORTRAIT WITH TWO PUPILS **p.62** MADAME VIGÉE-LEBRUN AND HER DAUGHTER, JEANNE-LUCIE-LOUISE **p.64**

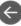

Celebrating the Female

KEY ARTISTS: SOFONISBA ANGUISSOLA • BERTHE MORISOT • JENNY SAVILLE
CINDY SHERMAN • JUDY CHICAGO

In an effort to rectify the imbalance of centuries of portrayals of women made by men, many women artists have celebrated the female. This can be seen in Sofonisba Anguissola's *Self-Portrait at the Easel* (1556) and Elisabetta Sirani's *Timoclea Killing the Thracian Captain* (1659).

As time passed, more female artists boldly represented themselves and other women, conveying their sex from assertive viewpoints and tackling the clichés of showing them within the confines of domesticity or as objects, such as Evelyn De Morgan's *The Love Potion* (1903) and Berthe Morisot's *The Mother and Sister of the Artist*

(1869/70). In the late twentieth century some, such as Laura Knight, Ana Mendieta (1948–1985), Cindy Sherman (b.1954) and Judy Chicago, explored the experience of being a woman in a male-dominated world in diverse and often unexpected ways, such as Knight's *Self-Portrait with Nude* (1913), Mendieta's *Untitled Self-Portrait with Blood* (1973), Chicago's *The Dinner Party* (1974–79) and Cindy Sherman's *Untitled Film Still #21* (1978). Despite their huge diversity, each of these works is unapologetic in its frank portrayal of the female.

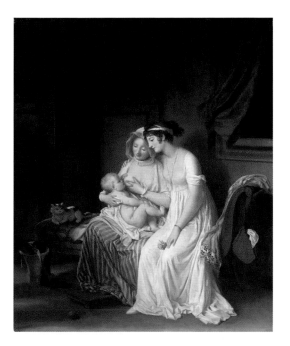

KEY DEVELOPMENTS
Not all approaches to celebrating the female are aggressive or audacious. Shown from a female perspective, boldly displaying the nursing woman's breast, *The Wet Nurse* of about 1802 by Marguerite Gérard depicts a woman breastfeeding a baby. Treated without sentimentality or salaciousness, the subject shows Gérard to be simply making a social observation and, as with her other works, exploring ideas that were relevant to women at the time.

The Wet Nurse or La Nourrice, Marguerite Gérard, c.1802, oil on panel, 59.7 x 48.6 cm (23½ x 19⅛ in), Private Collection

Vocation

KEY ARTISTS: MARY BEALE • EDMONIA LEWIS • HARRIET BACKER • CAMILLE CLAUDEL
PAULA MODERSOHN-BECKER • KÄTHE KOLLWITZ

Considering the obstacles with which female artists were faced, it may seem incomprehensible that so many have fought throughout their careers to create art and to gain recognition for it. As with their male counterparts, many have been driven by a vocation, a singular, overriding passion to produce art and fight for it.

Among these particularly driven women are Mary Beale, one of the most successful professional female painters in seventeenth-century England, who supported her family through her portrait-painting business. Paula Modersohn-Becker followed her vocation when she left her husband and moved to Paris, but after returning with him to Worpswede in Germany, she died of an embolism after childbirth. She was subsequently glorified by Rainer Maria Rilke in *Requiem for a Friend*, but he accused her

of choosing life over art, 'falling back' into a conventional marriage and ultimately dying. He blamed her for succumbing to a patriarchal society rather than following her vocation and living independently as an artist. Käthe Kollwitz was another who 'conformed' to the patriarchal society, but she managed to follow her vocation.

KEY DEVELOPMENTS

Another artist who died young through complications of childbirth was Eva Gonzalès (1849–1883). At the age of 16 she discovered her vocation, but as a woman she was prohibited from the École des Beaux-Arts. Instead, she studied art with the society painter Charles Chaplin, who ran an art studio in Paris specifically for women, and in 1869 she became the only acknowledged student of Édouard Manet.

Nanny and Child, Eva Gonzalès,
1877–78, oil on canvas, 65 x 81.4 cm
(25½ x 32 in), National Gallery of Art,
Washington DC, USA

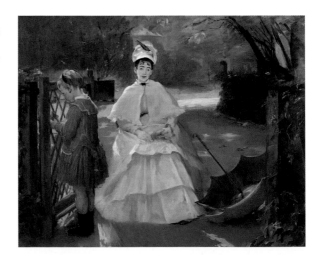

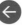

The Sisterhood

KEY ARTISTS: BERTHE MORISOT • LYUBOV POPOVA • OLGA ROZANOVA • ALEKSANDRA
EKSTER • LEE KRASNER • ELAINE DE KOONING • JUDY CHICAGO • MIRIAM SCHAPIRO

Whether blood-related or strangers, a
sisterhood between women is an unspoken
bond of solidarity, rather like an underlying
support network.

Among women artists, this sisterhood
has frequently been especially pronounced.
Naturally, real siblings are usually mutually
supportive, such as Elisabetta Sirani, who
taught her two younger sisters Barbara
and Anna Maria to paint, along with other
young women; the Anguissola sisters,
Sofonisba, Elena, Lucia, Europa and Anna
Maria, who all became painters, while
Sofonisba taught her younger siblings;
Margaret and Frances Macdonald, who
often worked collaboratively; and Berthe
and Edma Morisot, who trained together.
Friends and colleagues who formed
sisterhoods or working groups include the
artists Lyubov Popova, Olga Rozanova and
Aleksandra Ekster, who worked together
in the Verbovka Village Folk Centre in
Kiev, Ukraine. Others encouraged one
another within larger, male-dominated
groups such as the Impressionists, Abstract
Expressionists and Pre-Raphaelites,
including Morisot, Mary Cassatt, Eva
Gonzalès, Marie Bracquemond, Lee
Krasner, Helen Frankenthaler, Elizabeth
Siddal (1829–1862) and Emma Sandys
(1843–1877). In 1971 Judy Chicago and
Miriam Schapiro founded the Feminist Art
Program to create a sisterhood of artists in
California.

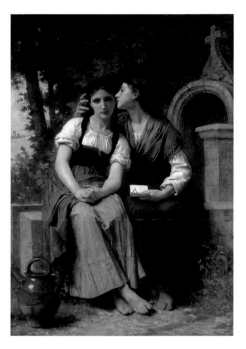

KEY DEVELOPMENTS
American-born Elizabeth
Jane Gardner (1837–1922)
lived most of her life in Paris,
where she studied with
the painters Hugues Merle
(1823–1881), Jules Joseph
Lefebvre (1836–1911) and
William-Adolphe Bouguereau
(1825–1905), the last of whom
she later married. Reflecting
the influence of Bouguereau,
Gardner's painting of two
women sharing a confidence
over a letter epitomizes the
sisterhood that has been so
prevalent among women.

La Confidence,
Elizabeth Jane
Gardner, c.1880,
oil on canvas,
172.7 x 119.7 cm
(68 x 47 in),
Georgia Museum
of Art, Athens,
USA

Contradicting 'the Passive Sex'

KEY ARTISTS: ELISABETTA SIRANI • OLGA ROZANOVA • HANNAH HÖCH • ROSA BONHEUR
FRIDA KAHLO • LOUISE BOURGEOIS • KARA WALKER

KEY DEVELOPMENTS
In 1963 *The Feminine Mystique* was published by the American writer Betty Friedan (1921–2006). Friedan wrote that women were restrained by the social fabrication of the idea of femininity. Long before that book was published, Rosa Bonheur had contradicted the notion of the passive sex when she cut her hair and wore men's clothes so that she could attend horse fairs, stockyards and slaughterhouses in order to study animal anatomy.

The Wounded Eagle, Rosa Bonheur, c.1870, oil on canvas, 147. 6 x 114.6 cm (58⅛ x 45⅛ in), Los Angeles County Museum of Art, California, USA

The English poet and author Geoffrey Chaucer (c.1343–1400) was probably the first to use the words 'femininity' and 'womanhood' when describing a set of characteristics that he believed to be specifically female.

Including kindness, meekness, modesty and humility, these 'female' characteristics are both biological and socially constructed. This, of course, has been a huge element in the gender-biased art world. Women who are not perceived as 'passive', such as those who have careers, stand up for themselves or create art that is not 'gentle', have traditionally been criticized for being 'unfeminine'. By the 1960s feminists were openly arguing that, although there are intrinsic feminine and masculine traits, most of the weaker female characteristics, such as passivity and frailty, have been culturally formulated specifically to subjugate women, who are generally physically weaker but not necessarily mentally weaker than men. While numerous female artists had attempted to counter this notion in the past, from the 1960s onwards more began producing deliberately provocative artworks to contradict the concept of the passive sex, such as Paula Rego's *Dancing Ostriches* (1995), Kara Walker's *Picturesque* (2006) and *Nature Morte aux Grenades* by Mona Hatoum (2006–07).

The Salon

KEY ARTISTS: MARIE BASHKIRTSEFF • MINA CARLSON-BREDBERG
LOUISE CATHERINE BRESLAU • ANNIE STEBLER-HOPF • ROSA BONHEUR

First held in 1667, the Salon was the official annual art exhibition of the Académie des Beaux-Arts in Paris. At first only members of the Académie Royale de Peinture et de Sculpture or of its school, the École des Beaux-Arts, were allowed to exhibit, but from 1737 any artist could submit work for selection.

From 1748 a jury consisting of members of the Académie formed the selection panel for the Salon's art, and a Hanging Committee determined how it would be displayed. As the only major art exhibition in France, it became the primary place for artists to establish their reputations. Although the Salon was open to female artists, few women had work accepted. *The Mother and Sister of the Artist* by Berthe Morisot was exhibited at the Salon of 1870. In 1881 *In the Studio* by Marie Bashkirtseff was successful, and in 1883 she won an honourable mention. Five years later *Une Mère* (*The Mother*) by Elizabeth Nourse (1859–1938) was accepted and hung 'on the line', which meant it was displayed at eye level, an excellent position for an unknown artist. While there were not enough women to make much of a collective impact, several individuals had successes, including Rosa Bonheur, Berthe Morisot and Mary Cassatt, who exhibited several times at Salons between the 1840s and 1870s.

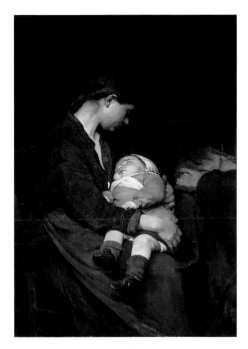

Une Mère, Elizabeth Nourse, 1888, oil on canvas, 115.6 x 81.3 cm (45½ x 32 in), Cincinnati Art Museum, Ohio, USA

KEY DEVELOPMENTS
Elizabeth Nourse first studied art in her native United States, but in 1887 she moved with her sister to Paris and enrolled at the Académie Julian. After three months, however, she was told that she needed no more instruction. Along with receiving accolades at the Salon for her extremely popular paintings, Nourse became one of the first American women to be elected a member of the Société Nationale des Beaux-Arts.

← NATURALISM **p.18** IMPRESSIONISM **p.19** THE MOTHER AND SISTER OF THE ARTIST **p.70**

Supporting other Female Artists

KEY ARTISTS: ELISABETTA SIRANI • NATALIA GONCHAROVA • ELIZABETH CATLETT
LOÏS MAILOU JONES • JUDY CHICAGO

As the twenty-first century continues, the dominance of male artists in galleries and exhibitions has been challenged by many women artists who directly support one another.

Although many female artists prefer to be classified not by their gender but by the merits of their work, several all-women exhibitions have proved extremely popular, showing how female-to-female support can enhance reputations. The exhibition at the Brooklyn Museum in New York in 2017, for example, featured the work of 40 artists, including Elizabeth Catlett, Loïs Mailou Jones, Lorraine O'Grady (b.1934) and Faith Ringgold (b.1930). Entitled *We Wanted a Revolution: Black Radical Women*

1965–85, it followed the rise of a distinctive African-American Feminist Art movement in the 1960s in which many women actively supported one another. One of the most notable ways in which one female artist supported other women was Judy Chicago's *The Dinner Party* (1974–79). Chicago said of the work: 'Because we are denied knowledge of our history, we are deprived of standing upon each other's shoulders and building upon each other's hard-earned accomplishments … The goal of *The Dinner Party* is to break this cycle.'

KEY DEVELOPMENTS

In 1972 Judy Chicago and Miriam Schapiro created Womanhouse as a space for women's art, and various female artists contributed installations. Female artists' mutual support has increased since the 1970s, but it has always occurred. In the 1860s Jeanna Bauck (1840–1926) ran a painting school for women in Munich. In the painting shown here, she depicts her friend the artist Bertha Wegmann (1847–1926) at her easel.

Bertha Wegmann Painting a Portrait, Jeanna Bauck, 1889, oil on canvas, 100 x 110 cm (37⅓ x 43⅓ in), Nationalmuseum, Stockholm, Sweden

BAROQUE **p.15** IMPRESSIONISM **p.19** CUBISM **p.23** HARLEM RENAISSANCE **p.29**
FEMINIST ART **p.37** CYCLIST **p.94** COMPOSITION **p.116**

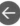

A Female Viewpoint

KEY ARTISTS: ARTEMISIA GENTILESCHI • ÉLISABETH CHAPLIN • MARY CASSATT
AMRITA SHER-GIL • FRIDA KAHLO • JENNY SAVILLE

All art is subjective, and whether a male artist thinks of his daughter, wife, mother, lover, friend or a goddess when he depicts a woman, his image will naturally be imbued with that viewpoint. Many women artists have, also naturally, sought to redress this, by depicting women – themselves or others – from a female perspective.

For instance, Artemisia Gentileschi, a painter of strong, independent women, bestows her Esther in *Esther Before Ahasuerus* (1628–30) with brains as well as beauty. In 1903, in *Outbreak*, Käthe Kollwitz portrays a powerful female revolutionary leading an army of peasants. Élisabeth Chaplin (1890–1982) has two self-portraits in the Vasari Corridor in

Florence. One, *Self-Portrait with a Green Umbrella* (1908), shows Chaplin at 17 in an objective manner. With no self-flattery or added narrative, she has simply painted the colours and shapes she sees. Amrita Sher-Gil's *Three Girls* (1935) combines a colourful atmospheric style with psycho-logical elements, exposing a sensitivity to the underlying thoughts of the female subjects. Jenny Saville's *Plan* (1993) takes objectivity even further in conveying a female body as a contoured map. Viewers are confronted with flesh pressed close to the picture plane, deliberately counterbal-ancing the traditional male idealization of the female form.

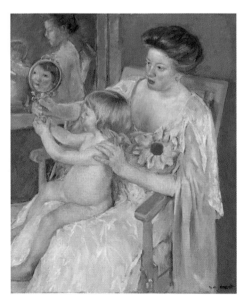

KEY DEVELOPMENTS
Even though the Madonna and Child was a popular subject among male artists in Christian countries, arguably many female artists have a closer understanding of the subject of a mother and child through personal knowledge or insight to maternal emotions. The mother and child was one of the few subjects that female artists could represent at the time Mary Cassatt produced the painting at left.

Mother and Child, Mary Cassatt, c.1905, oil on canvas, 92.1 x 73.7 cm (36¼ x 29 in), National Gallery of Art, Washington DC, USA

BAROQUE **p.15** NEOCLASSICISM **p.17** EXPRESSIONISM **p.22** MADAME VIGÉE-LEBRUN AND HER DAUGHTER, JEANNE-LUCIE-LOUISE **p.64** THREE GIRLS **p.110** THE BROKEN COLUMN **p.114**

Women's Crafts

KEY ARTISTS: SONIA DELAUNAY • FAITH RINGGOLD • AGNES MARTIN • MIRIAM SCHAPIRO
JUDY CHICAGO • TRACEY EMIN

Pictorial Quilt, Harriet Powers, 1895–98, cotton plain weave, pieced, appliquéd, embroidered and quilted, 175 x 266.7 cm (68⅞ x 105 in), Museum of Fine Arts, Boston, Massachusetts, USA

Throughout the history of art, decoration and domestic handicrafts have been generally perceived as 'women's crafts' and not as important as so-called fine art. These crafts include quilting, weaving, embroidery, knitting and sewing.

For a long time this was accepted, but in the 1970s several feminist artists began to reconsider these forms of art and to incorporate them into fine art in order to make them generally more respected. Faith Ringgold, for instance, has been making 'story quilts', combining fabric, painting and narrative, since the beginning of her career, seeing them as a form of 'soft sculpture'. Tracey Emin has also created fine art employing these crafts, such as in her appliquéd blanket *Hate and Power Can Be a Terrible Thing* (2004). In the 1970s and 1980s Miriam Schapiro created 'femmages' – collages and objects made with patterned fabric and appliqué – to challenge the marginalization of 'women's crafts', such as her *Black Bolero* (1980). Her femmages became part of an art movement called the Pattern and Decoration movement. Similarly, Judy Chicago's *The Dinner Party* (1974–79) consists of sewing, needlework, embroidery and other media traditionally associated with 'women's crafts'.

KEY DEVELOPMENTS

Born a slave, Harriet Powers (1837–1911) made the quilt above – and at least one other – using appliqué techniques. *Pictorial Quilt* consists of 15 squares depicting biblical scenes and African and Christian symbols, along with stories of meteorological and astronomical events, such as a series of forest fires that occurred in 1780, and nights of falling stars during August 1846.

ART NOUVEAU **p.21** ABSTRACT EXPRESSIONISM **p.33** NOUVEAU RÉALISME **p.36** FEMINIST ART **p.37**
CONCEPTUAL ART **p.39** HOMAGE TO GREECE **p.124** THE DINNER PARTY **p.136**

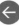

Changing Opinions

KEY ARTISTS: JUDITH LEYSTER • SOPHIE DE BOUTEILLER • ROSA BONHEUR • FRIDA KAHLO
NATALIA GONCHAROVA • PAULA MODERSOHN-BECKER • JENNY HOLZER • TRACEY EMIN

Through their unique perspectives, backgrounds and environments, some women have created art so different that it permanently changes opinions about what art is, or could or should be.

Most of the works in this book have changed opinion in some way. For instance, through her lifestyle as well as her work, Rosa Bonheur showed that women could thrive without conforming to society's standards. Similarly, Judith Leyster in the seventeenth century produced paintings that demanded attention, although much of her work was attributed to contemporary male artists. Many did not believe they could have been painted by a woman. When they realized, her work helped to alter many opinions about what women artists were capable of. Sophie de Bouteiller (1829–1901), who used the pseudonym Henriette Browne, became renowned internationally during her lifetime for her fresh approach to Orientalism, which was less sensational than most male Orientalists' art, and which showed harems as spaces for social interaction among women. As a woman herself, Browne was able to enter harems and meet their inhabitants, learn how the groups were constructed socially, and depict the interaction between the women in a way that male artists of similar subjects could not. Her success shifted general opinion about the Oriental style of painting.

KEY DEVELOPMENTS

With her fearless, unflattering paintings of herself, surrounded by blatant symbols of her suffering, Frida Kahlo altered the attitudes of viewers and ensuing artists to fashionable styles and what was suitable to paint. Similarly courageous, although with a different painting style, Paula Modersohn-Becker produced paintings in a unique style that changed opinion about both the development of art and the ability of women artists to be innovative.

Self-Portrait with Changuito, Frida Kahlo, 1945, oil on masonite, 56 x 42 cm (22 x 16½ in), Collection of Dolores Olmedo Patiño, Mexico City, Mexico

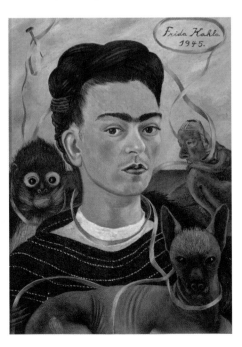

Abstract Art

KEY ARTISTS: HILMA AF KLINT • LEE KRASNER • AGNES MARTIN • BARBARA HEPWORTH
EVA HESSE • BRIDGET RILEY • LOUISE NEVELSON • HELEN FRANKENTHALER • YAYOI KUSAMA

KEY DEVELOPMENTS

Hilma af Klint was 17 when she attended her first spiritualist séance, and in 1905 she claimed she heard a voice saying: 'You are to proclaim a new philosophy of life and you yourself are to be a part of the new kingdom. Your labours will bear fruit.' Between November 1906 and March 1907 she painted a series of small abstract paintings entitled *Primordial Chaos*.

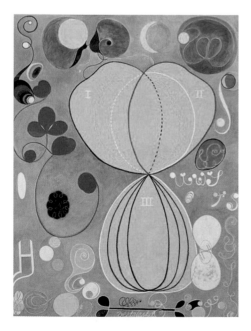

The Ten Largest, No. 7, Adulthood, Group IV, Hilma af Klint, 1907, tempera on paper, mounted on canvas, 315 x 235 cm (124 x 92 ½ in), Hilma af Klint Foundation, Stockholm, Sweden

Despite the common belief that Wassily Kandinsky was the first artist to produce a totally abstract painting, it is now generally accepted that this was achieved by Hilma af Klint in 1906, about five years earlier.

After gaining recognition as a landscape and portrait painter, Klint worked as a draughtswoman for a veterinary institute, and also produced detailed botanical illustrations. She became inspired – like Kandinsky and Piet Mondrian – by theosophy, a spiritual and philosophical movement founded by Helena Petrovna Blavatsky (1831–1891), and the first religious organization in Europe that did not discriminate against women. Many women artists followed Klint in producing abstract art, from paintings to sculpture, installations and conceptual work. Abstract painters include the Abstract Expressionists Lee Krasner, Agnes Martin and Helen Frankenthaler, and the Op artist Bridget Riley. After initially working solely with paint, Yayoi Kusama began producing multidisciplinary abstract works that focus on repeating patterns. By contrast, Louise Nevelson (1899–1988) created pioneering monumental, monochromatic wooden wall structures and outdoor sculptures, while Eva Hesse produced abstract paintings, sculpture and installations, and Barbara Hepworth created biomorphic sculptures that seem to evolve from their surroundings.

CONSTRUCTIVISM **p.26** SUPREMATISM **p.27** CONCRETE ART **p.32** ABSTRACT EXPRESSIONISM **p.33**
OP ART **p.34** COMPOSITION **p.116** CERTAIN DAY **p.140**

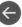

Assertiveness

KEY ARTISTS: SUZANNE DE COURT • CLARA PEETERS • EDMONIA LEWIS
SUZANNE VALADON • GWEN JOHN • HANNAH HÖCH • TRACEY EMIN

The only woman to earn a reputation in the enamel workshops of Limoges in the late sixteenth and early seventeenth centuries, Suzanne de Court (dates unknown) developed a unique method of enamelling.

Moving away from the admired grisaille technique, she demonstrated a rare assertiveness for the period. Another self-assured female artist in the seventeenth century, who also pushed boundaries, was Clara Peeters. Instead of emulating the revered style of Peter Paul Rubens, Peeters painted with a natural, realistic approach. A century later Élisabeth Vigée-Lebrun established a portrait studio while still in her teens, and at 23 she painted the first of many portraits of Marie Antoinette.

Her success caused envy among her male peers, who began rumours that a man had painted some of her works. Vigée-Lebrun remained determined, and was the most successful and expensive portraitist of her time.

Social conditioning has created the idea that women should be meek, so in the past, when female artists resisted expectations and contradicted preconceptions, they were often shunned, ignored or ridiculed. Before the feminist movement began in the 1970s, most female artists fought against deep-rooted beliefs that women should be passive and retiring, and their assertiveness was often viewed with suspicion.

KEY DEVELOPMENTS
Overshadowed by her more successful brother Augustus John (1878–1961) and her lover Auguste Rodin, Gwen John (1876–1939) strove for recognition and achieved it through quiet determination. Here, in her thoughtful and subtle style, she conveys mood and atmosphere in closely modelled tones, demonstrating her underlying assertiveness. The anonymous female sitter in a three-quarter-length format is enigmatic and open to interpretation.

The Convalescent, Gwen John, c.1923–24, oil on canvas, 40.9 x 33 cm (16 x 13 in), Fitzwilliam Museum, University of Cambridge, UK

DUTCH GOLDEN AGE **p.14** DADA **p.28** OP ART **p.34** MADAME VIGÉE-LEBRUN AND HER DAUGHTER, JEANNE-LUCIE-LOUISE **p.64** THE BLUE ROOM **p.100** THE ADVANTAGES OF BEING A WOMAN ARTIST **p.138**

Roman Prizes

KEY ARTISTS: LUCIENNE HEUVELMANS • ODETTE PAUVERT

Created by Louis XIV in France in 1663, the Prix de Rome was a prestigious scholarship for painters and sculptors. Every year winners were selected from students at the Académie Royale de Peinture et de Sculpture, the idea being to enable the best young French artists to study and learn from ancient Roman and Renaissance art. The overall winner was awarded the First Grand Prize, a stay at the French Academy in Rome for between three and five years, paid for by the state. Second prizes were also awarded, and by 1804 the awards had been expanded to include architecture, music and engraving. The contest was abolished in 1968.

It was not until 1897 that women were accepted to the Académie des Beaux-Arts, but they were not allowed in the workshops until 1900, and were permitted to enter the Prix de Rome only from 1903. Eight years later Lucienne Heuvelmans (1885–1944) became the first woman to be awarded the First Grand Prize for sculpture, for her work *The Sister of Orestes Guarding Her Brother's Sleep*. In 1925 Odette Pauvert (1903–1966) won the First Grand Prize for her painting *The Legend of St Ronan*.

KEY DEVELOPMENTS
The British School at Rome was established in 1901 to 'promote knowledge of and deep engagement with … the art, history and culture of Italy by scholars and fine artists from Britain and the Commonwealth, and to foster international and interdisciplinary exchange'. Winifred Knights (1899–1947) was the first woman to win its Scholarship in Decorative Painting, for *The Deluge*.

The Deluge, Winifred Knights, 1920, oil on canvas, 152.9 x 183.5 cm (60 x 72¼ in), Tate, London, UK

NEOCLASSICISM **p.17** ART DECO **p.31**

Rejecting Male Authority

KEY ARTISTS: SOFONISBA ANGUISSOLA • TAMARA DE LEMPICKA • BARBARA KRUGER
GUERRILLA GIRLS • JENNY HOLZER

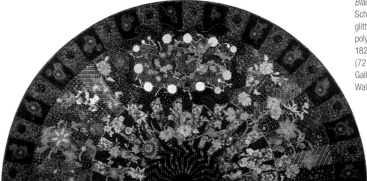

Black Bolero, Miriam Schapiro, 1980, fabric, glitter and synthetic polymer paint on canvas, 182.9 x 365.8 x 6.6 cm (72 x 144 x 2½ in), Art Gallery of New South Wales, Sydney, Australia

Male artists have frequently objectified women in diverse ways, such as in *The Rape* (1934) by Rene Magritte (1898–1967), or Yves Klein using women as 'living paintbrushes' in his *Anthropometry* series of 1961.

As early as the sixteenth and seventeenth centuries, female artists reacted against objectification. For instance, through her intelligence, education, skill and respectful treatment of women in her art, Sofonisba Anguissola attacked Renaissance patriarchal convention. Following her, however, few women managed to make much of an impact in their renunciation of male dominance until the 1960s, when more women artists came together, determined to break free of rigid gender roles. Prompted by such writings as Betty Friedan's *The Feminine Mystique*, some formed collectives, some staged exhibitions and others produced art that attempted to shock in protest against continued male control. To establish themselves and to change common attitudes and art history, these women often worked together. The Feminist Art movement began in the 1960s, but it continues, regenerating with each new generation. Early achievements by Feminist artists against male authority included the establishment of the feminist Art Program by Judy Chicago in 1970, and her collaboration with Miriam Schapiro in 1971.

KEY DEVELOPMENTS
Exemplifying Feminist Art and the Pattern and Decoration movement, Miriam Schapiro created *Black Bolero* (above) to highlight male authority, especially in the art world, that dismisses 'feminine' techniques, such as appliqué and lacemaking, as inferior. With their project Womanhouse, Schapiro and Chicago included consciousness-raising sessions in which women artists were encouraged to consider and discuss their personal experiences of being women in a male-dominated society.

SUPREMATISM **p.27** CONSTRUCTIVISM **p.26** ART DECO **p.31** FEMINIST ART **p.37** SHELL NO. I **p.104**
THE ADVANTAGES OF BEING A WOMAN ARTIST **p.138** CERTAIN DAY **p.140**

Challenging Contempt

KEY ARTISTS: EDMONIA LEWIS • AUGUSTA SAVAGE • LOÏS MAILOU JONES • FRIDA KAHLO
GEORGIA O'KEEFFE • PAULINE BOTY • ELIZABETH CATLETT • ALICE NEEL • PAULA REGO

While many female artists faced contempt in various forms, the diverse and often light-hearted or determined ways in which they challenged it can be surprising.

Certain art movements were more misogynistic than others, so women's approaches when tackling contempt were necessarily different. For instance, women artists of the Harlem Renaissance, such as Augusta Savage, Elizabeth Catlett and Loïs Mailou Jones, dealt with both sexual and racial prejudice. They challenged their critics' contempt by producing innovative, unexpected works such as Catlett's dynamic *Sharecropper* (1952), which openly confronts disturbing injustices, but without hostility. Pop Art was notoriously misogynistic, but Pauline Boty – a lone female

on the British side – challenged her male colleagues' attitudes by focusing on serious, often political subjects from a distinctly female perspective. By contradicting previously conceived notions of women's roles that in many ways had become social norms, many feminist artists shocked their critics, and artists such as Frida Kahlo, Georgia O'Keeffe, Paula Rego and Alice Neel all produced works that convey their subjects boldly, clearly aiming to encourage viewers to reconsider any previous bias or contempt.

KEY DEVELOPMENTS

Drawn from life, the female in this painting represents the artist herself, Claudette Johnson (b.1959). Created with geometric lines and thin paint, and inspired by Picasso's painting *Les Demoiselles d'Avignon* (1907), the work contains three other figures, each of them wearing African masks. Johnson's work arises from the negativity she perceives being shown towards black women artists. She says she wants to 'give space' to black women, which previously 'has been distorted, hidden and denied'.

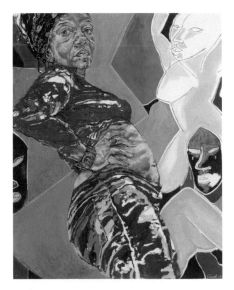

Standing Figure with African Masks, Claudette Johnson, 2018, pastel and gouache on paper, 151.5 x 122 cm (60 x 48 in), Tate Modern, London, UK

FUTURISM **p.24** HARLEM RENAISSANCE **p.29** POP ART **p.35** FEMINIST ART **p.37** SHELL NO. I **p.104**
PORTRAIT OF MILDRED MYERS OLDDEN **p.112** THE BROKEN COLUMN **p.114**

Questioning Democracies

KEY ARTISTS: HANNAH HÖCH • NATALIA GONCHAROVA • AUDREY FLACK • MONA HATOUM
MARINA ABRAMOVIĆ • YAYOI KUSAMA • LIN JINGJING • MARTA MINUJIN

Uncertainty, repressed anxiety and a loss of individuality in contemporary democracies are just a few of the problems faced by some in Western society, and some of these notions have been explored by female artists, including Hannah Höch, Yayoi Kusama, Mona Hatoum and Marina Abramović.

For example, Kusama's *Aftermath of Obliteration of Eternity* (2009) and Abramović's *The Artist Is Present* (2010) both explore individuals' anxiety within contemporary culture, and how it manifests. In 2017 Lin Jingjing created *Take Off*, a multimedia project that explores paradoxes of democracies. She transformed a gallery space into an imaginary international airport that explores the ways in which individuals increasingly lose their

uniqueness. Featuring several different types of artwork, *Take Off* functions as a whole or singularly; each work conveys an aspect of airports in contemporary democracies, and how people are being taken over through advancing technology and human control so that identities can be taken away. For instance, she includes a fabricated advertisement about a mobile phone app. *Superzoom* is produced by her imagined PRD government and promises to help travellers pass through customs speedily while also making new friends and business connections. This can be achieved only if the user submits all of his or her personal information when signing up.

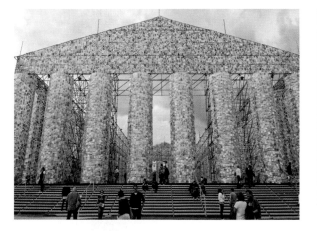

KEY DEVELOPMENTS
The Argentinian artist Marta Minujín (b.1943) created *The Parthenon of Books* (2017), in Kassel, Germany, where in May 1933 more than 2,000 books were burned by the Nazis. Using over 100,000 books that are currently banned in various countries, Minujín built a replica of the Parthenon in Athens, a symbol of the world's first democracy. The installation is formed with metal scaffolding, the books and plastic wrapping.

The Parthenon of Books, Marta Minujín, 2017, constructed from banned books,
Documenta 14 art exhibition, Friedrichsplatz, Kassel, Germany

CONSTRUCTIVISM **p.26** SUPREMATISM **p.27** DADA **p.28** FEMINIST ART **p.37** HIGH FINANCE **p.102**
WE ARE FREE TO CHOOSE, BUT WE ARE NOT FREE FROM THE CONSEQUENCES OF OUR CHOICES **p.168**

Themes

Self-portraits

KEY ARTISTS: SOFONISBA ANGUISSOLA • ARTEMISIA GENTILESCHI
ADÉLAÏDE LABILLE-GUIARD • MARIE BASHKIRTSEFF • HELENE SCHJERFBECK • ALICE BAILLY

Portrait of a Woman, probably a self-portrait, Catharina van
Hemessen, 1548, oil on panel, 23 x 15.2 cm (9 x 6 in),
Rijksmuseum, Amsterdam, Netherlands

KEY DEVELOPMENTS

Known mainly for her small-scale portraits of
women, Catharina van Hemessen (1528–1588) is
often named as the first artist (of either gender)
to have painted a self-portrait sitting at an easel.
This is one of her other self-portraits, showing
her looking young and serious. Van Hemessen
was fortunate in that she trained with her father,
the respected artist Jan Sanders van Hemessen
(c.1500–c.1566).

The self-portrait has always been a useful
way for artists to practise painting, develop
accurate eye-to-hand observation, market
themselves and work with a free model.

For women, who for centuries were for-
bidden from attending life-drawing classes,
self-portraiture was valuable for learning
about anatomy. For instance, in *Self-Portrait
at the Easel* (1556) Sofonisba Anguissola
presents herself as a modest woman
painting the Virgin Mary and Christ. Her
decision to paint herself with her palette,
brush and mahl stick was rare for the era,
and implies that she wanted recognition
for her artistic skill. In *Self-Portrait as the
Allegory of Painting* (1638–39), Artemisia
Gentileschi boldly presents herself as the
embodiment of painting. In the eighteenth
century Adélaïde Labille-Guiard also
depicted herself painting, watched by two
female students in her *Self-Portrait with
Two Pupils* (1785), and Marie Bashkirtseff's
self-portrait *In the Studio* (1881) depicts
a group of female painters in a life-draw-
ing class, with a young, semi-nude boy
modelling, inverting usual practice. Helene
Schjerfbeck's *Self-Portrait with Black
Background* (1915) and *Self-Portrait* (1917)
by the Swiss artist Alice Bailly (1872–1938)
are radical and avant-garde. Bailly was fas-
cinated by Cubism, Fauvism and Dada, and
invented her own mixed-media technique
using short strands of coloured yarn to
imitate brushstrokes.

RENAISSANCE **p.12** BAROQUE **p.15** POST-IMPRESSIONISM **p.20** SELF-PORTRAIT AT THE EASEL **p.42**
SELF-PORTRAIT AS THE ALLEGORY OF PAINTING **p.52** SELF-PORTRAIT WITH BLACK BACKGROUND **p.98**

Identity

KEY ARTISTS: MARY BEALE • SIGRID HJERTÉN • ÉLISABETH VIGÉE-LEBRUN • BERTHE MORISOT
VANESSA BELL • FRIDA KAHLO • JUDY CHICAGO • YAYOI KUSAMA • CINDY SHERMAN

'Every painter paints himself' is a saying that was first documented in the early Renaissance – explaining that the artist's identity is at the heart of every work of art.

Some artists make that especially apparent. For instance, Frida Kahlo is renowned as much for her colourful art as for her traumatic life and her German-Mexican identity. Her paintings convey her physical and mental pain and her heritage. In 1916 the Swedish artist Sigrid Hjertén (1885–1948) painted *Ateljéinteriör* (*Studio Interior*), portraying her roles in life as a woman, artist and mother. Vanessa Bell (1879–1961) produced bright, bold paintings that project her personality. After World War II, in Kyoto, Yayoi Kusama studied the formal style of Japanese Nihonga painting, later becoming inspired by Abstract Expressionism in New York. Amalgamating these influences, she now explores her identity as a Japanese female artist alongside her own neuroses. In 1970 Judy Chicago taught female art students the skills they needed to express women's perspectives. The course became the Feminist Art Program, which encouraged the artists to focus on their own identities. Meanwhile, Cindy Sherman uses make-up, costumes, props, prosthetics and costumes to hide her own identity and explore others in our consumer-focused society.

KEY DEVELOPMENTS

In this self-portrait, Mary Beale conveys her identity as artist, mother and middle-class, fashionable woman. Beale was one of just a few women artists working in England at the time, and she thrived through her art; her husband acted as her assistant. Here her palette hangs on the wall and she holds a small canvas showing unfinished portraits of her two sons, Bartholomew and Charles.

Self-Portrait, Mary Beale, c.1665, oil on canvas, 109.2 x 87.6 cm (43 x 34½ in), National Portrait Gallery, London, UK

HARLEM RENAISSANCE **p.29** MADAME VIGÉE-LEBRUN AND HER DAUGHTER, JEANNE-LUCIE-LOUISE **p.64**
THE MOTHER AND SISTER OF THE ARTIST **p.70** THE BROKEN COLUMN **p.114**

Religion

KEY ARTISTS: LAVINIA FONTANA • BARBARA LONGHI • CATHARINA VAN HEMESSEN
PLAUTILLA NELLI • ARTEMISIA GENTILESCHI • HILMA AF KLINT • LYGIA PAPE

Being forbidden from studying nudes, women rarely painted large Christian images, because such works required a detailed understanding of anatomy.

However, some, including Catharina van Hemessen, Barbara Longhi and Artemisia Gentileschi, did paint Christian narratives – usually smaller works, such as Longhi's *Virgin and Child with Saint* (c.1590–95) and *Lamentation with Saints* (1524) by Plautilla Nelli, often highlighting the female perspectives of biblical stories. Different spiritual notions have dominated many female artists' work, such as the concepts of theosophy that especially influenced Hilma af Klint, who, with four other women, formed The Five, a group that tried

through seances to make contact with the 'High Masters'. Klint's resulting abstract paintings were a visual representation of some of these complex spiritual ideas.

The Australian artist Julie Dowling (b.1969) focuses in many of her paintings on elements of Aboriginal identity that she blends with her experiences at a Catholic convent school. Reflecting this, her earliest icon-like images were strongly influenced by Renaissance religious paintings, and much of her work is a synthesis of elements of Aboriginal culture and Christianity, particularly Catholicism.

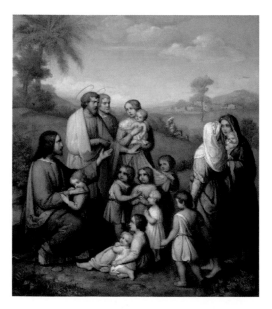

KEY DEVELOPMENTS
The first woman to be admitted to a German art academy, in 1813, Marie Ellenrieder (1791–1863) enrolled at the Academy of Fine Arts Munich. Between 1822 and 1824, on a trip to Rome, she met the Nazarenes, a group of German artists who produced religious art in early Renaissance styles. Ellenrieder soon began painting religious images in a similar style, such as *Jesus Among the Children*.

Jesus Among the Children, Marie Ellenrieder, 1839, oil on paper, 23.5 x 20 cm (9¼ x 7¾ in), Private Collection

RENAISSANCE **p.12** BAROQUE **p.15** NOLI ME TANGERE **p.44** THE TEN LARGEST, NO. 2, CHILDHOOD, GROUP IV **p.90**

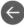

History

KEY ARTISTS: ELISABETTA SIRANI • MARIE-GUILLEMINE BENOIST • ANGELICA KAUFFMAN
LUCY MADOX BROWN ROSSETTI • ARTEMISIA GENTILESCHI • KARA WALKER

KEY DEVELOPMENTS
The French Neoclassical painter
Marie-Guillemine Benoist
trained with Élisabeth Vigée-
Lebrun and then Jacques-Louis
David (1748–1825). Her pre-
ferred themes were historical,
as evidenced by this painting,
which she exhibited in the Paris
Salon of 1800 to symbolize
women's emancipation and the
rights of black people (slavery
had been abolished in 1796). In
striking white, Madeleine, the
elegant young woman, turns to
look directly at the viewer.

Portrait of Madeleine, Marie-Guillemine
Benoist, 1800, oil on canvas,
81 x 65 cm (31¾ x 25½ in), Musée
du Louvre, Paris, France

As academies were established in France, Italy and England during the eighteenth century, the arts became more regulated. These institutions began controlling their artists and publicizing them as intelligent and unique to raise their reputations.

Each academy also promoted a national style, and themes and subjects it valued. History paintings and sculptures were considered the greatest genre, as had been the general belief since 1435, when the Italian polymath Leon Battista Alberti (1404–1472) declared the fact in his treatise *On Painting* (*Della Pittura*). Yet because history paintings – which included history, myth and legend – required the knowledge of complex figure drawing, perspective,

history, classical literature, mythology, the Bible and art theory – most women, who had no training in anatomy, perspective or compositions featuring many figures, struggled to create them. Nonetheless, it was a woman who introduced history paintings to England. As she travelled through Europe with her artist father, Angelica Kauffman studied the great masters. Her history paintings became celebrated and were extremely well received, particularly in Britain. Other female artists accomplished in this genre are Elisabetta Sirani, Marie-Guillemine Benoist (1768–1826) and Lucy Madox Brown Rossetti (1843–1894).

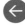

RENAISSANCE **p.12** BAROQUE **p.15** NEOCLASSICISM **p.17** TIMOCLEA KILLING THE THRACIAN CAPTAIN **p.54**
THE JUDGEMENT OF PARIS **p.60**

The Senses

KEY ARTISTS: CLARA PEETERS • MARIE BASHKIRTSEFF • MARGARET MACDONALD MACKINTOSH • ANNIE SWYNNERTON • CLARICE BECKETT • BRIDGET RILEY • YAYOI KUSAMA

KEY DEVELOPMENTS

The senses became a popular theme among artists in the late sixteenth to the mid-eighteenth century, as can be seen from such works as Clara Peeters's *Still Life with Cheeses, Artichoke and Cherries* (c.1625). Viewers enjoyed working out artists' references. In 1898 Annie Swynnerton, who was recognized for her portraits and symbolist paintings, depicted an angel on earth who needs her sight to find heaven. Her glowing expression suggests that she can see it.

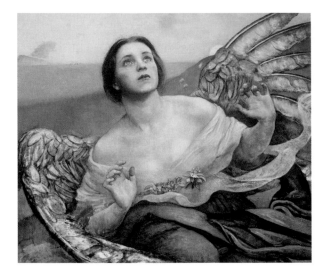

The Sense of Sight, Annie Swynnerton, 1898, oil on canvas, 88.9 x 102.8 cm (35 x 40½ in), Private Collection

While the sense of sight is the conventional way in which art is experienced, many artists have either created artworks that require the use of other senses, such as hearing or touch, or have conveyed in their work some or all of the five senses, such as taste, touch and hearing.

For instance, Marina Abramović's performance *The Artist Is Present* (2010) challenged viewers to use several of their senses at once and to explore feelings that were inspired by the experience. In her abstract paintings, Bridget Riley has worked with phenomena that cause the brain to dictate to the eyes when looking at her work, and to suggest senses other than what viewers are actually perceiving – usually a sense of dynamism. Although not as rigid as Riley's work, *Springtime in Washington* (1971)

by Alma Thomas also affects the senses. Thomas and other Abstract Expressionist artists, such as Helen Frankenthaler, Lee Krasner and Elaine de Kooning, relied on the viewer engaging visually with their abstract paintings, for emotions to be evoked and for the brain to evoke senses beyond sight, such as sound, taste and touch. Earlier works by such artists as Clara Peeters, Harriet Backer, Clarice Beckett and Camille Claudel have engaged touch, taste, hearing and smell as well as sight.

DUTCH GOLDEN AGE **p.14** IMPRESSIONISM **p.19** PERFORMANCE ART **p.38** BLUE INTERIOR **p.76** SPRINGTIME IN WASHINGTON **p.134** CERTAIN DAY **p.140** THE ARTIST IS PRESENT **p.164**

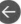

Women's Work

KEY ARTISTS: MARY CASSATT • SUZANNE VALADON • AMRITA SHER-GIL
ELIZABETH CATLETT

Along with 'feminine crafts', certain jobs and activities, such as nursing babies, rearing children and caring for the sick, have traditionally been assigned to women.

Since most are physically weaker than men, women have traditionally done jobs that are less strenuous and more nurturing. Although the reason for this divide is partly biological and partly socially fabricated, it has long been questioned by many. Historically, women artists have also been restricted to depicting activities that can be undertaken by women. For instance, the painting *The Anatomy Lesson of Dr Nicolaes Tulp* (1632) by Rembrandt van Rijn could never have been painted by a woman at that time because women were forbidden from attending such demonstrations. Instead, such paintings as Mary Cassatt's *The Child's Bath* (1893) convey 'women's work' with decorum, and were therefore socially

acceptable. Thirty years later, Suzanne Valadon's *The Blue Room* depicts a reclining woman in corset-free garments smoking a cigarette. It was the antithesis of the doting mother or reclining goddess. In 1935 Amrita Sher-Gil painted *Three Girls*, indicating how women's roles were not always welcomed by women themselves, but were usually faced with dignity and resolve.

KEY DEVELOPMENTS
Inspired by Paul Gauguin, Louis Anquetin (1861–1932) and Edvard Munch (1863–1944), Marianne von Werefkin painted with Alexej von Jawlensky, Wassily Kandinsky and Gabriele Münter in Murnau in 1908. The following year they founded the New Association of Artists in Munich, and the next year she painted the working women below carrying white bundles back to their mountain village, having finished their day's laundering.

The Black Women, Marianne von Werefkin, c.1910, gouache on cardboard, 72.5 x 111.5 cm (28½ x 44 in), Sprengel Museum, Hanover, Germany

IMPRESSIONISM **p.19** POST-IMPRESSIONISM **p.20** ART NOUVEAU **p.21** EXPRESSIONISM **p.22** HARLEM RENAISSANCE **p.29** BLUE INTERIOR **p.76** THE CHILD'S BATH **p.82** THREE GIRLS **p.110**

Gender

KEY ARTISTS: ROSA BONHEUR • FRIDA KAHLO • LEE KRASNER • CORINNE MICHELLE WEST
KARA WALKER • CLAUDE CAHUN

Rosa Bonheur wore men's clothes for practical reasons; she could not go into slaughterhouses and livestock markets as a woman, and when she was out sketching, being disguised as a man allowed her to avoid unwanted attention. A critic once 'praised' her by saying, 'She paints like a man.'

In a similar sentiment, in the 1940s Hans Hofmann told his pupil Lee Krasner that her work was 'so good you would not know it was painted by a woman'. Both Krasner and Corinne Michelle West signed their work with masculine-sounding names – Lena became Lee and Corinne became Michael – to appeal to the traditionally gender-biased public.

Gender has long been a hindrance for female artists, and while some have tried to ignore it, others have attempted to explore some of the complex notions surrounding it. In her naive folk-art style, Frida Kahlo investigated questions of identity, gender, class and race. When she was a child, her father encouraged her to participate in boxing and football to strengthen her polio-weakened leg. In 1940, after her divorce, she painted *Self-Portrait with Cropped Hair*, depicting herself wearing an oversized man's suit. In this way, her consideration of the gender theme is emotionally and symbolically charged.

KEY DEVELOPMENTS

The French photographer, sculptor and writer Lucie Renée Mathilde Schwob (1894–1954) challenged gender roles in a society where they were strictly implemented. In 1917 she adopted the gender-ambiguous name Claude Cahun and produced a series of self-portraits that convey her gender-neutral status. In her autobiography *Disavowals* (1930), she wrote: 'Shuffle the cards. Masculine? Feminine? It depends on the situation. Neuter is the only gender that always suits me.'

Self-Portrait, Claude Cahun, 1928, photograph, 17.9 x 23.7 cm (7 x 9⅓ in), Jersey Heritage Trust, Jersey, UK

EXPRESSIONISM **p.22** SURREALISM **p.30** CONCEPTUAL ART **p.39** SCOTLAND FOREVER! **p.72** CATTLE AT REST ON A HILLSIDE IN THE ALPS **p.78** THE BROKEN COLUMN **p.114** COMPOSITION **p.116**

Heritage

KEY ARTISTS: NATALIA GONCHAROVA • SONIA DELAUNAY • FRIDA KAHLO • AMRITA SHER-GIL
KARA WALKER • HARRIET POWERS • MIRA SCHENDEL • LYNETTE YIADOM-BOAKYE

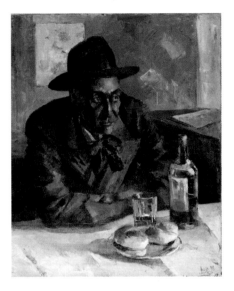

KEY DEVELOPMENTS
Loïs Mailou Jones did not go to Africa until she was 65, but the forms, lines and colours she discovered in African ceremonies had been infusing her art for years. These influences are apparent in this painting of a man of African heritage, sitting at a table in a café. The composition is reminiscent of nineteenth-century paintings by Edgar Degas of white sitters.

Dans un Café à Paris (Leigh Whipper),
Loïs Mailou Jones, 1939, oil on canvas,
91.4 x 73.7 cm (36 x 29 in), Brooklyn
Museum, New York, USA

After her marriage, Frida Kahlo dressed in traditional Mexican costumes and painted herself wearing them. Amrita Sher-Gil's painting style and subjects convey her Indian and European heritage; the quilts made by Harriet Powers reveal her history as an African-American slave; and Natalia Goncharova drew inspiration from traditional Russian icons and folk prints, or *lubki*, derived from popular Russian stories.

The Ukrainian-born Sonia Delaunay (1885–1979) began creating her colourful art after making her newborn son a blanket 'composed of bits of fabric like those I had seen in the houses of Ukrainian peasants. When it was finished, the arrangement of the pieces of material seemed to me to evoke Cubist conceptions.' Mira Schendel's mixed heritage (she was born Jewish, but baptized and raised Roman Catholic) and her experiences in Europe and Brazil affected her art powerfully. Like so many artists, Kahlo, Sher-Gil, Goncharova, Delaunay and Schendel were strongly influenced by their heritage, often drawing on unexpected elements in their work.

British-born Lynette Yiadom-Boakye (b.1977) is of Ghanaian descent, and, after noticing that art history is full of white faces, she began painting fictional portraits of black subjects, creating timeless evocations of these individuals relaxing in traditionally white art-historical poses.

← RAYONISM **p.25** FEMINIST ART **p.37** CONCEPTUAL ART **p.39** CYCLIST **p.94** COMPOSITION WITH FIGURES **p.96** THREE GIRLS **p.110** SHARECROPPER **p.118** UNTITLED **p.126**

Nature

KEY ARTISTS: RACHEL RUYSCH • MARIA SIBYLLA MERIAN • MARIE BRACQUEMOND
ANA MENDIETA • ANYA GALLACCIO • GILLIAN AYRES • LOUISE BOURGEOIS

In 1860 Marie Bracquemond, a promising young student of the celebrated painter Jean-Auguste-Dominique Ingres, noted: 'Monsieur Ingres ... doubted the courage and perseverance of a woman in the field of painting ... He would assign to them only the painting of flowers, of fruits, of still lifes, portraits and genre scenes.'

Bracquemond's observations reflect the general limitations of women's artistic training before the twentieth century. Still lifes and flower paintings were generally considered mild enough themes for women artists. The detailed flower paintings of Rachel Ruysch often feature petals and leaves that are starting to wither, conveying life's fragility and transience. The German naturalist and scientific illustrator Maria Sibylla Merian (1647–1717) travelled to South America, without a male companion, to create meticulous illustrations of animals and insects. After her mother's death, Louise Bourgeois became obsessed with the

spider, its patience and resolve, its appearance and its sense of being comforting and frightening at once: 'Because my best friend was my mother and she was deliberate, clever, patient, soothing, reasonable, dainty, subtle, indispensable, neat and as useful as a spider'. Anya Gallaccio (b.1963) builds on the natural processes of change and decay in organic materials, and the performance artist Ana Mendieta became known for her 'earth-body' sculptures, or *siluetas*.

KEY DEVELOPMENTS
While nature has been a common theme for female artists, its treatment has been particularly divergent. Gillian Ayres (1930–2018) discovered the work of Claude Monet (1840–1926), Vincent van Gogh (1853–1890) and Paul Gauguin through books in her school library. She also visited the National Gallery in London. All based on nature, her vibrant abstract paintings and prints show the influence of the art of Henri Matisse and Joan Miró (1893–1983).

Dawn-bright Lawn, Gillian Ayres, 2013, oil on canvas, 122 x 244 cm (48 x 96 in), Courtesy Estate of Gillian Ayres and Cristea Roberts Gallery, London, UK

NATURALISM **p.18** STILL LIFE WITH CHEESES, ARTICHOKE AND CHERRIES **p.46** STILL LIFE WITH FLOWERS IN A GLASS VASE **p.56** CATTLE AT REST ON A HILLSIDE IN THE ALPS **p.78** SHELL NO. I **p.104**

Individuality

KEY ARTISTS: PAULA MODERSOHN-BECKER • HELENE SCHJERFBECK
HELEN FRANKENTHALER • MAGDALENA ABAKANOWICZ • CINDY SHERMAN • SARAH LUCAS

Influenced by Conceptual and Pop Art, the Pictures Generation is a loose association of American artists who experiment with a variety of media, including photography and film, to explore social stereotypes and present their ideas, often wittily, to viewers who are bombarded by the mass media.

Challenging notions of individuality and originality, one of these artists is Cindy Sherman, who began using photography and film after finding painting restricting. She uses props, make-up and costumes to alter her own appearance to investigate many different stereotypes, expressing her concerns about the overpowering influence of the mass media both on individuals and on wider society. One of the Young British Artists of the 1990s, Sarah Lucas (b.1962) creates unexpected self-portraits that highlight the objectification, sexualization and lack of individuality of the female body made so often by male artists. Helene Schjerfbeck experimented with her own individuality as her work evolved from her early realistic painting style into something more abstract. Her painting became bright and colourful, then subdued, and during the 1930s, towards the end of her life, she began building angular shapes into her self-portraits, creating mask-like appearances and then repeatedly reworking the painted surfaces with a brush, palette knife or cloth to create a completely individual style.

KEY DEVELOPMENTS

Known for her sculptures of organic forms, the Polish artist Magdalena Abakanowicz (1930–2017) became known for her humanoid, faceless figures often made of sewn burlap (hessian) and synthetic resins, or in bronze. The figure below deliberately conveys the loss of individuality that Abakanowicz recognized under the Communist regime of her homeland. She wrote: 'Art does not solve problems, but makes us aware of their existence.'

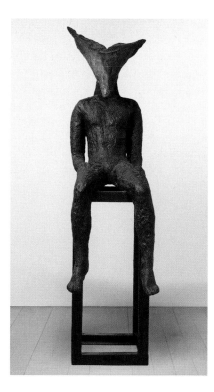

Osiel (Embodied Forms), Magdalena Abakanowicz, 2006, bronze, 226.1 x 58.1 x 89.9 cm (89 x 22⅞ x 35⅜ in), Private Collection

ABSTRACT EXPRESSIONISM **p.33** NOUVEAU RÉALISME **p.36** PERFORMANCE ART **p.38** THE BLUE ROOM **p.100** THE WOUNDED SHOOTING STAR **p.144** DANCING OSTRICHES **p.148** RETOPISTICS **p.150**

Body Image

KEY ARTISTS: FRIDA KAHLO • ALICE NEEL • JENNY SAVILLE • PAULA REGO • MARINA ABRAMOVIĆ • FAITH RINGGOLD • MARTHA ROSLER • ARIANE LOPEZ-HUICI • IVONNE THEIN

Along with ideas about identity, gender and objectification, many female artists have sought to redress established attitudes about body image.

In 1988 Faith Ringgold created *Change 2: Faith Ringgold's Over 100 Pound Weight Loss Performance Story Quilt*. She produced a number of quilts, exploring her own feelings and attitudes towards herself and her body after losing 45.5 kg (100 lb) in weight. Martha Rosler's conceptual art explores various aspects of our media-saturated society. In 1977 she created *Losing: A Conversation with the Parents*, an 18-minute film showing the tragedy of anorexia from the point of view of parents who have lost their daughter to the disease. The German artist Ivonne Thein (b. 1979) creates photographs, videos and installations that explore the appearance of women and how they are portrayed. Her series *Thirty-two Kilos* (2008) focuses on the extreme body shapes that commonly appear in fashion magazines. Through computer manipulation, Thein modified photographs of slender women, making them even thinner. Wearing hardly any clothes, they are all positioned to resemble models' contorted poses. Their bodies appear shockingly anorexic. Also considering body image, Ariane Lopez-Huici (b.1945) focuses on large bodies, rather than the extra-gaunt.

KEY DEVELOPMENTS
Sylvia Sleigh (1916–2010) moved to London in 1941, and 20 years later to the United States. In about 1970 she produced several paintings that contradict stereotypical images of naked women by featuring nude men in traditional female nude poses. One of these is *The Turkish Bath*, which depicts a group of naked art critics and recalls a painting of the same name by Ingres.

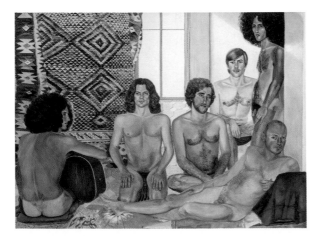

The Turkish Bath, Sylvia Sleigh, 1973, oil on canvas, 193 x 259 cm (76 x 102 in), David and Alfred Smart Museum, University of Chicago, Illinois, USA

NATURALISM **p.18** SURREALISM **p.30** POP ART **p.35** FEMINIST ART **p.37** PERFORMANCE ART **p.38**
THE BLUE ROOM **p.100** PLAN **p.146** DANCING OSTRICHES FROM DISNEY'S 'FANTASIA' **p.148**

The Nude

KEY ARTISTS: LAVINIA FONTANA • ZINAIDA SEREBRIAKOVA • PAULA MODERSOHN-BECKER
CAMILLE CLAUDEL • JENNY SAVILLE • PAULA REGO • ANA MENDIETA

Representation of the nude by female artists will always contrast strongly with that of male artists. Different art movements and eras also influence styles and approaches to the subject.

For instance, in her smooth Art Deco style, Zinaida Serebriakova made numerous paintings of stylish female nudes, including her own daughter in *Portrait of Ekaterina Serebriakova, the Daughter of the Artist* (1928). Camille Claudel was inspired by both Auguste Rodin and her own intense passions when she made *Vertumnus and Pomona* (1886–1905), while Frida Kahlo's *The Broken Column* (1944) depicts her nude body, partially covered in white sheets to express her hospitalization and pain, and her body's fragility. Deliberately contrasting with the traditional male gaze and the objectification of the female body, Jenny Saville creates huge paintings of female flesh using thick and thin paint. Fascinated by the work of Titian (1488/90–1576) and Tintoretto from a child, Saville gives her nudes large, drooping breasts, bulging stomachs and ample thighs as she focuses on social attitudes and prejudices. In the 1970s Ana Mendieta began incorporating her nude body into open-air performances, such as *Arbol de la Vida* (Tree of Life, 1976), where she covered herself in mud to suggest regeneration in nature.

KEY DEVELOPMENTS
Paula Modersohn-Becker had left her husband and moved to Paris when she painted the portrait below. Although not pregnant, she considers how she might look if she were. She had written that she did not want to have a child yet, so the image conveys how she felt about herself as a woman and an artist. Defying convention by depicting a female nude, she was also the first woman to paint a full-length nude self-portrait.

Self-Portrait on Sixth Wedding Anniversary, Paula Modersohn-Becker, 1906, tempera on canvas, 101.8 x 70.2 cm (40.1 x 27.6 in), Paula Modersohn-Becker Museum, Bremen, Germany

FEMINIST ART **p.37** PERFORMANCE ART **p.38** THE JUDGEMENT OF PARIS **p.60** PORTRAIT OF EKATERINA SEREBRIAKOVA, THE DAUGHTER OF THE ARTIST **p.106** THE BROKEN COLUMN **p.114** PLAN **p.146**

Memory

KEY ARTISTS: LEONORA CARRINGTON • BARBARA HEPWORTH • RACHEL WHITEREAD
REBECCA HORN • ALMA THOMAS • AUDREY FLACK • JULIE MEHRETU • LOUISE BOURGEOIS

KEY DEVELOPMENTS
Audrey Flack (b.1931) explained: 'I grew up during World War II, with all the fear and excitement that living through that time … entailed, and always with that particular sense of being a "Jew" (while Jews were being murdered) … Images of the war were imprinted in my brain … The war ended in 1945 and I did not start the painting until 1975: it took 30 years.'

World War II (Vanitas), Audrey Flack, 1977–78, oil over acrylic on canvas, 243.8 x 243.8 cm (96 x 96 in), Private Collection

From personal, private reminiscences to grand histories, memory is a recurring theme in art. It can be part of an artist's autobiography, a new treatment of old subjects, themes, materials or approaches, or a flashback to a previous moment, and all these have been explored in diverse ways by a wide range of female artists.

Translated as 'go back and get it', *sankova* is a Ghanaian word that was considered by Aminah Brenda Lynn Robinson (1940–2015). Referencing memories and portraying stories of her African-American ancestors and the cultures and customs she encountered on her travels, she created sculpture, woodcuts, drawings, books and mixed-media paintings. *Figures* by

Magdalena Abakanowicz, created in the 1970s, and *Retopistics* (2001) by Julie Mehretu, both explore the artists' memories and experiences, some painful, some happy. Rachel Whiteread's *Ghost* (1990) deliberately 'mummified' the interior of a Victorian room, and Rebecca Horn's *The Wounded Shooting Star (L'Estel Ferit)* (1992) sets out to evoke memories of a fishing village previously on the site, while Leonora Carrington's *Ulu's Pants* of 1952 developed from her knowledge of Celtic mythology and other international cultural traditions. Louise Bourgeois's *Giant Crouching Spider* of 2003 draws on memories of her mother.

HARLEM RENAISSANCE **p.29** SURREALISM **p.30** ABSTRACT EXPRESSIONISM **p.33** FAMILY OF MAN **p.132** GHOST **p.142** THE WOUNDED SHOOTING STAR **p.144** RETOPISTICS **p.150** GIANT CROUCHING SPIDER **p.154**

Confrontation

KEY ARTISTS: HANNAH HÖCH • ELIZABETH CATLETT • KARA WALKER • AUDREY FLACK
MARTHA ROSLER • MONA HATOUM • MARINA ABRAMOVIĆ • CINDY SHERMAN

Female artists have explored the theme of confrontation in exceptionally diverse ways, and there are examples of women artists from almost every movement and period who have focused on it.

Showing themselves to be enterprising and courageous, some have created unique self-portraits and portraits that challenge both viewers and their male counter-parts, such as Paula Modersohn-Becker's *Self-Portrait on Sixth Wedding Anniversary* (1906), Helene Schjerfbeck's *Self-Portrait with Black Background* (1915), Suzanne Valadon's defiant gaze from her sofa in *The Blue Room* (1923) and Jenny Saville's *Plan* (1993). Others have used confrontation to challenge the viewer to reconsider such things as racism, slavery and sexism, as in Kara Walker's silhouettes and Elizabeth Catlett's *Sharecropper* (1952). Others have confronted aspects of contemporary society that cause anxiety, worry and discomfort,

such as Marina Abramović's *The Artist Is Present* (2010) and Lin Jingjing's *We Are Free to Choose, but We Are Not Free from the Consequences of Our Choices* (2017). Confrontation has also been expressed in artworks that focus on the horrors of war, such as Hannah Höch's *High Finance* (1923), Audrey Flack's *World War II (Vanitas)* (1977–78), *Nature Morte aux Grenades* by Mona Hatoum (2006–07) and Martha Rosler's *Invasion* (2008).

KEY DEVELOPMENTS

Cindy Sherman presents herself in disguise to confront stereotyping, inviting viewers to come to their own conclusions. Each of her 69 *Untitled Film Stills* (1977–80) presents a stereotypical female heroine from the films of the 1950s and 1960s. Here, she is a smart career girl in a new suit in the big city.

Untitled Film Still #21, Cindy Sherman, 1978, photograph, 19.1 x 24.1 cm (7½ x 9½ in), Museum of Modern Art, New York, USA

Anger

KEY ARTISTS: ELISABETTA SIRANI • ARTEMISIA GENTILESCHI • HANNAH HÖCH
ELIZABETH CATLETT • KARA WALKER • SUZANNE LACY • AUDREY FLACK • PIPILOTTI RIST

During her short life, Elisabetta Sirani championed both female painters and female subjects. In her painting school she trained many women, including her younger sisters, and in her own work she often projected female courage.

Timoclea Killing the Thracian Captain (1659) inverts conventional hierarchy. The rapist is upside down and helpless, and Timoclea stands above him, extracting her revenge. Artemisia Gentileschi's *Judith Slaying Holofernes* (1610) is another dramatic scene of an ordinary woman overpowering a high-ranking man. In it, the biblical Judith and her maidservant also convey their cool but murderous anger as they behead the invading Assyrian general. *In Mourning and In Rage* was a performance created by Suzanne Lacy (b.1945) and Leslie Labowitz-Starus (b.1946) in response to an epidemic of unsolved rapes and murders in Southern California in 1977. For the work,

artists, politicians and the families of the rape victims all gathered at Los Angeles City Hall to perform a ritual of mourning and rage in front of the press. In *Ever Is Over All,* Pipilotti Rist (b.1962) smashes the windows of parked cars as she passes. Instead of stopping her, a female police officer salutes her. This is another expression of anger against traditional views, expectations, portrayals and treatment of women.

KEY DEVELOPMENTS
Early in her career, Pipilotti Rist created the video below, using colours and hallucinatory effects. Formed with two mirrored reflections, it shows an underwater paradise, with images of a woman in a bikini, often in extreme close-up, plus views of domestic objects, all set to a melancholy soundtrack with Rist repeatedly, unnervingly shrieking lyrics over the top. The work conveys anger as it considers female empowerment.

Sip My Ocean, Pipilotti Rist, 1996, audio
video installation (video still)

Transformation

KEY ARTISTS: GEORGIA O'KEEFFE • MARÍA BLANCHARD • LOUISE BOURGEOIS
EVA HESSE • CINDY SHERMAN • CORNELIA PARKER • ANYA GALLACCIO

In *Shell No. 1* of 1928, Georgia O'Keeffe transformed a small, ordinary object into a sensual painting. It and her flower paintings also challenged traditional notions of still-life painting and ideas about abstraction.

By having to break from the stereotype of the female artist, many women in this book have transformed conventional artistic processes or featured transformation as a theme. María Blanchard's *Woman with a Fan* (1916), for example, is broken into planes conveying different viewpoints. Cindy Sherman constantly transforms herself, from 1960s pin-up to housewife, mechanic and clown. Her ambiguous characters suggest complex lives, but by leaving the works untitled, she makes the viewer's interpretation an essential aspect. Since 1960 Bridget Riley has been creating transformations through optical phenomena, and Maggi Hambling (b.1945) has created energetic images using vibrant marks to express the sea's continual transformations. Others, among them Louise Bourgeois, Eva Hesse, Claire Falkenstein (1908–1997) and Lynda Benglis (b.1941), have used the theme of transformation in their art and unusual materials, while Anya Gallaccio and Michelle Stuart (b.1933) include natural, unpredictable transformations in their work.

KEY DEVELOPMENTS
Frequently transforming existing materials or established artworks, Cornelia Parker (b.1956) works with both physical and conceptual ideas to transform the viewer's thoughts. *Hanging Fire (Suspected Arson)*, for example, is constructed from the charred remains of a suspected arson case, creating a visual explosion. Carefully suspended and placed, the blackened embers hang from the ceiling, evoking ideas of destruction, fragility and the transformation of sculpture over time.

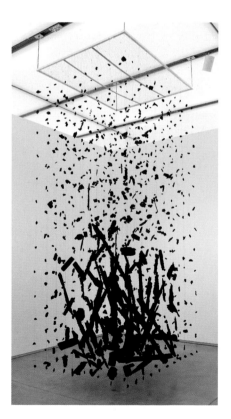

Hanging Fire (Suspected Arson), Cornelia Parker, 1999, charcoal, wire, pins and nails, 365.8 x 152.4 x 182.9 cm (144 x 60 x 72 in), Institute of Contemporary Art, Boston, Massachusetts, USA

Race

KEY ARTISTS: EDMONIA LEWIS • FAITH RINGGOLD • ELIZABETH CATLETT
BETYE SAAR • GUERRILLA GIRLS • KARA WALKER • CLAUDETTE JOHNSON

The first African-American woman to be recognized as a sculptor, Edmonia Lewis encountered racial problems throughout her education. In response, she sculpted portraits of well-known abolitionists, including William Lloyd Garrison (1805–1879) and Wendell Phillips (1811–1884).

The first African-American woman to obtain an MFA from the University of Iowa, Elizabeth Catlett explored race and feminism, highlighting the struggle of black people, especially in relation to segregation and the fight for civil rights: 'I have always wanted my art to service my people – to reflect us, to relate to us, to stimulate us, to make us aware of our potential.' Faith Ringgold, who similarly faced racial as

well as sexual discrimination, eventually achieved acclaim for her representations of the black female experience. In the mid-1980s the anonymous feminist group Guerrilla Girls emerged, boldly attacking female and racial inequality in the art world, while Kara Walker has made several artworks about race, such as *A Subtlety* or *The Marvellous Sugar Baby* (2014), using 80 tons of sugar in Brooklyn's now defunct Domino Sugar Factory. This huge sphinx with the head of a stereotypical black female slave highlighted the slave trade, which for years was an integral part of sugar processing.

KEY DEVELOPMENTS

While enslaved, African Americans were forbidden from learning to read and write. Many did in secret, however, and they also developed their own 'language'. This is part of a larger work by Betye Saar (b.1926) that presents symbols of enslavement and personal and collective memories. Blackbird, molasses, honey and coffee were some of the words used by slaves to describe one another's skin tones.

Blackbird, Betye Saar, 2002, mixed-media assemblage on child's black-board, 59.4 x 59 x 7 cm (23⅜ x 23¼ x 2¾ in), signed; Pennsylvania Academy of the Fine Arts, Philadelphia, USA

HARLEM RENAISSANCE **p.29** FEMINIST ART **p.37** PERFORMANCE ART **p.38** CONCEPTUAL ART **p.39**
HIAWATHA **p.68** SHARECROPPER **p.118** PICTURESQUE **p.156**

The Environment

KEY ARTISTS: CLARICE BECKETT • BARBARA HEPWORTH • AGNES DENES • ANYA GALLACCIO
REBECCA HORN • MONA HATOUM • JULIE MEHRETU

Land or Environmental Art began as part of Conceptual Art in the 1960s and 1970s, as artists wished to raise awareness about environmental problems using a wide range of media, techniques and styles.

One of the most prominent of these artists is Agnes Denes, who often focuses on the relationship between the natural and the built environment, raising awareness about ecological problems. Much Environmental Art is huge and created for one particular place, so it cannot be moved or exhibited in museums or galleries except as photographs. In 1982 Denes created *Wheatfield, a Confrontation* over six months by planting a 0.8-hectare (2-acre) field of wheat on a landfill site near Wall Street in Manhattan. Other artists who have explored aspects of the environment include Naturalists, Impressionists, Australian Tonalists such as Clarice Beckett, and some Expressionists, such as Gabriele Münter with her *Village Street in Murnau* (1908). Barbara Hepworth created sculpture that appeared to emerge directly from her environment, for instance *Family of Man* (1970), which intentionally resembles ancient Cornish standing stones. Julie Mehretu and Mona Hatoum often consider manmade environments, and Rebecca Horn uses elements from different locations to change the immediate environment.

White Trash (from the series *Beach Couture: A Haute Mess*), Marina DeBris, 2017, found beach and ocean rubbish

KEY DEVELOPMENTS

Marina DeBris is the name used by an Australian-based artist and social activist who uses washed-up rubbish from beaches to raise awareness of ocean and beach pollution. She has been collecting rubbish from beaches since 2001, and she makes outfits from what she finds. *White Trash* is one of these outfits: a textured top made from cigarette lighters, straws, utensils and bottle caps.

Conflict

KEY ARTISTS: OLIVE MUDIE-COOKE • HANNAH HÖCH • FRIDA KAHLO • LAURA KNIGHT
MARY KESSELL • MONA HATOUM

Refugees, Mary Kessell, 1944, charcoal on paper, 260 x 346 cm (102⅓ x 136¼ in), Kettle's Yard, Cambridge, UK

Not all representations of conflict are images of war, but these provide a powerful avenue. Since the twentieth century a number of women have captured aspects of the social, industrial and personal experience of war and the human cost.

In the early twentieth century it was considered indelicate for women to witness war from the front, so many female artists produced unofficial images. For instance, during World War I Olive Mudie-Cooke (1890–1925) drove ambulances for the British Red Cross in France and painted images of the wartime helpers she encountered, as well as evidence of war damage and battlefields. Almost simultaneously in Berlin, Hannah Höch highlighted the negative aspects of German culture. At the end of World War II Mary Kessell (1914–77) created drawings of homeless women and children in Berlin, and of the destruction of Hamburg. Also in the 1940s, Laura Knight

became one of only three women war artists to be commissioned to travel abroad to record the war. In Berlin in 1946 she painted the Nuremberg Trials. Disturbed by the negativity, she depicted the back wall of the courtroom as the ruins of the city of Nuremberg. In the early twenty-first century, Mona Hatoum recorded her experiences of war in *Nature Morte aux Grenades*.

KEY DEVELOPMENTS
The London-born figurative painter, illustrator, designer and war artist Mary Kessell was one of three women commissioned to work in Germany as an official war artist at the end of World War II. Spending six weeks in Germany, she visited the recently liberated Bergen-Belsen concentration camp and produced charcoal drawings of refugees, primarily women and children, as in the expressive image above, created predominantly with tonal contrasts.

EXPRESSIONISM **p.22** PERFORMANCE ART **p.38** CONCEPTUAL ART **p.39** OUTBREAK **p.86**
HIGH FINANCE **p.102** NATURE MORTE AUX GRENADES **p.158** INVASION **p.160**

Empathy

KEY ARTISTS: LILLY MARTIN SPENCER • MARY CASSATT • MARIE LAURENCIN • FRIDA KAHLO
MARINA ABRAMOVIĆ • LYGIA PAPE • BARBARA HEPWORTH • YAYOI KUSAMA • TRACEY EMIN

Physical and emotional connections between sitters have always been a powerful theme for female artists, one that was often expected of them and that many executed well. Élisabeth Vigée-Lebrun's *Madame Vigée-Lebrun and Her Daughter, Jeanne-Lucie-Louise* (1789), *Conversation Piece* (c.1851–52) by Lilly Martin Spencer, Berthe Morisot's *The Mother and Sister of the Artist* (1869/70) and Mary Cassatt's *The Child's Bath* (1893) are all examples. Conveying empathy between family members, especially between mothers and children, they usually capture sitters in relaxed, candid poses.

Another empathetic connection is that directly between artist and sitter, as depicted by Jeanna Bauck of her friend in *Bertha Wegmann Painting a Portrait* (1889) and Paula Modersohn-Becker's *The Sculptress Clara Rilke-Westhoff* (1905). Empathy with past experiences runs through and binds some visual narratives, conveying the artists' intense emotional ties, as in the work of Leonora Carrington and Frida Kahlo, while psychological bonds are created by others in various ways. For example, Marina Abramović and Yayoi Kusama convey empathy with the viewers who participate in their works; Jenny Holzer, Cindy Sherman and Barbara Kruger trigger empathetic thoughts through the viewers' memories; and Helen Frankenthaler inspires visual sympathy and associations with her soak-stain paintings. Lygia Pape's *Book of Creation* (1959–60) has elements that seem to empathize with the creation of the world.

KEY DEVELOPMENTS

Artworks are often sympathetic to their surroundings, as evidenced by Barbara Hepworth's *Family of Man* and *I Want My Time with You* (2018) by Tracey Emin, a huge pink neon sign suspended high up in St Pancras station, one of the United Kingdom's busiest railway stations. The largest text artwork Emin has made, it is intended to convey empathy towards travellers arriving in London from Europe.

I Want My Time With You, Tracey Emin, 2018, pink neon lights, length 20 m (65 ft 7⅜ in), St Pancras station, London, UK

IMPRESSIONISM **p.19** CONVERSATION PIECE **p.66** THE CHILD'S BATH **p.82**
APOLLINAIRE AND HIS FRIENDS **p.92** FAMILY OF MAN **p.132** THE ARTIST IS PRESENT **p.164**

Index

Illustrations are indicated in *italic*
Main entries are indicated in **bold**

Museums

Works from the following museums and institutions are featured in this book.

AUSTRALIA
Art Gallery of New South Wales, Sydney
National Gallery of Art, Melbourne

FINLAND
Ateneum Art Museum, Finish National Gallery, Helsinki

FRANCE
Château la Coste Art Centre, Provence
Musée d'Art Moderne et Contemporain, Strasbourg
Musée d'Art Moderne de la Ville de Paris
Musée du Louvre, Paris
Musée National d'Art Moderne, Centre Georges Pompidou, Paris
Musée d'Orsay, Paris
Musée Rodin, Paris

GERMANY
Hamburger Kunsthalle, Hamburg
Paula Modersohn-Becker Museum, Bremen
Sprengel Museum, Hanover

INDIA
National Gallery of Modern Art, New Delhi

ITALY
Galleria degli Uffizi, Florence
Museo di Capodimonte, Naples
Museo di San Marco, Florence
Museo de San Petronio, Bologna

MEXICO
Museo Dolores Olmedo, Mexico City

THE NETHERLANDS
Frans Hals Museum, Haarlem
Rijksmuseum, Amsterdam

NORWAY
Nasjonalmuseet, Oslo

POLAND
Muzeum Zamek, Łańcut, Poland

PUERTO RICO
Museo de Arte de Ponce, Puerto Rico

RUSSIA
Samara Regional Art Museum, Russia
State Russian Museum, St Petersburg
State Tretyakov Gallery, Moscow

SPAIN
Museo Nacional Centro de Arte Reina Sofía, Madrid

SWEDEN
Hilma af Klint Foundation, Stockholm
Nationalmuseum, Stockholm

UK
British Museum, London
De Morgan Foundation, Guildford, Surrey
Fitzwilliam Museum, Cambridge
Jersey Heritage Trust, Jersey
Kelvingrove Art Gallery and Museum, Glasgow
Kettle's Yard, Cambridge
Leeds City Art Gallery, Leeds
National Galleries of Scotland, Edinburgh
National Portrait Gallery, London
Royal Collection Trust, London
Snape Maltings, Suffolk
Tate Modern, London

USA
The Art Institute of Chicago, Illinois
Brooklyn Museum, New York
Cincinatti Art Museum, Ohio
Crystal Bridges Museum of American Art, Bentonville, Arkansas
Dallas Museum of Art, Texas
David and Alfred Smart Museum, Chicago, Illinois
Davis Museum and Cultural Center, Wellesley College, Massachusetts
Detroit Institute of Arts, Michigan
Georgia Museum of Art, Athens
Institute of Contemporary Art, Boston, Massachusetts
Los Angeles County Museum of Art, California
Mead Art Museum, Massachusetts
Metropolitan Museum of Art, New York
Museum of Fine Arts, Boston, Massachusetts
Museum of Fine Arts, Houston
Museum of Modern Art, New York
National Gallery of Art, Washington, DC
Pennsylvania Academy of Fine Arts, Philadelphia
Philadelphia Museum of Art, Pennsylvania
San Diego Museum of Art, California
San Francisco Museum of Modern Art, California
Smithsonian American Art Museum, Washington, DC

Picture Credits

10 Mondadori Portfolio/Electa/Luciano Pedicin /Bridgeman Images 12 Bridgeman Images 13 Gift of William and Selma Postar/Bridgeman Images 14 Purchased with the support of the Vereniging Rembrandt/Rijksmuseum 15 Mondadori Portfolio/Electa/Luciano Pedicin/Bridgeman Images 16 The Regenstein Collection/The Art Institute of Chicago 17 The Picture Art Collection/Alamy Stock Photo 18 Ivy Close Images/Alamy Stock Photo 19 The Walter H. and Leonore Annenberg Collection, Bequest of Walter H. Annenberg, 2002/Metropolitan Museum of Art, New York 20 Painters/Alamy Stock Photo 21 Photo © Christie's Images/Bridgeman Images 22 © DACS 2020; Photo © Christie's Images/Bridgeman Images 23 History and Art Collection/Alamy Stock Photo 24 Musée d'Art Moderne de la Ville de Paris, Paris, France/Bridgeman Images 25 © ADAGP, Paris and DACS, London 2020; State Russian Museum, St. Petersburg, Russia/Bridgeman Images 26 Art Collection 4/Alamy Stock Photo 27 Art Museum, Samara, Russia/Bridgeman Images 28 © DACS 2020; Bridgeman Images 29 Pennsylvania Academy of the Fine Arts, Henry D. Gilpin Fund; Courtesy of Michael Rosenfeld Gallery LLC, New York, NY 30 © Estate of Leonora Carrington/ARS, NY and DACS, London 2020; Photo © Christie's Images/Bridgeman Images 31 © Tamara de Lempicka Estate LLC/ADAGP, Paris and DACS, London 2020; Musée National d'Art Moderne, Centre Pompidou, Paris, France/Bridgeman Images 32 © 2020. Digital image, The Museum of Modern Art, New York/Scala, Florence 33 © The Pollock-Krasner Foundation ARS, NY and DACS, London 2020; Philadelphia Museum of Art, Pennsylvania, PA, USA/Gift of the Aaron E. Norman Fund Inc./Bridgeman Images 34 Courtesy the artist, David Nolan Gallery/New York, Sexauer Gallery/Berlin 35 Courtesy of the Pauline Boty Estate/Mayor Gallery, London/Bridgeman Images 36 © Niki de Saint Phalle Charitable Foundation/ADAGP, Paris and DACS, London 2020; Photo © Christie's Images/Bridgeman Images 37 © the artist; courtesy Sprüth Magers, Berlin; Glenstone Museum, Potomac, Maryland 38 © Marina Abramović. Courtesy of Marina Abramović and Sean Kelly Gallery, New York, DACS 2020; Photography by Marco Anelli; Courtesy of the Marina Abramović Archives 39 © Jenny Holzer. ARS, NY and DACS, London 2020. Charlie J Ercilla/Alamy Stock Photo 40 Royal Collection Trust © Her Majesty Queen Elizabeth II, 2020/Bridgeman Images 43 Muzeum Zamek, Lancut, Poland/Bridgeman Images 45 Galleria degli Uffizi, Florence, Tuscany, Italy/Bridgeman Images 46–49 Los Angeles County Museum of Art 50 Purchased with the support of the Vereniging Rembrandt/Rijksmuseum 53 Royal Collection Trust © Her Majesty Queen Elizabeth II, 2020/Bridgeman Images 55 Museo di Capodimonte, Naples, Campania, Italy/Mondadori Portfolio/Electa/Luciano Pedicini/Bridgeman Images 56 Rijksmuseum 59 Galleria degli Uffizi, Florence, Tuscany, Italy/Photo © Raffaello Bencini/Bridgeman Images 61 The Picture Art Collection/Alamy Stock Photo 63 Gift of Julia A. Berwind, 1953/Metropolitan Museum of Art, New York 65 Louvre, Paris, France/Bridgeman Images 67 Maria DeWitt Jesup and Morris K. Jesup Funds, 1998/Metropolitan Museum of Art, New York 69 Morris K. Jesup and Friends of the American Wing Funds, 2015/Metropolitan Museum of Art, New York 71 National Gallery of Art, Washington DC 72–75 Leeds Museums and Galleries (Leeds Art Gallery) UK/Bridgeman Images 77 Nasjonalmuseet, The Fine Art Collection/Høstland, Børre 78–79 A.A. Munger Collection/Art Institute of Chicago 80 Musée Rodin, Paris, France/Peter Willi/Bridgeman Images 83 Robert A. Waller Fund/Art Institute of Chicago 85 De Morgan Collection, courtesy of the De Morgan Foundation/Bridgeman Images 87 Hamburger Kunsthalle, Hamburg, Germany/Bridgeman Images 89 Art Collection 3/Alamy Stock Photo 90–91 British Museum, London, UK/Bridgeman Images 92–93 © Fondation Foujita/ADAGP, Paris and DACS, London 2020. Photo 12/Alamy Stock Photo 94–95 © ADAGP, Paris and DACS, London 2020. State Russian Museum, St Petersburg, Russia/Bridgeman Images 97 Art Heritage/Alamy Stock Photo 99 Ateneum Art Museum, Finnish National Gallery, Helsinki, Finland/Bridgeman Images 100–101 Painters/Alamy Stock Photo 102 © DACS 2020; Private Collection/Bridgeman Images 104 © Board of Trustees, National Gallery of Art, Washington DC. Alfred Stieglitz Collection, Bequest of Georgia O'Keeffe, National Gallery of Art, Washington DC 107 © ADAGP, Paris and DACS, London 2020. Mead Art Museum, Amherst College, MA, USA/Gift of Thomas P. Whitney (Class of 1937)/Bridgeman Images 108–109 Photo: National Gallery of Victoria, Melbourne 111 GL Archive/Alamy Stock Photo 113 © The Estate of Alice Neel. Courtesy The Estate of Alice Neel and David Zwirner. San Diego Museum of Art, USA/Bequest of Stanley K. Oldden 115 © Banco de México Diego Rivera Frida Kahlo Museums Trust, Mexico, D.F./DACS 2020. Museo Dolores Olmedo Patino, Mexico City, Mexico/Photo © Selva /Bridgeman Images 117 © The Pollock-Krasner Foundation/ARS, NY and DACS, London 2020. Philadelphia Museum of Art, Pennsylvania, PA, USA/Gift of the Aaron E. Norman Fund Inc./Bridgeman Images 118 © Catlett Mora Family Trust/VAGA at ARS, NY and DACS, London 2020. Philadelphia Museum of Art, Pennsylvania, PA, USA/Purchased with the Alice Newton Osborn Fund, 1999/Bridgeman Images 120–123 © Estate of Leonora Carrington/ARS, NY and DACS, London 2020. Photo: © Christie's Images/Bridgeman